D1644649

Chain Reactions

Pioneers of British Science
and Technology
and the stories that
link them

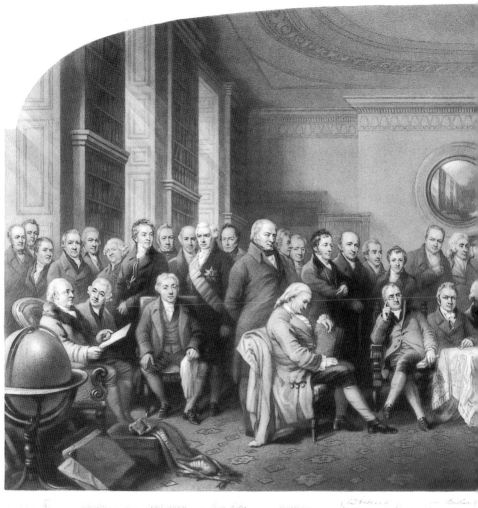

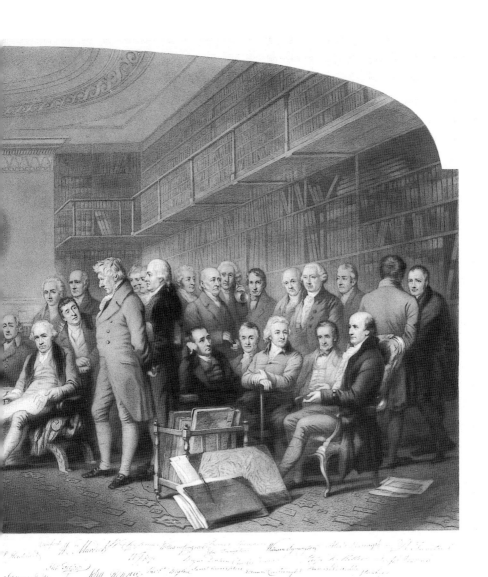

0. Engraving after *Men of Science Living in 1807–1808*
George Zobel and William Walker, 1862
Engraving, 629 x 1089mm (24³/₄ x 42⁷/₈")
National Portrait Gallery, London (NPG 1075a)

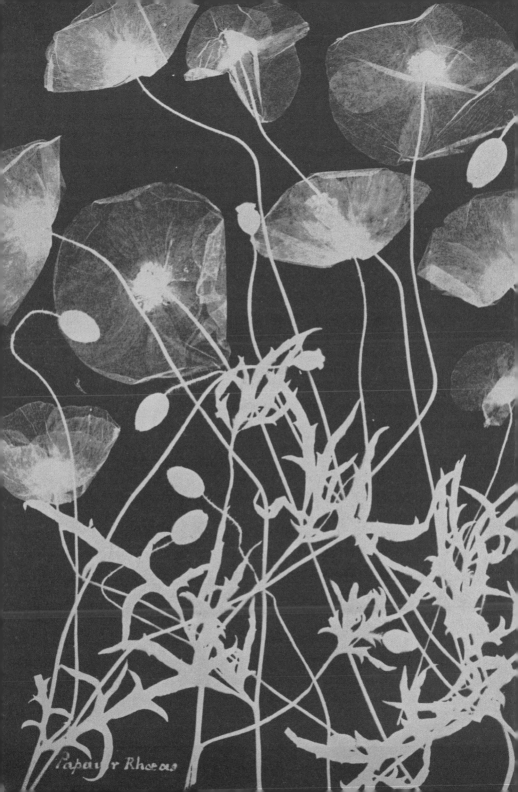

Papaver Rhoeas

Chain Reactions

Pioneers of British Science and Technology and the stories that link them

Adam Hart-Davis

National Portrait Gallery

Published in Great Britain by
National Portrait Gallery Publications,
National Portrait Gallery,
St Martin's Place,
London WC2H 0HE

For a complete catalogue of current publications,
please write to the address above, or visit our website on
www.npg.org.uk/pubs

A catalogue record of this book is available from the British Library.

ISBN 1 85514 291 0

Publishing Manager: Jacky Colliss Harvey
Editor: Susie Foster
Production: Ruth Müller-Wirth
Designer: Simon Loxley

Printed by Clifford Press Ltd, Coventry

Front cover (top to bottom): Francis Bacon, Viscount St Alban, 1731 (detail);
Robert Boyle, c.1689–90 (detail); Sir Isaac Newton, 1702 (detail); Erasmus Darwin, n.d. (detail);
James Cook, 1776 (detail); Caroline Herschel, n.d. (detail); Edward Jenner, 1803 (detail);
Sir Joseph Banks, 1810 (detail); Charles Darwin, 1883 (detail); Florence Nightingale, 1850s (detail);
Thomas Henry Huxley, 1883 (detail); Marie Carmichael Stopes, 1953 (detail)

Frontispiece: Engraving after *Men of Science Living in 1807–1808*, 1862

Page 4: Cyanotype of flora by Anna Atkins, published c.1841 (detail)

Back cover (left): Matthew Boulton, c.1799 (detail)

To Sue

I should like to thank Dr Allan Chapman for reading the typescript, correcting many errors, and introducing a bunch of new ideas. Also Ursula Payne for carefully going through the manuscript and Paul Bader and his colleagues at Screenhouse Productions for all their hard work in producing the *Local Heroes* programmes.

Introduction

When a letter arrived on my doormat inviting me to write a book about the scientists whose portraits are in the National Portrait Gallery I was keen at once; when I went to look at the scientists on display I was even more enthusiastic – wonderful glowing pictures of energetic young men and women, quite unlike the black-and-white engravings of old men that I was used to – and these lovely pictures were to be in my book!

During the last ten years I have presented a television programme called *Local Heroes*, in which I bicycle around to visit the homes and work-places of pioneers of science and technology, talk about their lives, and use simple demonstrations to give some idea of what they did. In all I have presented some sixty programmes, and covered more than 250 heroes. This has been immensely rewarding, since I love science and trying to explain bits of it in simple terms; thus these pioneers are genuinely my heroes.

The programmes have been made by a succession of teams that started with just two of us and progressed eventually to five; my enthusiastic colleagues have done at least as much as I have to bring the heroes to life. We chose our heroes partly for geographical reasons – 'Let's go to Scotland again this year' – with a slight bias against London and Cambridge, because otherwise we could have made many programmes from either place – some because the people were immensely important, some because they invented something odd and amusing – a mousetrap or an automatic egg-boiler – others simply because they appealed to us. We have generally avoided trying to cover science later than 1900. Thus the heroes do not come from some *Who's Who* of dead scientists, nor do they all have statues in their honour; rather they comprise a random selection of pioneers from the length and breadth of the country.

As we collected stories I began to notice odd coincidences. For example, 1769 was an

exceptional year for science and technology: the Transit of Venus was observed by several astronomers organised by the Royal Society, and in Tahiti by Captain James Cook and Joseph Banks; the first steam-powered vehicle, a gun carriage, was built by Nicholas Cugnot in France; James Watt took out his famous steam-engine patent; Richard Arkwright took out a patent for a cotton-spinning machine that was to become a major money-spinner too; and Eleanor Coade set up a factory in Lambeth to make artificial stone – the magnificent lion at the south end of Westminster bridge is a tribute to her skill.

There were more subtle coincidences, too. On 6 December 1799 the elegant and refined Dr Joseph Black died in style (see page 38), and on the same day was born in Attercliffe, on the edge of Sheffield, one John Stringfellow, who went on to achieve the world's first powered flight in Somerset in 1848.

A chronological chart of the heroes shows that there were three periods between 1650 and 1900 in which British science and technology flowered (see page 186). These were the late 1600s, the late 1700s, and the mid- to late 1800s, in other words in the reigns of Charles II, George III, and Victoria.

This may be simply because those were the times when new ideas happened to surface, but I suspect that all three monarchs were positively interested in science and technology. Charles II founded the Royal Society, or at least made it Royal; he also ordered the building of the Greenwich Observatory and appointed the first Astronomer Royal. George III collected scientific instruments (now in the Science Museum in South Kensington) and built his own observatory at Richmond in order to observe the Transit of Venus in 1769. Queen Victoria must have seen her empire grow as a direct result of the colossal strides forward in heavy engineering – railways, iron ships and flying machines. She even went once to visit a steelworks in Sheffield. I imagine all the men dressed in their Sunday best, sweating away with vast furnaces and rivers of molten iron and steel. The queen drove in, safely enclosed in a coach with six horses, looked round once with horror at the scene, and drove out again, without getting out of the coach.

I am no historian – my only qualification is that I failed O level history – and so I have little knowledge of kings and queens, nor of social conditions in Victorian times or the Middle Ages. However, each of these heroes formed a little island of information in my sea of ignorance, and gradually I began to notice that many of the islands were connected. Some connections were obvious – Marc Isambard Brunel was Isambard Kingdom Brunel's father; Charles Darwin was Erasmus Darwin's grandson. However, some were more subtle: Joseph Black discussed latent heat with James Watt, enabling him to improve the steam engine; James Watt's son Gregory taught chemistry to a young Cornishman called Humphry Davy, who went on to run the Royal Institution.

Several times I have come across men whose brilliant work was a direct consequence of the obsession or bloody-mindedness of their masters, and who in their turn went on to inspire or drive others to great works. Yorkshireman Joseph Bramah hired young Henry Maudslay to make his precision locks, and Maudslay went on to become the father

of precision engineering; he made the world's first iron machine tools for Marc Brunel and inspired such disciples as James Nasmyth, who had been articled to Maudslay, and Joseph Whitworth.

Occasionally we stumbled across splendid gatherings of scientists and technologists – the Royal Society is well known; less well-known but in its time as important was the Lunar Society of Birmingham. Meanwhile John Michell's 'entertainments' at his Rectory at Thornhill are not well chronicled, and yet they too were important, I believe, and may have led to William Herschel's interest in astronomy.

Thus I discovered that the links between these people ran not only vertically between the generations, but horizontally between contemporaries. In the eighteenth and nineteenth centuries there was no Internet, no e-mail; not even the telephone, and yet news could spread at tremendous speed. When Alessandro Volta discovered how to make an electrical battery in Italy in 1799 he wrote to Joseph Banks, President of the Royal Society; as a result the philosophers in Britain knew within weeks – and hurried to make their own batteries – and this in spite of the Napoleonic wars, which were raging and might have been expected to hamper post between Italy and England.

These multiple links had been gradually building in my mind for some years, and when the National Portrait Gallery asked me to write about them and use their wonderful portraits as illustrations I could hardly say no!

This book is an attempt to convey some idea of those links between the philosophers – we cannot call them scientists, since the word scientist was invented only in 1840 – both between the generations and across the landscape. The links can be roughly assembled into chains, and my editors at the National Portrait Gallery suggested the title *Chain Reactions*, cunningly implying something to do with science. Some of the chains in the book are indeed linear chains, but others are more like groups: the Lunar Society of Birmingham, for example, was an extraordinary group of men who all knew one another, so that to put them in any particular order is arbitrary. I have further confused that chapter by leaving out several of the Lunar Society but including a few others who had considerable influence on them.

I have tried to highlight the many interconnections between all the people throughout the book without making the chains into an impenetrable web, and I have deliberately left out some of the intriguing facts that have been thrown up. For example, at least a dozen of these people lost a parent at an early age – the mothers of John Flamsteed, Christopher Wren, Anna Atkins and Robert Stephenson all died when the babies were very young. Isaac Newton's father died before he was born, and when he was three his mother abandoned him for ten years. Perhaps this is mere coincidence, since death in middle age must have been more common in past centuries, but perhaps early loss of a parent may have been a contributory factor in turning these children towards thoughtful pursuits.

Another potential strand I ignored was the flash of inspiration, the *eureka!* moment, remembered in honour of Archimedes jumping out of his bath when the solution to a problem came to him. Newton told the French philosopher Voltaire in 1724 that the idea of

gravity was inspired by the fall of an apple – although he may have made up this story long after the event (see page 30). In 1833 the teenage George Boole had what he described as a vision in a field in Doncaster; he thought he had solved the mystery of the human mind. Although he was mistaken, he had invented what we now call Boolean algebra, the system of logic that forms the basis of all our computer software today. Boole does not get into this book; nor does Leo Szilard, who in 1933 had a similar vision as he stepped off the kerb to cross the road in Russell Square in the West End of London; his vision led to the harnessing of atomic power, both for bombs and for power stations. James Watt, however, does appear; he had a vision about how to make a better steam engine as he walked on Glasgow Green one Sunday afternoon in May 1765. According to the writer Sam Smiles, he afterwards said 'I had not walked further than the Golf-house when the whole thing was arranged in my mind'. This vision on a walk is reminiscent of George Boole's – except that Boole was walking on a frosty day in January – and also of the experience of Thomas Edmondson, who while walking in a field near Carlisle in 1837, had a vision that led to the railway ticket, which was used for 150 years, and made him a fortune. According to the history books, 'he worked out his invention with skill and patience, enjoyed its honours with modesty, and dispensed its fruits with generosity'.

This is not intended to be a work of reference. I have made no attempt to include all the most important scientists or engineers or inventors. Please do not feel that if I have left out some of your heroes I do not believe they were important. One or two people are included because they are famous, even though I don't think much of their scientific credibility – and I say so. My aim has been to bring together, in chains, some of the scientists whose portraits hang in the National Portrait Gallery, and to write about them in a way that gives some feel for them as people and for their finest achievements. I have deliberately avoided comprehensive lists of titles, honours, positions and results, for I find such listings tedious. I wanted to write stories that deserved to be told.

As I wrote – rather frantically, between weeks of filming on location – I continually wished I had more time to tease out the interconnections, and to read more of the letters that many of these people wrote to one another, but I hope I have not made too many mistakes or glaring omissions; I hope I have given in this little book some flavour of the scientific heritage of Britain; and I hope you enjoy reading the stories as much as I have enjoyed writing them.

1

Modern Science and the Royal Society

Francis Bacon 1561–1626

Robert Boyle 1627–91

Richard Towneley 1629–1707

John Flamsteed 1646–1719

Christopher Wren 1632–1723

Isaac Newton 1642–1727

Edmond Halley 1656–1742

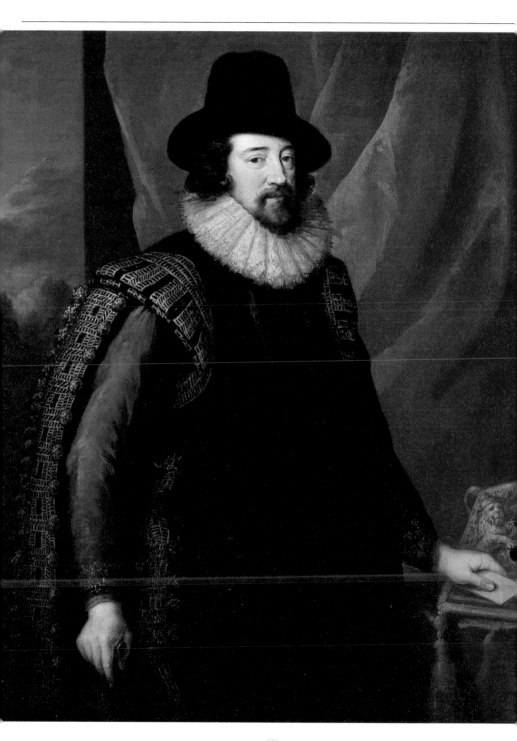

The Greek philosopher Aristotle (384–322 BC) had a complete theory of science and a simple method for discovering scientific theories. He believed that all you had to do was gather a group of clever people and argue; if they were clever enough and argued for long enough then the truth was sure to emerge. One of the first people to challenge this in writing, as England emerged from the Middle Ages into the light of the Renaissance, was **Francis Bacon**, lst Baron Verulam.

Bacon was born in 1561, the sixth child of Sir Nicholas Bacon, Lord Keeper of the Great Seal in the court of Elizabeth I. As a younger son, Francis had to earn his own living. After being educated at Cambridge University, he became a lawyer and was elected to the House of Commons in 1584. He rose to become Lord Chancellor, and in 1621 he was created Viscount St Albans. Yet he fell out with Elizabeth I and was eventually convicted on a technical charge of bribery and briefly thrown into prison.

In spite of the roller-coaster of his public life, Bacon remained at heart a philosopher. He was appalled that Tudor science had not progressed beyond its basis in the teachings of Aristotle and wrote various books refuting his ideas. In *The Advancement of Learning* (1605) Bacon reviews the state of knowledge in his own time. The title page shows a ship sailing through the Pillars of Hercules – the end of the known world – and into the modern age, over the biblical quotation 'Many shall run to and fro, and knowledge shall be increased' (Daniel 12:4; ironically this was quoted as a sign of the end of the world).

Bacon's *Novum Organum; or Indications Respecting the Interpretation of Nature* (1620) pours scorn on Aristotle's ideas, saying that the Greek philosophers were like spiders, spinning webs from their own substance. The way to find out about science, Bacon asserts, is by observing the real world, and he urges his followers to go out and see for themselves how things happen, and to collect data against which to check their ideas.

Francis Bacon 1561–1626 ●

One of the observations he reports, although he does not claim to be the first to notice it, is that hot water freezes more quickly than cold water. This seems improbable, and Bacon has no rational explanation as to why it should happen. Yet I have heard recently from a pair of window-cleaners in Nottingham, who say that in frosty weather they have to use cold water because it does not turn to ice on the windows, whereas hot water freezes rapidly and prevents them from working.

But more than merely stressing the importance of observation, Bacon champions the experimental scientific method. He proposes, for example, that one could investigate gravity by comparing two clocks, one powered by a weight (i.e. gravity) and the other by a spring. Their differences in behaviour at the top of a mountain and at the bottom of a mine should

1. Francis Bacon, Viscount St Alban
Copy by John Vanderbank, 1731,
after an unknown artist, c.1618
Oil on canvas, 1276 x 1026mm (50¹/₄ x 40³/₈")
National Portrait Gallery, London (NPG 1904)

reveal something about how gravity works.

In his book *The New Atlantis* (1627), published posthumously, he describes a fictitious, hands-on science centre called the House of Salomon, where people could learn about science, for it would contain

> Perspective-houses, where we make demonstrations of all lights and radiations ... We procure means of seeing objects afar off; as in the heaven and remote places ... We have also helps for sight, far above spectacles and glasses in use.
>
> We have also sound-houses ... We represent and imitate ... the voices of and notes of beasts and birds.
>
> We have also engine-houses ... Also fire works for pleasure and use. We imitate also flights of birds; we have some degree of flying in the air; we have ships and boats for going under water ... We have divers curious clocks, and other like motions of return, and some perpetual motions. We imitate also motions of living creatures, by images of men, beasts, birds, fishes, and serpents.

In *The New Atlantis* Bacon dreams of a future of scientific exploration: he envisages a college of thirty-six fellows divided into groups, each charged with a specific area of research. They will try to 'establish the causes of things, and amass such a collection of facts as would lead to new discoveries and inventions'. Half of the fellows are to collect from foreign countries and from books all that has been discovered or invented. The other half are to 'try new experiments, tabulate former experiments, and endeavour to draw forth conclusions useful for man's life and knowledge'. In other words, he hoped that scientific experiments would lead to innovations of benefit to humankind.

> There is much ground for hoping that there are still laid up in the womb of Nature many secrets of excellent use ... They too, no doubt, will some time or other come to light of themselves, just as the others did; only by the method of which we are now treating [the experimental method] they can be speedily and suddenly and simultaneously presented and anticipated.

Unfortunately Bacon became a victim of his own enthusiasm. Among his many brilliant ideas was the notion that it might be possible to preserve food, and especially meat, by cooling. Seized by experimental passion, on a wintry April day in 1626, he bought a chicken on Highgate Hill and stuffed it with the snow that was lying on the ground. History does not relate what happened to the bird, but Francis Bacon caught a chill and died – in the process of inventing the frozen chicken.

Bacon summed up his philosophy of observational and experimental investigation by saying, 'Whether or no anything can be known can be settled not by *arguing* but by *trying*'. This insistence on the experimental method inspired those who came after him to look for scientific truth in generalisations drawn out of experiments rather than to try and deduce it by abstract reasoning and mysticism. One of the first to take Bacon's ideas on board was ● **ROBERT BOYLE** ●

THE HON^BLE ROBERT BOYLE
London Published as the Act directs April 15^th 1800 by J.Wilkes

2. Robert Boyle
John Chapman after Johann Kerseboom,
published 1800
Stipple engraving, 190 x 135mm
(7¹/₂ x 5³/₈")
National Portrait Gallery, London
(NPG D10729)

orn in magnificent Lismore Castle on the south coast of Ireland, **Robert Boyle** was the seventh son of the Great Earl of Cork. His parents were much too busy with affairs of state to raise children, so Robert was sent away to Eton at the age of eight. He was later educated in Switzerland and Italy before settling in Oxford, and he spent most of his adult life in Oxford and London.

While Boyle was in Italy he heard of the death of the physicist and astronomer Galileo Galilei (1564–1642), and he began to read Galileo's inspiring books but, sadly, he soon had to return to England. This was the time of the Civil War, and life must have been difficult. Boyle found Ireland particularly uncomfortable when he returned to Cork to sort out some family affairs: he called it 'a barbarous country, where chemical spirits are so misunderstood, and chemical instruments so unprocurable, that it was hard to have any hermetic [i.e. scientific] thoughts in it'.

Boyle was particularly interested in the nature and behaviour of air. Two thousand years earlier, in Sicily, the Greek philosopher

Robert Boyle 1627–91 ●

Empedocles had proved that air is not nothing by holding a bucket upside-down and plunging it into the sea. Taking it out, he showed that the bucket was not wet all the way up the inside; trapped air had kept the water from wetting the entire bucket. This demonstrated that air had real substance and was not merely empty space.

However, since then little progress had been made in researching how air behaves.

Boyle heard about an air pump that had been made in Germany and he hired an assistant, Robert Hooke (1635–1703), to make one for him. Hooke was a brilliant but difficult man, who is remembered now for his study of elasticity and his pioneering studies in microscopy. He is a rather unknowable figure – no portrait of him has survived, and while he repeatedly claimed that he had had stunning original ideas, he did not bother to write them all down. Later he started a famously bitter dispute with **Isaac Newton** (see page 30). However, he built a fine air pump for Boyle, and by using it to pump air from a glass jar Boyle showed that air was necessary both for combustion and for the transmission of sound, enormously extending the ideas of Empedocles.

Boyle tried to construct a corpuscular theory of chemistry, suggesting that tiny particles of primary matter combine in various ways, and paving the way for the modern definition of an element. He invented the litmus test to distinguish acids from bases. However, his most important contribution to modern science was undoubtedly the work with the air pump. This caused much interest and controversy, and the instrument became known as the *machina Boyleana*. Boyle was one of the first people in Britain who really practised experimental science; he said, 'In my laboratory I find that water of Lethe which causes that I forget everything but the joy of making experiments'. (In Greek mythology, Lethe was the river of forgetfulness in the underworld.)

Francis Bacon had dreamed of a college of researchers; in 1645 Boyle began to turn Bacon's dream into reality. He set up a philosophical group which flourished, even though it had no fixed location and thus became known as the 'Invisible College'. It split when some members moved to Oxford but carried on the association there, sometimes convening in the house of John Crosse, an apothecary with whom Boyle lodged, but more generally in Wadham College. The London branch met at Gresham College in Bishopsgate – roughly where Liverpool Street Station is today. This institution had been founded by Sir Thomas Gresham, a wealthy merchant who had also (in 1570) built the first Royal Exchange.

Late in 1660 the London group drew up a memorandum, agreeing to meet regularly and to pay a subscription. Charles II, recently married to Catherine of Braganza and restored to power with much celebration, heard of the society, and on 3 May 1661 was invited to Gresham College to look through a telescope at Saturn's rings and Jupiter's moons. Ten days later he chatted enthusiastically about the experience with the diarist John Evelyn. By the end of that year the college was being called the Royal Society of London for Improving Natural Knowledge, and on 15 July 1662 it was incorporated by royal charter – the Royal Society had arrived.

Even more important than the founding of the Royal Society, however, was Boyle's commitment to experimental science. He has been immortalised for generations of schoolchildren as the person who formulated Boyle's Law:

3. Robert Boyle
After Johann Kerseboom, c.1689–90
Oil on canvas, 1270 x 1035mm (50 x 40³/₄")
National Portrait Gallery, London (NPG 3930)

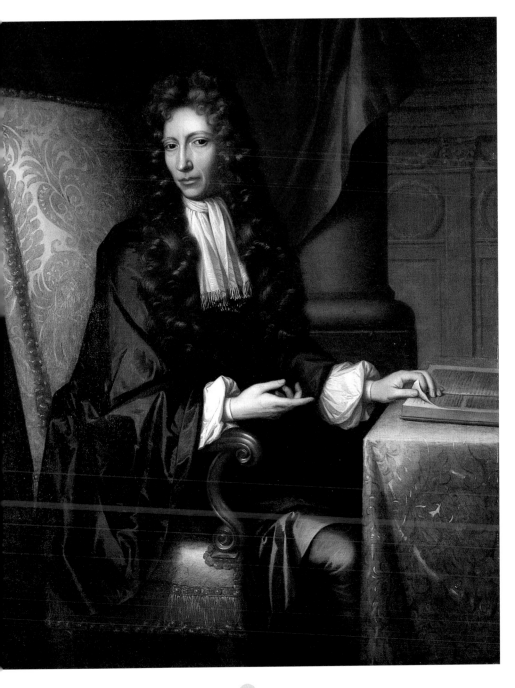

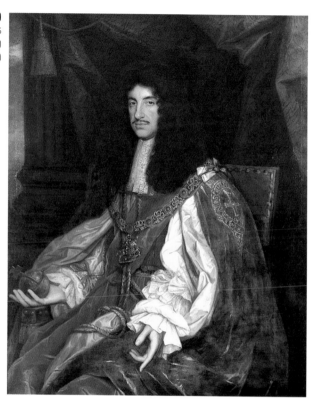

4. Charles II (1630–85)
Studio of John Michael Wright, c.1660–65
Oil on canvas, 1264 x 1010mm (49³/₄ x 39³/₄")
National Portrait Gallery, London (NPG 531)

the idea that at a constant temperature the pressure and the volume of a fixed amount of gas are inversely proportional to one another. Once again he used his air pump, this time with a lamb's bladder, partly filled with air – he surely would have used a rubber balloon, but it had not been invented! The bladder was placed inside a glass vessel, from which Boyle gradually removed the air with his pump. As the pressure in the glass vessel was reduced the bladder began to swell. Boyle noted that the greater the reduction in pressure the more the bladder swelled. In other words, there was a fixed amount of air inside the bladder, and its volume increased as the pressure decreased. He attributed this to 'the spring of the air' – following René Descartes (1596–1650) and Evangelista Torricelli (1608–47), he imagined the particles of air to be like little coils of wool: the more they were compressed the more they would bounce back. Yet the discovery was not really Boyle's – it was first made by ● **RICHARD TOWNELEY** ●

The Towneley family were Roman Catholics, and thus were used to persecution. Richard's father was killed at the battle of Marston Moor in 1644, and although Towneley Hall, near Burnley in Lancashire, had been the family home since the thirteenth century, Oliver Cromwell confiscated it. By 1653 **Richard Towneley** was back in residence and passionately pursuing science, especially meteorology.

To investigate the behaviour of air as the pressure varied, on 27 April 1661 he collected a sample of 'valley ayr' at the Hall, in a glass tube over mercury. With the help of his friend Henry Power, Towneley took this sample 1,000 feet up nearby Pendle Hill. By the time they reached the top, where the pressure was lower, the valley air had expanded – its volume had significantly increased, pushing the mercury down. At the top they collected a sample of 'mountain ayr' and took it down, only to find that the volume decreased in the higher pressure at the Hall.

Towneley wrote to Robert Boyle about his observations, and Boyle confirmed them, publishing their results in 1662. Thus the theory came to be called Boyle's Law, which seems rather unfair, since Boyle himself (and also **Isaac Newton**) called it 'Mr Towneley's Hypothesis'.

Towneley was also the first person in Britain to measure rainfall systematically. In 1676 he made a rain gauge, which he described in detail to the Royal Society as a round tunnel – probably a cylinder – of 12 inches in diameter, soldered to a lead pipe. He wanted to make sure that no nearby building could interrupt the falling rain, so he fixed the cylinder on the roof and took the pipe down the wall and in at his bedroom window. Nowadays the Meteorological Office advises against putting rain gauges on roofs, because wind eddies can sweep rain over the top and give false readings, but Towneley did not have the benefit of their advice.

In his bedroom he let the water collect in a bottle. He measured it three times a day for more than twenty-five years, and faithfully recorded how much rain had fallen. In 1689 he reported the initial ten years' observations to the Royal Society, and his first conclusion was that twice as much rain fell on Towneley as on Paris, where someone else had started recording rainfall. He said that he thought this was

Richard Towneley 1629–1707 ●

because of the high ground in east Lancashire and Yorkshire; the prevailing south-west winds brought in rain clouds which 'are oftener stopt and broken and fall upon us'.

Perhaps because being a Roman Catholic made him feel isolated from his Protestant neighbours, Towneley was not sociable. He rarely visited London and had little direct contact with the growing Royal Society, but he kept in touch with many people by correspondence. Furthermore, distinguished scientists journeyed north to visit him, including a brilliant astronomer who wanted a super-accurate clock that would run for a whole year, so that he could find out whether the earth's rotation was regular. Towneley made the escapement mechanism for this clock – for his friend ● JOHN FLAMSTEED ●

John Flamsteed was born at Denby, near Derby. His mother died when he was only three; at the age of fourteen he went swimming, caught a cold, complications set in, and he was left crippled with rheumatism, so that he could not walk to school. He began studying on his own and became fascinated

● John Flamsteed 1646–1719

by astronomy. He observed the partial solar eclipse of 12 September 1662, and wrote an account of the one on 25 October 1668, which led him to comment 'that the tables differed very much from the heavens'.

In 1670 Flamsteed went to London and met various influential people, including Sir Jonas Moore, who presented him with a micrometer (an instrument for the accurate measurement of small distances or angles) made by Richard Towneley. He proceeded to Cambridge, where he met Isaac Barrow and perhaps **Isaac Newton**, recently Lucasian Professor of Mathematics, and began to make serious astronomical observations, both there and occasionally at Towneley Hall. In 1673 he published an important paper on the real and apparent diameters of the planets, which provided vital information for Newton, who was in the process of writing his master work *Philosophiae Naturalis Principia Mathematica* (1687). At Charles II's command, Flamsteed also published tide tables, and instructions as to how to predict the weather using barometer and thermometer.

As a member of a royal commission to examine a plan for determining longitude at sea, Flamsteed explained to the king that in principle this might be possible using the stars, but the positions of the stars were not known with anything like enough accuracy. Charles II said that 'he must have them anew observed, examined, and corrected for the use of his seamen', and on 4 March 1675 he appointed Flamsteed Astronomical Observator by royal warrant, which directed him 'forthwith to apply himself with the most exact care and diligence to the rectifying the tables of the motions of the heavens, and the places of the fixed stars, so as to find out the so much desired longitude of places for the perfecting the art of navigation'.

An observatory was urgently needed, and £520 was raised by the sale of spoiled gunpowder. The building was hastily erected on a site at Greenwich, which in 1884 would become the defining point of longitude 0°. However, when Flamsteed arrived he found the observatory totally bare; he was supposed to use his own money to pay for astronomical instruments! During the following twelve years he made 20,000 observations, but he said they were only preliminary and approximate, and his equipment was not good enough to produce accurate results, although in fact his 1675 sextant was the best in the world. He was often ill, and always overworked, and Newton became increasingly frustrated with Flamsteed because he was waiting for an accurate astronomical map to complete his own work on the theory of gravitation. Flamsteed became more and more bitter, and during the 1690s and

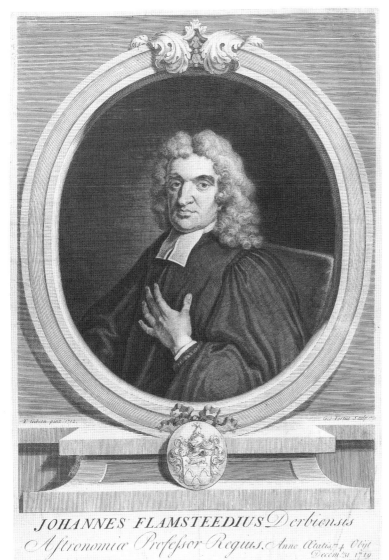

5. John Flamsteed
George Vertue after
Thomas Gibson, n.d.
Line engraving,
323 x 221mm
(12³/₄ x 8³/₄")
National Portrait
Gallery, London
(NPG D7653)

early 1700s Newton and Flamsteed were perpetually at loggerheads. When the catalogue *Historia Coelestis* was published in 1712, Flamsteed claimed that Newton had stolen an imperfect set of results and published them against his will; Flamsteed managed to get hold of 300 of the 400 copies and burned them. Flamsteed's lovely Royal Observatory, on the hill above the river at Greenwich, though, still stands as a testament to his skill both as an astronomer and as the man who persuaded the king to support astronomy. The building was designed by ● **CHRISTOPHER WREN** ●

Christopher Wren is known as Britain's foremost architect, but he does not seem to have started designing buildings until he was twenty-nine years old; before that his passion was for science.

He was born at East Knoyle, near Tisbury in Wiltshire, on 20 October 1632. His father was a well-known clergyman. His mother died when he was very young; he was brought up by

● Christopher Wren 1632–1723

an elder sister and educated by an uncle who was a mathematician. His health was delicate, and he never grew tall, but he was a precocious youth; at Westminster School he learned to write Latin well and began astronomical research. He went to Oxford University at the age of fourteen, spent seven years there, and then moved to London.

In 1657 Wren became Professor of Astronomy at Gresham College (see page 20). The Invisible College used to meet in Wren's rooms there on the days when he gave lectures, and soon after the Royal Society received its charter in 1662 he gave an address on the aims he thought the Society should have, including the study of meteorology, refractions and the growth of fruits and grain; plenty, scarcity and the price of corn; the seasons of fish, fowl and insects; and epidemic diseases. 'The Royal Society should plant crabstocks for posterity to graft on', he remarked. Wren remained an enthusiastic Fellow for twenty years, and was President from 1680 to 1682.

Isaac Barrow, Professor of Geometry at Gresham College, praised Wren for 'the divine felicity of his genius combined with the sweet humanity of his disposition – formerly, as a boy, a prodigy; now, as a man, a miracle, nay, even something superhuman'. He had an exceptional talent for detailed and accurate drawing, which must have been invaluable in architecture; earlier he made beautiful drawings of microscopic creatures for Charles II. In the preface to his famous book *Micrographia* (1665), Robert Hooke wrote of Wren 'I must affirm that since the time of Archimedes there scarce ever met in one man in so great a perfection such a mechanical hand and so philosophic a mind'.

Although Wren practised science actively for only ten years, he managed to cover an extraordinary range. He invented a planting instrument which 'being drawn by a horse over land ploughed and harrowed, shall plant corn equally and without waste' – and this was fifty years before the seed drill was invented by Jethro Tull (1674–1741). Wren also designed a method for making fresh water at sea.

He experimented on blood transfusion between animals, and he spent some time trying to solve the problem of determining longitude. He produced an elegant scheme to explain eclipses, and solved several mathematical problems. He described a recording weathercock, a recording thermometer and a novel spirit level; he experimented with the force of gunpowder required to lift weights, and tried to cure smoking chimneys.

However, when he was twenty-nine, the king asked Wren to become assistant to the Surveyor-General of his majesty's works. He

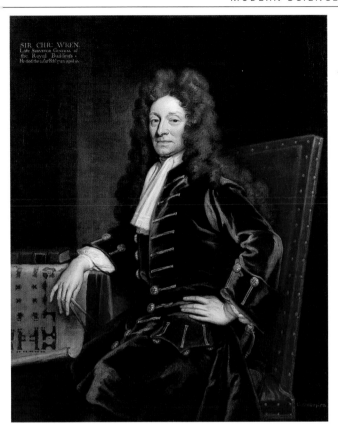

6. Sir Christopher Wren
Sir Godfrey Kneller, 1711
Oil on canvas,1245 x 1003mm
(49 x 39¹/₂")
National Portrait Gallery, London
(NPG 113)

started by building the chapel at Pembroke College, Cambridge, and the Sheldonian Theatre in Oxford. After the great fire burnt down the oldest part of London in 1666 he was appointed Deputy Surveyor-General (1667) and then Surveyor of the Royal Works (1669), which gave him control of all government building in Britain for the following fifty years.

Among the wonderful buildings Wren designed were fifty-two churches in London – no two alike – and even though he was cruelly restrained by conservative clergymen, he achieved a masterpiece of grandeur and proportion in St Paul's Cathedral. He was buried at St Paul's, and an inscription in his honour ends *Si monumentum requiris,* *circumspice* – 'If you want a monument, look around you'.

A neat clerihew sums up his friendliness, his modesty, and his greatest achievement:

Sir Christopher Wren
Said 'I am going to dine with some men.
If anybody calls
Say I am designing St Paul's.

(E.C. Bentley, *Biography for Beginners*)

Perhaps the simplest endorsement of Wren the scientist came after he deduced laws of motion by making swinging balls collide, using an apparatus that is now called Newton's cradle, for even ● ISAAC NEWTON ● acknowledged that Wren had beaten him to it.

Isaac Newton was born at his mother's home of Woolsthorpe Manor, 5 miles south of Grantham in Lincolnshire. The house, not as grand as I would expect a manor house to be, is a modest stone building with a steeply pitched roof and about four bedrooms, including the servants' quarters.

Newton was born under a full moon in the early hours of Christmas Day, and was such a puny baby that it was said he would have fitted into a quart pot – about the size of an average kettle. He was also so sickly that he was not expected to survive the night; in fact he lived to the ripe old age of eighty-four.

His childhood cannot have been happy.

● Isaac Newton 1642 – 1727

His father had died a few months before he was born, and three years later his mother went off to marry a rich clergyman, leaving Newton in the not-very-tender care of his grandmother. He was sent away to the King's School in Grantham, where he was bullied and miserable, until in desperation he turned on the school bully and beat him into submission. After that he began to enjoy his studies, and he became popular with the other boys because he built working models of windmills and other such mechanical devices. He also made himself paper lanterns to light his way to school, and then mischievously flew them on a kite to startle the citizens of Grantham – unidentified flying objects in the 1650s!

When he was in his teens his mother, by then widowed a second time, called him home to Woolsthorpe Manor to work on the farm.

However, he was much more interested in arithmetic than in agriculture, and his teacher eventually persuaded her to send him to Cambridge University in 1661. In spring 1665 the university was closed down because of an outbreak of the plague, and Newton returned home, where during the following eighteen months he produced some of the most spectacular results in physics and mathematics that have ever been achieved by anyone. As he put it himself, 'I was more minded … than at any time since.' Why this happened is not clear. He went back to Cambridge in 1667 and stayed there for nearly thirty years, being appointed Lucasian Professor of Mathematics in 1669. He moved to London in 1696 and became Warden and then Master of the Mint, reforming the entire coinage. And as President of the Royal Society for twenty-five years, he ruled it with a rod of iron. Yet in the last sixty years of his life he never came near the brilliance of his *annus mirabilis* of 1665–6. Some experts suggest he had a unique ability to concentrate, to hold a problem in the forefront of his mind for days and weeks at a time, chipping away until he cracked it, and that this concentration was possible in the solitude of Woolsthorpe Manor but out of the question in the bustle of Cambridge and London.

In mathematics, Newton in that one year solved several major puzzles that had baffled mathematicians for decades, and invented calculus, a vital tool for tackling problems in physics. Unfortunately Newton did not publish his calculus – or fluxions, as he called it – for some forty years, and then he used a difficult and obscure notation. In the mean-

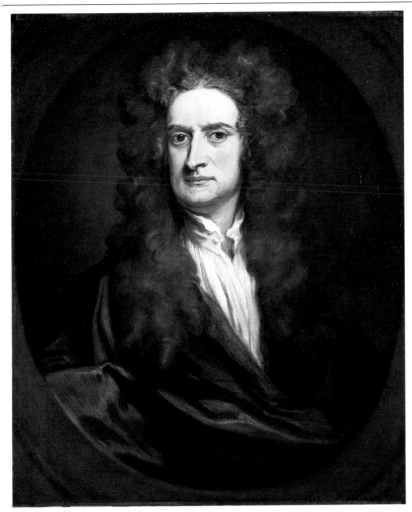

7. Sir Isaac Newton
Sir Godfrey Kneller, 1702
Oil on canvas, feigned oval, 756 x 622mm (29³/₄ x 24¹/₂")
National Portrait Gallery, London (NPG 2881)

time a German mathematician called Gottfried Wilhelm Leibniz (1646–1716) produced a similar set of ideas with a much simpler notation. Newton claimed that Leibniz had stolen his ideas, and indeed that is possible, but the fact is that Leibniz laid calculus before the world earlier and in a more palatable form than Newton.

The first scientific paper that Newton published was a letter to the Royal Society, dated 6 February 1672, in which he explains the colours of the rainbow. 'In the beginning of the year 1666', he writes, 'I procured me a triangular glass prism to try therewith the celebrated phenomena of colours.' He goes on to describe how he cut a hole in his 'window shuts' (shutters), put the prism on the window sill and cast a spectrum on the opposite wall of his study, 22 feet away. The letter makes vivid reading, as though Newton had just come from the bench, although in fact it was written five or six years after he first bought the prism, and

indeed after he had become a professor and delivered two courses of lectures on optics; so it was written with a good deal of hindsight.

Almost casually, in the middle of this letter, Newton explains why simple lenses always produce images with coloured fringes. Therefore, to produce a good astronomical telescope, he recommends using mirrors instead of lenses – since mirrors do not produce coloured fringes – and he describes how to make a reflecting telescope. The one he made in 1668, used to study the moons of Jupiter, and demonstrated to the Royal Society, was probably the first in the world (see page 67).

And in that same miraculous year of 1666, he claimed he had sorted out how gravity works. He spoke about it to Voltaire in 1724, and then in 1725 he told his friend William Stukeley, sitting in the garden after a good lunch, that it was in just such a situation that the idea of gravity first came to him, 'occasioned by the fall of an apple'. He said that wondering why the apple fell down, rather than sideways, he concluded that it must be pulled down towards the earth. How high did this pull operate? If it reached as high as the moon, then it would affect the moon's orbit, or indeed it might cause the moon's orbit. He grabbed a piece of paper – one of his mother's leasehold contracts – and did some calculations, and then said that they seemed to 'answer pretty nearly'. This was a modest claim for a scientist who had just solved a problem that had baffled philosophers for thousands of years. However, it now seems that he did not fully work out his gravitational theory until he came to write *Principia* some twenty years later. In 1666 his ideas about gravity were naive and unfinished, and the story of the apple, which he also told to Voltaire, was almost certainly made up long after it was supposed to have happened.

Newton was a cantankerous man, certain in the knowledge that his ideas were original and right, and that anyone who disagreed with him was wrong. He had terrible and long-running disputes not only with Leibniz, because Leibniz published first, but also with John Flamsteed, because Flamsteed would not publish quickly enough, (see page 25) and with Hooke, who took issue with the arguments in Newton's first publication on light and colours – the letter to the Royal Society: Hooke said that Newton's *experimentum crucis* [crucial experiment] did not work, and that his conclusions were nonsense. Much later Newton wrote to Hooke, in what appeared to be a conciliatory letter, 'If I have seen further, it is by standing on the shoulders of giants'. Although this seems to acknowledge his debt to Galileo, Descartes, Johannes Kepler (1571–1630) and the ancients, he may actually have been insulting Hooke, who was short and claimed to have spinal curvature due to his use of a 'turn lathe'.

Newton was disingenuously modest when he said at the end of his life, 'I do not know what I may appear to the world, but to myself I seem to have been only like a boy playing on the sea-shore, and diverting myself in now and then finding a smoother pebble or a prettier shell than ordinary, whilst the great ocean of truth lay all undiscovered before me.'

Despite his difficult and quarrelsome nature, Newton did have some good friends, and one of the most important – in terms of both friendship and the advancement of science – was ● EDMOND HALLEY ●

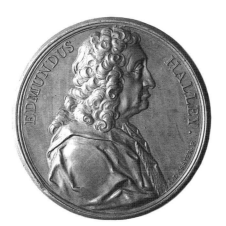

8. Edmond Halley

Jacques Antoine Dassier, 1744

Bronze medal, diameter 54mm (2¹/₈")

National Portrait Gallery, London

(NPG 6235)

Edmond Halley (probably pronounced Hawley) was the second Astronomer Royal and unlike several other scientists in this chapter, seems to have been a thoroughly pleasant man. He rarely lost his temper, bore no grudges and went out of his way to help others, especially Isaac Newton.

Halley was probably born in Shoreditch, London. His father was a rich soap-manufacturer and sent him to St Paul's School, where he did exceptionally well and spent so much time watching the stars that it was said 'that if a star were displaced in the globe he would find it out'. He carried on with his observations at Oxford University and published several papers, but then took a courageous decision.

Realising how important it was for sailors to have accurate star maps such as those John Flamsteed was making for the northern hemisphere (see page 24), Halley decided to produce some for the southern hemisphere. Accordingly he left Oxford before taking his degree,

and armed with a telescope and other instruments, and the blessing of his father and the king, he went off for eighteen months to the South Atlantic, to live on the island of St Helena – a place so remote that it was chosen for Napoleon's exile 140 years later.

Halley hoped to chart most of the brighter stars in the southern skies, but unfortunately the climate proved unhelpful – there was usually too much cloud – and he managed to observe only 341 stars. Nevertheless, he laid the found-

Edmond Halley 1656–1742 ⬤

ations of astronomy in the southern hemisphere, and he did manage, on 7 November 1677, to make the first ever complete observation of the transit of the planet Mercury across the face of the sun. He returned to a great reception in England; was elected a Fellow of the Royal Society at the age of twenty-two; and was christened by Flamsteed the 'southern Tycho' after the famous Danish astronomer Tycho Brahe (1546–1601).

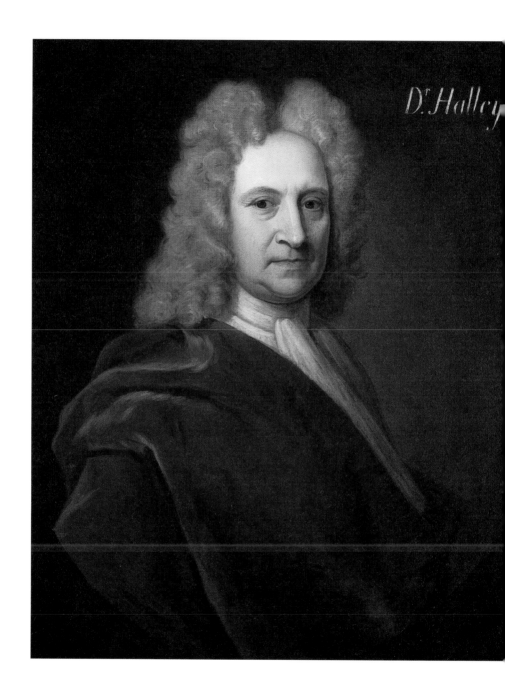

Halley's main claim to fame, and indeed his memorial, is the comet that he observed in 1682. Newton had by then begun to write about gravity and the laws of motion, and Halley used Newton's laws to calculate the orbit of the comet. With what must have been growing excitement he realised that the same comet had been observed before, and more than once. He wrote,

Now many things lead me to believe that the comet of the year 1531, observed by Apian, is the same as that which in the year 1607 was described by Kepler... and which I saw and observed myself at its return in 1682... The identity of these comets is confirmed by the fact that in 1456 a comet was seen, which passed in a retrograde direction between the Earth and the Sun, in nearly the same manner ... From its period and path I infer that it was the same comet as that of the years 1531, 1607, and 1682. I may, therefore, with some confidence predict its return in the year 1758.

The comet did indeed return, on Christmas Day 1758, and then every seventy-six years, its most recent appearance having been in 1985–6. Records also show that it has been recorded by the Chinese since 240 BC; it was noted in the Nuremberg Chronicles of 684 and its 1066 appearance was illustrated in the Bayeux Tapestry (c.1073–83).

The essence of the scientific method, as

9. Edmond Halley
Richard Phillips, 1721 or before
Oil on canvas, feigned oval, 749 x 622mm (29$^1/_2$ x 24$^1/_2$")
National Portrait Gallery, London (NPG 4393)

developed by Francis Bacon, Robert Boyle and Isaac Newton, included not only doing experiments – which is rarely possible in astronomy – but formulating theories that lead to testable predictions. Halley's prediction of the comet's return was a beautiful example of this. He did not live to see it come true, and indeed few people see Halley's comet twice, but he was right.

Halley also carried out some impressive and brave marine surveys, including one voyage that approached the Antarctic, where he 'fell in with great islands of ice, of so incredible a height and magnitude that I scarce dare write my thoughts of it'. He became secretary to the Royal Society in 1713 and then, at the age of sixty-four, was made Astronomer Royal. He made major innovations at Greenwich, installing novel instruments made by George Graham (1675–1742), and establishing the precedent that the government should pay for them. He was fond of brandy, and on 14 January 1742 he asked for a glass of wine, drank it and died.

Arguably, the greatest service Halley performed for posterity was to persuade Newton to complete the *Principia*. Halley, Christopher Wren and Hooke were unable to work out the motions of the planets, but Newton claimed he had done so. Halley visited him in Cambridge in 1684 to ask for details, and three months later Newton sent him the first section of the book. Halley returned to Cambridge to encourage Newton, and then not only explained Newton's work to the Royal Society, but generously offered to pay for the printing of the book. Without his interest and generosity it might never have been published.

2

The Lunar Society of Birmingham

Joseph Black 1728–99

James Watt 1736–1819

Matthew Boulton 1728–1809

Erasmus Darwin 1731–1802

Josiah Wedgwood 1730–95

John 'Iron-mad' Wilkinson 1728–1808

Joseph Priestley 1733–1804

John Dalton 1766–1844

Benjamin Franklin 1706–90

Science can rarely progress without argument and the sharing of knowledge. One way to organise this, as we have seen, is in the meetings of a scientific society. The Royal Society (see page 20), was undoubtedly the best known of these, but by the 1760s it had become as much a social gentlemen's club as a forum for hard-headed scientific debate. And it was a long way from what was to become the industrial heartland of Britain.

In 1766 the manufacturer **Matthew Boulton** (1728–1809: see page 43) got together with his doctor, William Small and the physician **Erasmus Darwin** (1731–1802; see page 45).

● Joseph Black 1728-99

Together they founded what became the Lunar Society of Birmingham – a group of scientists who met once a month, usually for afternoon dinner at Boulton's home, Soho House. In order to have light to ride home after many hours of discussion, they gathered at the time of the full moon, which was why they called themselves the Lunar Society, or the Lunaticks. They met nearly every month until about 1800. They were perhaps the most extraordinary collection of brilliant scientists ever to be gathered regularly in one room. Many of the ideas that fuelled the Industrial Revolution were generated by the Lunar Society of Birmingham, of whom the most famous member was **James Watt** (1736–1819; see page 40), pupil of and assistant to **Joseph Black**.

Joseph Black was every inch a gentleman: always beautifully dressed in a dark suit, and always sporting a rolled silk umbrella. Born in

Bordeaux, France, he was educated in Scotland and went on to teach at the universities of Glasgow and Edinburgh. He had made his first dramatic mark on the world, however, with his doctoral thesis of 1754, on the potentially dull subject of the metal salts known as carbonates. Black produced a stunning piece of work that was in effect the foundation of quantitative chemistry.

When limestone (calcium carbonate) is roasted it turns into the caustic material quicklime. People imagined this was because fire adds some caustic material to the limestone. Black decided to investigate the process carefully. He weighed a sample of limestone, roasted it and then weighed the quicklime produced, discovering that it was lighter than the limestone had been. Rather than adding, the roasting had deducted something.

Black then found that, when treated with acid, limestone fizzed and a gas was given off. This proved to be exactly what was lost in the roasting. At this time gases were generally called 'airs' and, because this particular gas (carbon dioxide) was originally fixed in the limestone, Black called it 'fixed air'. He also discovered that animals exhale the same gas. Black thus established two important facts: first, the existence of carbon dioxide; and second, the value of quantitative measurement – he was led to his discovery by the simple process of weighing the materials involved.

After ten years in Glasgow, Black went on

10. Joseph Black
David Martin, 1787
Oil on canvas, 1270 x 1040mm (50 x 40^1/$_8$")
Collection of The Royal Medical Society, Edinburgh

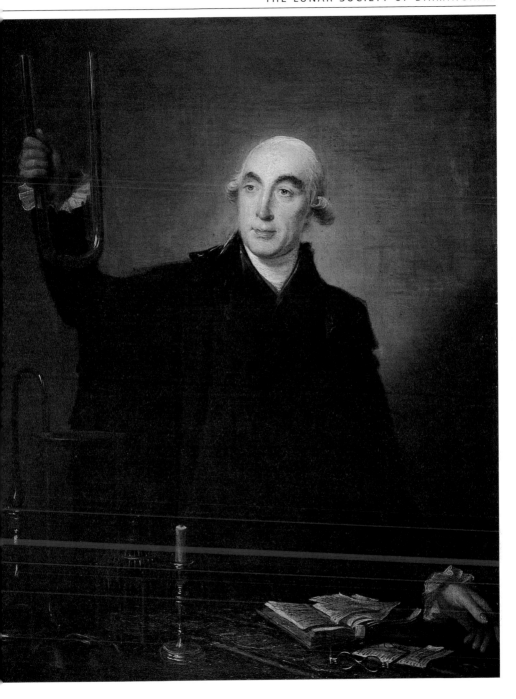

to teach natural philosophy at Edinburgh, where many of his pupils were the sons of whisky distillers. They were much concerned about the costs of distilling and turned to Black for advice. In the making of Scotch whisky, barley grain is allowed to ferment and is then stewed to make a sort of slightly alcoholic soup. However, fermentation can never produce an alcohol content higher than about 15 per cent, since the yeast that produces the alcohol is unable to survive high concentrations. To make spirit, the 'soup' must be distilled.

As alcohol boils at a lower temperature than water, heating a mixture of the two liquids tends to boil off the alcohol, leaving water behind along with many impurities. This process is called distilling; what distils is not in practice pure alcohol but a mixture of alcohol and water in roughly equal proportions. Scottish distillers generally carry out the process twice, in order to improve the purity of the whisky.

The early stages of the whisky-making process are relatively cheap, but distillation requires a lot of heat. Then, after the spirit has been distilled, it needs careful cooling to condense it. The question the distillers asked Black was why the process needed so much heat.

Imagine a saucepan on a stove, full of cold water. When the heat is turned on the water gets warmer; a thermometer in it would show the temperature rising from, say, 20°C to 100°C. The higher the heat, the faster the temperature rises.

When it reaches 100°C the water begins to boil, and the temperature does not rise any more, however much it is heated. If you were making soup, you would probably turn the heat down to minimum, so that the liquid just simmered, while for cooking rice you might want to turn it up to give a rapid boil. But whether the water is barely simmering or boiling rapidly, the temperature stays stubbornly at 100°C. This is quite different from frying bacon or cooking anything in oil, for then the temperature goes on rising, and you can easily burn the food. As long as there is water in the pan, though, the temperature will not rise above boiling point, and the food will not burn.

Turning the heat up to maximum does not affect the temperature of boiling water; so what is happening to the extra heat? Black studied the process of boiling and came to an unexpected conclusion. The heat is needed just to boil the water, without changing its temperature. Each molecule of water at 100°C needs extra heat to lift it out of the liquid and turn it into steam. Because this heat has no effect on the temperature, Black called it 'latent heat', meaning hidden heat. When the steam condenses back into water, it gives up the latent heat, which is why steam is so effective for heating, and why it can cause terrible scalding burns.

Latent heat was what was costing the distillers so much money, both while distilling the spirit and while condensing it again. Black was able not only to explain what was going on but to suggest how they could minimise their costs. Incidentally, latent heat is also needed to melt ice, which is why a couple of ice cubes in a glass of whisky cool the whole drink down to near 0°C before all the ice has melted.

Black died on 6 December 1799, while he was sitting with his family having dinner – a meal consisting of a few prunes, some bread and a bowl of milk diluted with water. With both

hands he picked up his bowl, took a sip, set it gently down on his knees and died, without spilling a drop. Apparently it was almost as though he had deliberately done an experiment to see whether he could die as peacefully and precisely as he had lived.

Black was not a member of the Lunar Society, but his work was of profound import-ance in the development of science, and his ideas concerning carbon dioxide, for example, were picked up enthusiastically by **Joseph Priestley** (1733–1804; see page 54). Perhaps the most remarkable effect of his advice, however, was to change utterly the life and fortunes of a young repairer of mathematical instruments named ● **JAMES WATT** ●

J ames **Watt** was born in Greenock, Scotland, on the banks of the River Clyde. Several of his brothers and sisters died in infancy, and he was a sickly child who became a chronic hypochondriac. Watt was apprenticed to an instrument-maker in London, and on his return to Scotland he set up his own small business and became repairer of instruments at

● James Watt 1736–1819

Glasgow University. This brought him into contact with eminent thinkers, including Joseph Black, eight years his senior.

In 1764 Watt was brought a table-top model of a Newcomen steam engine and asked to get it working. These engines, invented around 1710 by Devon ironmonger Thomas Newcomen (1663–1729), had for more than fifty years been pumping water from mines, especially coal mines in the Midlands. Arguably the Newcomen engine was the most important step forward ever in the evolution of tecnology, because it provided portable power. However, at that stage it was of no use for anything except pumping water, and even then it was dreadfully inefficient.

The single working cylinder of the Newcomen engine was filled with steam, which was then condensed to make a partial vacuum. Atmospheric pressure pushed the piston into the cylinder to eliminate the vacuum and thus created the working stroke of the engine. For each stroke, therefore, the temperature of the entire cylinder – a vast container of brass or cast iron – had first to be raised above 100°C so that it would fill with steam and then lowered below

100°C in order to condense it. This meant that most of the energy in the steam was wasted in overcoming the latent heat, as Black must have discussed with his protégé Watt.

Watt pondered this difficulty for months, and the solution came to him suddenly one Sunday afternoon in May 1765 on Glasgow Green (see page 13). His flash of inspiration was to build a separate condenser. Rather than heating and cooling the entire cylinder on every stroke, he would keep the working cylinder hot – above 100°C – and at the right moment lead the steam through a pipe to a separate chamber that would be kept cold, where the steam would condense rapidly without cooling the cylinder.

The idea was brilliant, but putting it into practice was not so easy, and four years went by before Watt took out a patent, in 1769. During the early 1770s his fortunes changed. His financial backer, John Roebuck, went bankrupt and Watt's wife died. Watt had met Small and **Erasmus Darwin** in 1768 and Boulton soon afterwards; they had repeatedly invited him to move south. Suddenly rootless, he accepted their offer to go to Birmingham and form a partnership with the business tycoon Matthew Boulton, one of the founders of the Lunar Society (see page 36). Boulton supplied cash and workshops with skilled craftsmen, whom he had installed at the Soho Manufactory. Watt supplied ideas, of which the foremost was his steam engine with a separate condenser.

In spite of all this material help, Watt still had terrible trouble with his engine, especially in getting a good fit between the piston and the cylinder. Cylinders were then made of cast iron, and even the best workmen could not make a

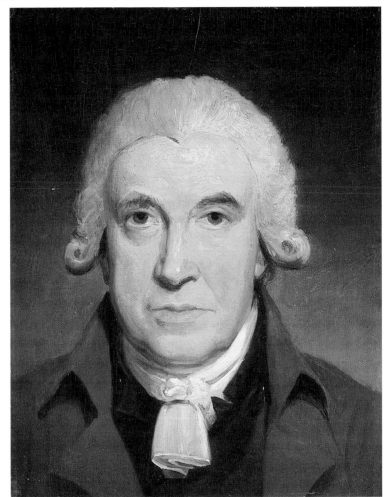

11. James Watt
Henry Howard, c.1797
Oil on panel, 191 x 146mm
(7¹/₂ x 5¹/₄")
National Portrait Gallery,
London (NPG 663)

cylinder that was straight and true. Newcomen engines were deliberately made with a gap of an inch or two between piston and cylinder; the gap was plugged with wet rope or leather, and the engine ran with a few inches of water on top of the piston, completing the seal. Since the cylinder was always just above or just below 100°C the water sufficed to keep in the steam. Watt's new engine, however, was to run with the cylinder always hot – well above 100°C – which meant that he could not have a seal of wet rope or water. He tried to plug the gap with oil and horse manure, but it did not work; he had to find a way of fitting the metal surfaces together to keep the steam in.

Then came Watt's third lucky contact, **John Wilkinson** (1728–1808), who had invented a boring machine for making cannons (see page 50), based on an earlier machine invented by John Roebuck himself, and was able with this machine to make a true cylinder for Watt's steam engine. Within weeks of the delivery of

this cylinder in spring 1775, Watt had his steam engine working for the first time. The second engine he made went back to Wilkinson to drive the blower for Wilkinson's furnace, and for twenty years Wilkinson made all the cylinders for Boulton & Watt engines.

Boulton & Watt engines were far more efficient than those of Newcomen, which was important where the coal required to drive them was expensive. The miners of Cornwall were in terrible trouble from flooding, but had to import coal from South Wales, and so were delighted at the new efficient engines, even though they had to pay royalties to Boulton & Watt. Later, Watt built double-acting engines, where steam was admitted alternately at each end of the cylinder, which were able to drive rotating machinery – from cotton-spinning machines to pumps used in the 1840s to power the atmospheric railway constructed by **Isambard Kingdom Brunel** (1806–59; see page 158). In all, the company made 496 steam engines, and each one generated a royalty.

Watt had wide scientific interests. He was an active member of the Lunar Society, he dabbled in chemistry, and he was the first person to publish the formula of water – H_2O – although he almost certainly picked up that idea from his brilliant but eccentric friend, the physicist and chemist Henry Cavendish (1731–1810). Fed up with having to make copies of business letters and, especially, plans of engines, Watt also invented a copying machine, which he patented in 1779. Not only did this bring Boulton & Watt further income, but it revolutionised office practice. And it gives a fascinating historical perspective on eighteenth-century business life because, almost for the first time ever, copies were kept of all the letters and transactions of a commercial business.

Watt continued to refine the steam engine, inventing sun-and-planet gears and a governor to regulate the speed, but of all his ideas the one that made the inventor himself proudest was the 'parallel motion' – a piece of applied mathematics that when translated into an iron linkage made a simple connection between the end of a piston rod and the beam of a steam engine. Watt is usually wrongly remembered as the inventor of the steam engine, a misconception that has probably arisen because he contributed so fundamentally to its development. Yet it is likely that he would not be remembered at all had he not had the good fortune to meet Joseph Black, John Wilkinson and, above all ● **MATTHEW BOULTON** ●

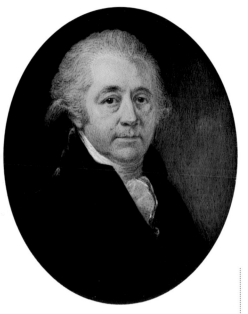

12. Matthew Boulton
Anne Jessop, Lady Beechey, after
Sir William Beechey, c.1799
Miniature on ivory, 79 x 64mm (3¹/₈ x 2¹/₂")
National Portrait Gallery, London (NPG 1595)

Matthew Boulton, who 'loomed like a titan through the mists of the eighteenth century', was born in Birmingham and joined his father's buckle-making business, inheriting it entirely when he was thirty-one. In 1762 he took a radical step by building a great communal workshop to bring together a variety of artisans who were working for him. This Soho Manufactory became world famous for the quality of its products, including silverware. Boulton helped establish Birmingham's assay office, where gold and silver articles were tested and hallmarks assigned, and he went on to make a mint – literally – when he produced coins of the realm. Most significantly, the partnership of Boulton & Watt, based at the Soho Manufactory, became the finest steam-engine company in the world.

Boulton built his home, Soho House, to overlook the manufactory. He equipped it with every modern convenience, from special alloy window frames to hot-air central heating, plus a lavatory patented by **Joseph Bramah** (see page 102). An engineer, Boulton was interested in many branches of science: he collected fossils, constructed thermometers and helped Jesse Ramsden (1735–1800) to make precision optical and mathematical instruments. Meanwhile, Ramsden's estranged wife Sarah was an astute businesswoman, and acted as Boulton's European agent.

Matthew Boulton 1728–1809 ●

Boulton loved to entertain friends who shared his passion for science and technology, and it was this combination of gregariousness and an enquiring mind that led to the founding of the Lunar Society in 1766 (see page 36). The Lunaticks met at two in the afternoon and discussed everything from the state of the canals and the latest theories on electricity to steam engines, hot-air balloons and various kinds of

air. Boulton called the meetings philosophical feasts. According to the contemporary writer Mary Ann Galton, Boulton 'took the lead in conversations, and with a social heart had a grandiose manner like that arising from position, wealth and habitual command'. James Watt, on the other hand, 'was one of the most complete specimens of the melancholy temperament. His head was generally bent forward or leaning on his hand in meditation; his shoulders stooping, and his chest fallen in …' She did not much like Erasmus Darwin: 'His figure was vast and massive; his head was almost buried on his shoulders'. On the other hand, **Joseph Priestley** was 'a man of admirable simplicity, gentleness, and kindness of heart, united with great acuteness of intellect'. When dinner was over the company would withdraw to the so-called Lunar Room and argue on into the evening. Then they would get back on their horses and ride home in the moonlight.

The society frequently devised experiments to try to answer their questions; for example, thunder is essentially an explosion in the sky; so why does it rumble? Is it because there are several bangs in succession, or is the rumbling merely a single bang echoing from hills, buildings or clouds?

This was 1784, and in France the Montgolfier brothers had just startled the world by going up in a hot-air balloon. The Lunar Society seized on the idea of an exploding balloon for their own thunder experiment. Boulton made a balloon 5 feet in diameter from varnished paper and filled it with a mixture of one part air and two parts 'inflammable air from iron' – hydrogen. He fitted a long fuse, lit it and released the balloon. The night was very dark and quite calm. Unfortunately the fuse was too long – it took about five minutes to burn, and the balloon drifted 2 miles. By then all the people waiting for the explosion thought the fuse had gone out. When the bang came they all shouted with joy – and failed to listen for the rumbling, if there was any.

Watt, at his home 3 miles from the explosion, wrote that it 'was very vivid and instantaneous; it seemed to last about one second'. It must have startled the local residents, but it did not answer the Lunaticks' question.

In fact, lightning is an explosion all along the path of the stroke, which may be as long as a mile. So although the explosion happens almost instantaneously, some of the bang – from the most distant part of the stroke – takes several seconds longer to reach the ears than that from the closest part – and that is why it usually sounds like a rumble rather than a sharp bang.

The man who most energetically encouraged these experiments, and whose sharp wit drove the society's discussions, was Boulton's close friend ● **ERASMUS DARWIN** ●

Erasmus Darwin was to be grandfather of two scientists – Charles Darwin (1809–82; see page 121) and Francis Galton (1822–1911). In his own right he was a poet and physician, a giant of a man, crippled and corpulent, but a brilliant wit. He prescribed sex as a cure for hypochondria, had a dozen children by his two wives, and two more by a governess. He was prolific with inventions too.

Darwin was born near Nottingham, and after studying at the universities of Cambridge and Edinburgh set up a medical practice in Nottingham. Failing to attract any patients, he tried again in Lichfield, Staffordshire, where he was lucky – or skilled – enough to cure a prominent local man who had been pronounced in-curable, and therefore be-came much in demand. He practised there for the following twenty years.

Darwin was prepared to travel far and wide to see his patients, in a coach of his own design. It was equipped with books and writing materials on one side and an immense hamper on the other, in case he became hungry en route. Patients also travelled a long way to see him. On one occasion a man came from London for a medical consultation. Darwin examined him, and then asked why on earth he had come all that way when he could have consulted the celebrated Dr Warren in London. The man replied, 'I *am* Dr Warren!' George III was so impressed with Darwin's ability that he invited him to become royal physician, but Darwin declined.

Darwin wrote several substantial books, including the prose work *Zoonomia* (1794–6), which anticipated some of the evolutionary theories of the French naturalist Jean Baptiste Lamarck (1744–1829). As an author he was much admired by the Romantic poets Samuel Taylor Coleridge and William Wordsworth. His most famous poetic work – *The Botanic Garden* (1789–92) – reflects his interest in science and technology. Even steam power was a worthy subject for his pen:

Soon shall thy arm, unconquered steam! Afar
Drag the slow barge, or drive the rapid car:
Or on the wide-waving wings expanded bear
The flying chariot through the field of air.

Darwin was one of the founders of the Lunar Society (see page 36); he loved the intellectual

Erasmus Darwin 1731–1802 ●

exchange, and on one occasion, mortified when he had to miss a meeting, wrote to Matthew Boulton, 'Lord, what invention, what wit, what rhetoric, metaphysical, mechanical, and pyrotechnical, will be on the wing, bandied like a shuttlecock from one to another of your troup of philosophers.'

The members of that intensely practical gathering met their match as Darwin came forth with a string of spectacular inventions, including a new and safer steering system for his wonderful carriage, a rotary pump and a speaking machine. He seems to have been interested in the human voice and, after working out that speech is made up from a limited number of individual sounds, constructed an artificial system to reproduce some of them.

He simulated the passage of air on vocal

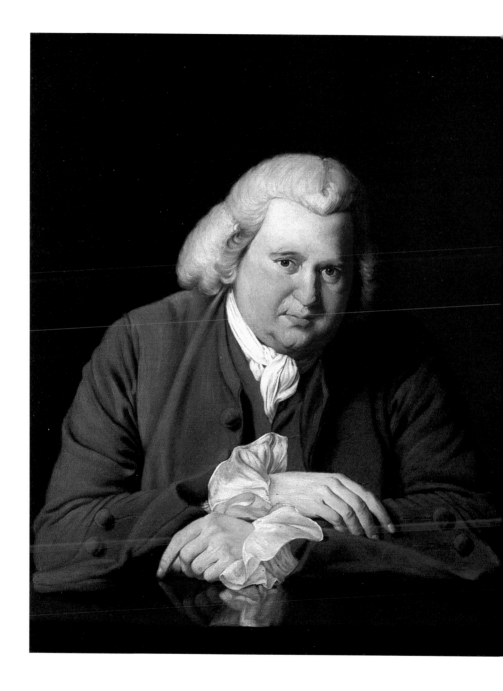

chords with bellows and a silk ribbon. A mouth device with soft leather lips could be opened and closed. Darwin showed that the simplest sound, made with the mouth open and relaxed, is *AAA*. (Changing the shape of the mouth produces the other vowels.) By saying *AAA* and closing and opening the lips gently one can get *AAA MAAA*, and opening the lips explosively produces *AAA PAAA*.

Darwin took his speaking machine to the Lunar Society and demonstrated that it could say Mama and Papa. Boulton was impressed and promised him £1,000 if he could get it to say the Lord's Prayer, the Apostles' Creed and the Ten Commandments – but that was beyond the good doctor's capabilities. Curiously, two or three other people were constructing speaking machines at about the same time, apparently independently.

Although Darwin invented about sixty interesting devices, he did not patent any of them. He put patients before patents; he felt that if he became known as an inventor people would have less confidence in his abilities as a doctor.

Many of his cultural ideas were ahead of their time: he supported the abolition of slavery; and he wrote a book about the education of women, believing, unlike most of his contemporaries, that they were intelligent. He set up a girls' school in Ashbourne, Derbyshire, and sent his illegitimate daughters, Susan and Mary, to teach there. As a result of his views on the curriculum, many young women were taught modern languages and even science.

Intellectually, however, the Lunar Society was his first love. For one member, who was not only a friend but also Charles Darwin's other grandfather, he designed a horizontal windmill. A sketch in his commonplace book shows that this was to be a hexagonal building with all six walls louvred – in order to reflect upwards wind from any direction. In the centre was a vertical shaft, with the horizontal rotor blades at the top to catch the wind, and a grinding wheel at the bottom. The recipient of the design was none other than ● JOSIAH WEDGWOOD ●

13. Erasmus Darwin
After Joseph Wright, 1770
Oil on canvas, 760 x 635mm (30 x 25")
National Portrait Gallery, London (NPG 88)

Josiah Wedgwood had twelve older brothers and sisters. He came from a prolific family, and its members had a habit of marrying other Wedgwoods or Darwins. Thus Josiah married his third cousin Sarah Wedgwood; their daughter Susannah married Robert Darwin; and their son **Charles Darwin** married his first cousin Emma Wedgwood, Josiah's granddaughter.

When Wedgwood was eight years old his father died, and he was taken away from school

● Josiah Wedgwood 1730–95

and sent to work in his brother Thomas's pottery in their home town of Burslem in Staffordshire. He soon became expert at throwing on the wheel, but when he was eleven he caught smallpox, which ruined his right knee. This meant that he had to leave the thrower's bench and work in other and apparently less glamorous areas of the pottery, which must have seemed a terrible blow, but in the long term it proved positive, for he became much more knowledgeable about the whole business than he would have been as a brilliant thrower.

Wedgwood was officially apprenticed to his brother in preparation for going into partnership with him, but Thomas disapproved of young Josiah's experimental streak and the plan did not materialise. Instead, Wedgwood worked for and with various potters, and in 1758 he set up his own business in Burslem. He started modestly but soon expanded, rapidly introducing radical new working practices.

He was a believer in the division of labour, and he rationalised the production process,

continually striving for less waste – of time, energy and clay. He also aimed at better finish and more precise forms than his rivals, setting his workers an example by making most of the models and mixing most of the clays himself.

There were two immediate benefits from his reforms. First, the shapes of his pieces were far more regular than those from other potteries; thus a dozen of his plates could be piled up without danger of toppling over. Furthermore, handles could be held, lids of pots fitted and teapots poured! Customers began to notice. Second, he had excellent taste, and his ornamental ware set new standards in elegance. Within a couple of years he began to make money.

In 1766, by which time he was royal supplier of dinnerware to Queen Charlotte Sophia of Mecklenburg-Strelitz, he bought some land between Burslem and Stoke-on-Trent. On it he built a new factory, a house for himself and a village called Etruria for his workforce. The factory was opened in 1769, a vintage year for technology.

Meanwhile, in Plymouth, William Cookworthy (1705–80) had worked out how to make porcelain, which had previously had to be imported from China (hence its colloquial name) or from Meissen, Germany. Wedgwood latched on to this and also developed his own revolutionary ceramic materials, experimenting with all sorts of minerals and methods. He succeeded in producing basalt and jasperware, and his business expanded both at the basic cup-and-saucer end and into medallions, plaques, salt-cellars, flowerpots, candlesticks, chess pieces and ornamental vases.

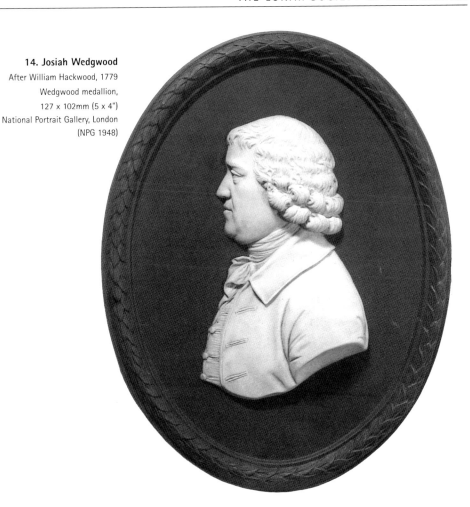

14. Josiah Wedgwood
After William Hackwood, 1779
Wedgwood medallion,
127 x 102mm (5 x 4")
National Portrait Gallery, London
(NPG 1948)

Wedgwood's catalogues were printed not only in English but also in French, Dutch and German, and he must have gained tremendous publicity in 1774 when he supplied Empress Catherine II of Russia with two dinner services comprising 952 pieces of cream-coloured ware, decorated in enamel with English views.

Today pottery is often considered more art than science, but Wedgwood undoubtedly brought a scientific approach to his development of the craft. As a founder member of the Lunar Society (see page 36) he probably discussed chemistry with Watt and **Joseph Priestley**, and from 1783, when he was elected Fellow of the Royal Society, he had a further forum of scientific stimulation and exchange.

The enthusiasm of scientific friends had considerable influence on the ideas of Wedgwood the potter, but they had a more direct effect on another manufacturer with a thirst for scientific precision, the ironmaster ● **JOHN WILKINSON** ●

John Wilkinson was born on a market cart on the road to Workington fair in Cumbria. His father, Isaac, was a farmer who also did some iron work, and Wilkinson was to become one of the great ironmasters in the developing Industrial Revolution.

Before 1700, iron was made by heating together iron ore and charcoal. Charcoal was produced by charring wood, and demand was growing so fast that whole forests were dis-

up another foundry at Broseley, near Ironbridge in Shropshire.

The problem with casting cannons was that it was impossible to make the inside of the barrel a perfectly regular cylinder – that is, exactly circular in cross-section and with straight, parallel sides. This meant that the cannon balls could never be a perfect fit, and on their way out of the barrel they often followed a corkscrew route around the irregularities in

● John 'Iron-mad' Wilkinson 1728–1808

appearing. No trees were to be seen within miles of any ironworks. Then in 1709 Abraham Darby (1677–1717) made a great breakthrough, discovering how to use coke instead of charcoal. Coke was cheap, at least near the coalfields in the West Midlands, and so ironworks proliferated there.

This was the environment in which Wilkinson grew up. By 1748 he had saved enough money to build his first blast furnace, the Bradley Works at Bilston in the West Midlands. He became such an enthusiast that he wanted to make everything from iron, which was why he came to be called 'Iron-mad'. He installed iron window frames, pulpit and pews in the Methodist chapel at Bradley, although the pulpit was painted to look like wood. Iron pews must have been uncomfortably cold in winter!

In the late 1750s Wilkinson joined his father at his ironworks in Bersham, Clwyd, where they cast cannons, and, after taking over the foundry from his father, he continued to do this throughout the 1760s. He also set

the iron sides. As a result, cannons could never be very powerful or accurate, and there was always the danger that the ball might jam in the barrel and cause a devastating explosion.

In 1774 Wilkinson patented a new boring machine which allowed him to cast his cannons as solid lumps and then bore out the barrels as perfect cylinders. This made them much more accurate and powerful, and probably made Wilkinson rich but, more important for the development of industry, it allowed him to make true cylinders for James Watt's steam engines (see page 41). Watt had to have a cylinder and piston with a steam-tight fit – Wilkinson's bored cylinders were just what he needed.

Wilkinson continued to explore the many possible uses of iron. He was a major shareholder in the iron bridge built in 1779 that gave

15. John Wilkinson
Lemuel Francis Abbott, 1790s
Oil on canvas, 737 x 616mm (29 x 24^1/$_4$")
National Portrait Gallery, London
(NPG 3785)

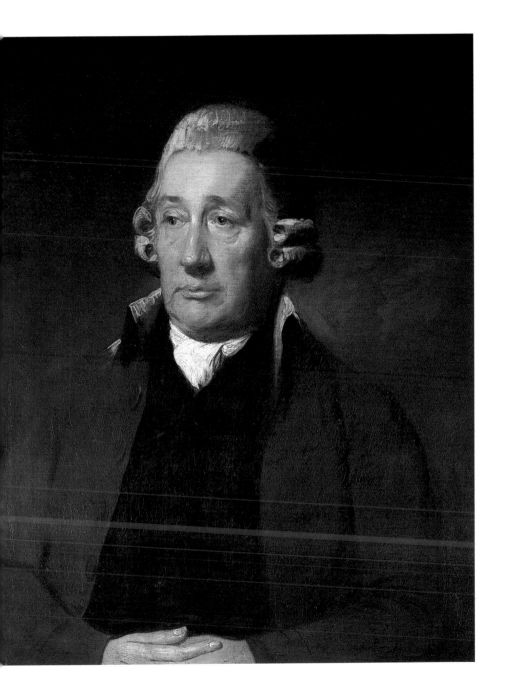

Ironbridge (near the new town of Telford in Shropshire) its name. In 1787 he built an iron barge which everyone else thought would sink – but he was right and they were wrong, and it went successfully into use on the River Severn.

He made an iron coffin for himself, kept it proudly in the corner of his office, showed it off to all his visitors, and tried to sell them iron coffins too. However, this coffin was to cause problems after he died, for his body was put in a wooden coffin, which then proved too big to fit in the iron one; so he was temporarily buried in the garden of his home, while a new iron coffin was cast. Then the body was dug up and put in the new iron coffin, which in turn proved too big to fit into the hole prepared in the rock; so he was buried again. A bigger hole was blasted, he was buried for a third time, and an iron obelisk was erected over the grave. Unfortunately the house was sold in 1828, and the new owners objected to having a huge obelisk in their front garden; so the body was dug up yet again and buried for the fourth time at Lindale Church in Cumbria.

On 14 July 1815 – four weeks after the Battle of Waterloo ended the Napoleonic Wars and seven years after Wilkinson died – thousands of people gathered on Monmore Green and attempted to sing him back to life. He had been immensely popular with his workers, and they hoped he would turn up on his grey steed to lead them back to prosperity.

He was also popular with the ladies: he married two rich women, having a daughter by the first, and then at the age of seventy-two he took a mistress who bore him three more children. Legal wrangling between the four children and a nephew used up all the money that they might otherwise have inherited. Meanwhile Wilkinson's sister Mary had married the great scientist ● JOSEPH PRIESTLEY ●

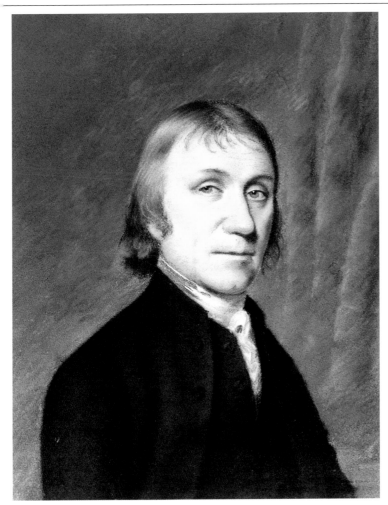

16. Joseph Priestley
By or after
James Sharples c.1797
Pastel, 216 x 171mm
(8¹/₂ x 6³/₄")
National Portrait
Gallery, London
(NPG 175)

Joseph Priestley was born at Fieldhead Farm, which now hangs over the M62 above Birstall in Yorkshire. His mother died when he was nine, and he spent his teenage years living with his aunt at the Old Hall in Heckmondwike, a few miles away. As a Unitarian minister, the normal channels of higher education were not open to him. He studied at Daventry Academy, and later taught at Warrington.

Joseph Priestley 1733–1804 ●

In 1767 Priestley became minister at Mill Hill Chapel in Leeds. For a time he lived next door to the brewery, within half a mile of where Tetleys is today. He loved to go in and watch the beer fermenting in the great stone tanks known as Yorkshire Squares. Malt, sugar and hops were boiled together to make a brown

liquid called wort, which was then allowed to sit in the Squares while a thick layer of frothing yeast formed on top, heaving gently as carbon dioxide bubbled to the surface. Priestley had heard about the work of Joseph Black and knew about this 'fixed air' (see page 36). He devised ingenious experiments to 'see' it and to trap some of it. He lit a candle and carefully lowered it into the tank. About a foot above the froth the candle went out as it sank into the thick blanket of carbon dioxide which, as it is denser than ordinary air, floated on top of the froth.

What was more, the smoke from the candle drifted slowly across the top of the carbon dioxide, clearly showing its upper surface. Thus Priestley could suddenly see the dividing line between the two gases. Knowing that below the wisps of smoke was pure carbon dioxide, he took two jugs and poured cold water from one to the other and back again several times, all within the layer of carbon dioxide. When he tasted the water it had a characteristic sharp, slightly acid taste – for he had made soda water by dissolving carbon dioxide in water.

Priestley isolated and described several new gases, including ammonia, nitrous oxide, sulphur dioxide and carbon monoxide, and this led to his election to the French Academy of Sciences in 1772. But he is best known for the discovery of oxygen, which he probably first made in Leeds in 1771, although, according to a plaque at Bowood House near Calne in Wiltshire, he discovered it there in 1774 while employed as librarian by the 2nd Earl of Shelburne – a job he probably took to give him more time to pursue his scientific research.

Priestley showed that animals needed his new gas or 'air' to be able to breathe, that it was needed for combustion and that green plants produced it. Unfortunately, however, he not only called it by the memorably awful name 'dephlogisticated air' (because of its connection with the phlogiston theory – that every substance capable of burning contains phlogiston and that combustion essentially entails losing phlogiston) but before publishing his results he also described them to a young French scientist called Antoine Lavoisier (1743–94). Lavoisier did some research of his own, confirmed Priestley's conclusions, published his work, and came up with the catchy name *oxygène*. As a result, Lavoisier got most of the credit. Lavoisier was also to disprove the phlogiston theory, demonstrating that combustion involves the combination of a substance with oxygen.

Priestley spent five years in Leeds, seven at Bowood House and then eleven years in Birmingham, where he returned to the ministry and became an active member of the Lunar Society. In 1791 he spoke out in favour of the French Revolution and provoked a riot, in the course of which his house was burnt to the ground. He went to live in London and then in 1794 emigrated to America, spending his final ten years in Pennsylvania, writing. His posthumously collected *Theological and Miscellaneous Works* (1817–32) run to twenty-five volumes and encompass a wide range of subjects in the areas of religion, politics and science.

Priestley's work on gases stimulated many scientists to devise new experiments, but perhaps none more than the extraordinary outsider ● JOHN DALTON ●

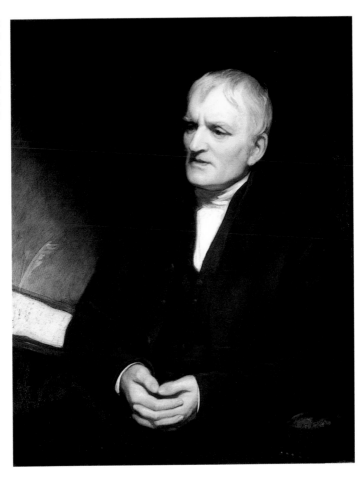

17. John Dalton
Thomas Phillips, 1835
Oil on canvas,
914 x 714mm
(36 x 28^1/$_8$")
National Portrait
Gallery, London
(NPG 5963)

A colour-blind mathematician who climbed Helvellyn forty times and laid the foundations of atomic theory, **John Dalton** was born in a weaver's cottage in Eaglesfield, near Cockermouth in Cumbria. His first job was as a teacher at a Quaker school; his own teacher had retired, and he took over the school for a couple of years – when he was only twelve years old!

Dalton's name was to enter the scientific vocabulary in two areas: Daltonism, or colour-blindness, and Dalton's Law. He himself was red-green deficient, and from his own observations he elegantly described what the problem

John Dalton 1766–1844 ●

was. The paper he gave to the Manchester Literary and Philosophical Society was the first ever scientific presentation on colour-blindness.

Dalton was convinced that he could not

distinguish between red and green because his eyeballs were tinted blue, and he made the rather macabre request that after his death his eyes be removed to prove him right. Unfortunately he was wrong; the cause of colour-blindness is a missing gene. However, Dalton had correctly suggested that the condition might be hereditary, as his brother had the same problem with his eyesight.

On 27 March 1787 Dalton saw the northern lights – the aurora borealis – and wrote an account in a meteorological journal. He was to keep up his journal for fifty-seven years, in all recording 200,000 observations. His neighbours used to set their clocks by the time he opened his window to read the temperature every morning. He also collected data – rainfall, temperature, wind speed and wind direction – at the top of Helvellyn on his frequent forays to the peak. In 1793 he published his first work, *Meteorological Observations and Essays*, and in that same year he moved to Manchester to become Professor of Mathematics and Natural Philosophy at New College.

Later in life he said that this book contained the germs of most of the ideas he subsequently investigated. In one essay he explores whether the quantity of rain and dew is equal to the quantity of water carried off by rivers and raised by evaporation. He shows that springs are fed by rain – which some contemporaries did not believe. The same essay contains one new definition: of dew-point. Dew-point is the temperature of a surface at which water vapour just begins to condense on it – when you get a cold lager in a pub and the glass mists up, that means it is below the dew-point.

In the early 1770s, Joseph Priestley had discovered oxygen (see page 54), and Lavoisier had shown that there were different gases in the air. It was generally thought that they were chemically combined, and there was puzzlement as to how much space they occupied. Dalton's study of the atmosphere led him to the conclusion that the various gases all share the same space. The densest ones do not generally sink to the bottom; nor do the lightest rise to the top. Each gas somehow occupies all the volume. This is possible because at ordinary pressures the individual molecules or atoms of gas occupy a lot of space and are well separated from one another.

In the course of this investigation Dalton discovered that gases all exert their own separate pressures, too; the total pressure of a mixture of gases is the sum of the pressures that each individual gas would exert if it occupied the whole space – which became known as Dalton's Law of Partial Pressures.

One of the great moments in the history of chemistry came on 21 October 1803, when Dalton gave another paper to the Manchester Literary and Philosophical Society, this time on the solubility of gases in water. Building on Priestley's work and still in the process of discovery, he said, 'I am nearly persuaded that the circumstance depends on the weight and number of the ultimate particles of the several gases: those whose particles are lightest and single being least absorbable and the others more as they increase in weight and complexity. An enquiry into the relative weights of the ultimate particles of bodies is a subject, as far as I know, entirely new ...'

To the end of his paper, Dalton added the

first ever list of atomic weights. The way he calculated them was intriguing. The lightest element was hydrogen; he gave it the atomic weight of 1. He knew that 1 ounce of hydrogen reacted with 8 ounces of oxygen to make water. Assuming that water was a one-to-one compound (one atom of hydrogen to one of oxygen), he gave oxygen an atomic weight of 8. Unfortunately, water is H_2O, not HO; so Dalton got most of his values wrong in that first list. But he had had the idea and sown a seed. Atomic theory was born, and quantitative chemistry was on its way.

Most of the scientific community did not believe Dalton's theories, and some of his peers simply disliked him. In 1804 and 1809 he was invited to deliver some courses at the Royal Institution in London. **Humphry Davy** (1778–1829), Professor of Chemistry there, said of him, 'his aspect and manner were repulsive. His voice was harsh and brawling', and yet he considered Dalton a genius. Dalton was appointed Fellow of the Royal Society in 1822 and won its first Royal Medal in 1826. French scientists also acclaimed him and in 1830 he became one of the eight foreign associates of the French Academy of Sciences.

Dalton was not a social person, and although he met the mathematician and inventor Charles Babbage (1792–1871), **Joseph Banks**, James Watt and many other great scientists, he did not seem to form friendships with them. Asked why he had not married, he replied, 'I never had the time'. And yet when he died and his body was placed in Manchester Town Hall, 40,000 people filed past it. No fewer than a hundred carriages formed his funeral procession.

Dalton was also a poor communicator, both in lectures and on paper. However, like Isaac Newton, he had extraordinary powers of concentration, and although his apparatus and his experiments were generally crude, he was able to distil great ideas from simple observations.

Dalton was too much of a loner to have been a member of the Lunar Society. However, there was one outsider who not only introduced William Small to Matthew Boulton and became a close friend of Erasmus Darwin, Matthew Boulton and Joseph Priestley, but had a profound influence on the direction of British science. He was that brilliant writer and speaker ● BENJAMIN FRANKLIN ●

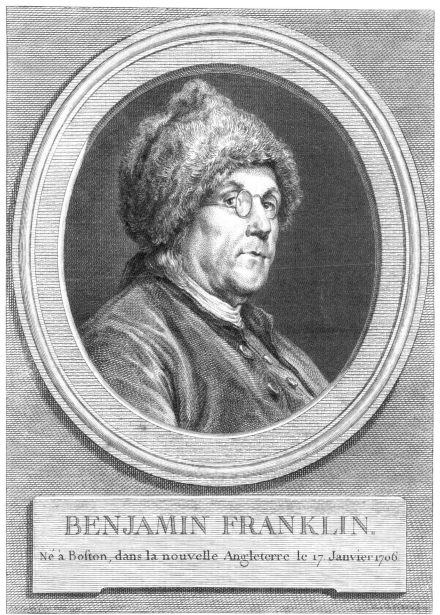

BENJAMIN FRANKLIN.

Né à Boston, dans la nouvelle Angleterre le 17 Janvier 1706

Dessiné par C. N. Cochin Chevalier de l'Ordre du Roi, en 1777 et Gravé par Aug. de St. Aubin Graveur de la Bibliotheque du Roi

Benjamin Franklin – one of America's greatest ever statesmen – was also a scientist, philosopher and printer. Born in Boston, Massachusetts, as the fifteenth child of a tallow chandler, he grew up in modest circumstances and was apprenticed at the age of thirteen to his brother James, a printer.

When Franklin was eighteen he went to Philadelphia and found work with another printer, who gave the impression that he thought his new worker was a genius and put him on a boat for England to acquire some extra equip-

Benjamin Franklin 1706–90 ●

ment and experience. However, Franklin discovered, when he was at sea, that he had been given neither letters of introduction nor money to buy equipment – in fact his boss had merely been 'playing … pitiful tricks on a poor ignorant boy'.

Nevertheless Franklin did find work at two of the foremost printing houses in England, Palmer's and Watt's, and when he returned to Philadelphia two years later he set up his own printing business. He published a newspaper and an almanack and rose to become a prominent citizen: in 1750 he was elected to the Pennsylvania Assembly and in 1753 he became Deputy Postmaster-General for the British Colonies in North America.

Throughout his impressive career he was greatly interested in science. He was the first American to make a scientific name for himself,

and he was one of the important pioneers of the study of electricity. He was the first to use the electrical expressions 'plus', 'minus', 'positive', 'negative', 'charge' and 'battery', although unfortunately he died before the invention of the battery as we know it by Alessandro Volta (1745–1827) in 1799.

Franklin enjoyed making gadgets and experimental apparatus, realising what an advantage it was 'to construct little machines for my experiments while the intention of making the experiment was fresh and warm in my mind'. In 1749, experimenting with charged metal bowls to represent thunderclouds, he showed that if a bowl came near an earthed object that had a sharp point it was repelled and the charge was dissipated, whereas if the earthed object was smooth and round the bowl was attracted and the electricity discharged with a spark – so buildings with domes might actually attract lightning strikes.

He immediately published this finding and suggested that buildings should be fitted with pointed lightning conductors to prevent lightning strikes. Thus he achieved one of the aims of Francis Bacon: that experimental scientific work should lead to innovations of benefit to humankind. The first public building in England to be fitted with a lightning conductor was Christopher Wren's St Paul's Cathedral.

Franklin suggested that if a cloud was positively charged then a negative charge would be induced in the earthed object and sprayed off

18. Benjamin Franklin
Augustin de Saint Aubin after a drawing by
Charles Nicolas Cochin, 1777
Engraving, 205mm x 150mm (8 x 6")
National Portrait Gallery, London (NPG RN40985)

the point to neutralise the positive charge on the cloud, and so prevent a spark. He later discovered a secondary benefit of the lightning conductor: if lightning did strike, the conductor would carry the charge safely to earth, protecting the building.

As part of his efforts to show that lightning was simply flashes of electricity – the same as the electricity he could generate by rubbing, say, a glass rod with wool – in 1752 he flew a kite into one of the violent thunderstorms that are common in Philadelphia. He stood on an insulated platform and held the end of the kite string with a piece of dry silk (another insulator). The kite string was wet and therefore a conductor, and he was able to draw sparks from a key tied to the kite string when he held an earthed wire near it. The experiment confirmed his belief and also captured the public's imagination, making Franklin famous as a scientist. However, it was highly dangerous, since lightning strokes can be lethal; indeed, Georg Richmann of St Petersburg was killed while trying a similar experiment on 6 August 1753, apparently after being struck by the very rare ball lightning.

Franklin lived in England for some sixteen years and crossed the Atlantic eight times in all, which must have been quite an ordeal in the eighteenth century. He became interested in various maritime phenomena; he plotted a chart of the course of the Gulf Stream, and he investigated the old saying about pouring oil on troubled waters.

Once, sailing in a convoy, he noted that one of the other ships had a much less turbulent wake than his own. Asking why this might be, he was told that probably the cooks had just discharged greasy water through the scuppers (drainage holes). He began to collect other anecdotes. Bermudians used oil to calm the water above fish they were going to spear if the surface was ruffled. Fishermen of Lisbon supposedly used oil to suppress the breakers as they returned to harbour. Portuguese clam divers would actually dive down with their mouths full of olive oil and release some to calm the surface above, giving them a clearer view of the seabed.

Franklin determined to try himself to pour oil on water to calm it, and he first did so on the pond at Clapham Common in London. The effect of just a little oil was so striking that from then on he kept some in the hollow handle of his walking cane in case the opportunity arose to try it again. In 1772 he even travelled to the Lake District and rowed out on Ullswater to try the experiment with a local scientist, William Brownrigg (1711–1800), the local vicar, and the President of the Royal Society, Sir John Pringle (1707–82).

Franklin was a prolific inventor: he invented the rocking chair, bifocal spectacles and Summer Time. He also invented a curious musical instrument, the glass armonica, comprising twenty-four glass bowls of tapering width turning on a single shaft; it was rotated by treadling and played with wet fingers.

He retained a great interest and influence in politics, serving in the top job of Postmaster-General for a year. In 1776 he was one of the three authors of the American Declaration of Independence, borrowing a few words and ideas from his friend Joseph Priestley, and from the seventeenth-century philosopher John Locke. In 1768 Priestley, probably borrowing

19. Alessandro Volta
Ambroise Tardieu after Nicolo Bottoni, n.d.
Engraving, 184 x 121mm (7¹/₄ x 4³/₄")
The Institution of Electrical Engineers Archives

As a student, Jefferson had been much influenced by one of his professors, William Small, who became one of the founders of the Lunar Society after being introduced to Matthew Boulton by Franklin.

Although he was a distinguished diplomat, Franklin had a Bohemian streak and loved to shock the establishment. One thing he advocated was the air bath: in 1768 he wrote to a friend that in the morning he liked to sit (in his house, now 36 Craven Street, close to where Charing Cross Station is today):

> ...without any clothes whatever, half an hour or an hour according to season either reading or writing ... And if I return to bed afterwards before I dress myself, as sometimes happens, I make a supplement to my night's rest of one or two hours of the most pleasing sleep that can be imagined.

from John Locke's *Two treatises on civil government* (1690), had written a political tract suggesting that the government should interfere as little as possible with the lives, liberty and property of the people. Eight years later Thomas Jefferson, John Adams and Benjamin Franklin wrote:

> We hold these truths to be self-evident, that all men are created equal, that they are endowed by their Creator with certain unalienable Rights, that among these are Life, Liberty, and the pursuit of Happiness. That to secure these rights, Governments are instituted among Men, deriving their just powers from the consent of the governed. That whenever any Form of Government becomes destructive of these ends, it is the Right of the People to alter or to abolish it, and to institute new Government ...

I cannot help wondering how often he surprised his landlady and her daughter – and indeed the people living across the street, since the windows are large and low and the street narrow.

Despite his American origins, Franklin had an enormous influence on science in England, and his first and greatest scientific friend was a polymath he met in Cambridge, ● JOHN MICHELL ●

3

From Black
Holes to
Photography

John Michell 1724–93

William Herschel 1738–1822

Caroline Herschel 1750–1848

John Herschel 1792–1871

Anna Atkins 1799–1871

William Henry Fox Talbot 1800–77

John Michell 1724-93

ost people think that black holes are an invention of modern astronomers, but in fact the phenomenon was first described in 1784 by **John Michell**, rector of St Michael and All Angels at Thornhill, near Dewsbury in Yorkshire. Before 'retiring' to Thornhill at the age of thirty-seven, Michell had been Professor of Geology at Cambridge University, also lecturing on arithmetic, geometry, theology, philosophy, Hebrew and Greek. He wrote a treatise on artificial magnetism, and in 1760 a high-powered paper on earthquakes. There seems to be no portrait of Michell, but a contemporary described him, not very kindly, as 'a little short man, of a black complexion, and fat'.

It was from Thornhill that Michell wrote for the Royal Society a theoretical paper, musing about gravity and acceleration, and inviting his audience to imagine a body under the influence of gravity, falling towards an enormous sphere, 500 times as big as the sun. It would move more and more quickly until in the end it would be travelling faster than light – thus light itself would not be able to escape. In other words, the sphere would be a black hole.

Michell's other enduring scientific achievement was to devise a piece of apparatus to measure the mass of the earth. Unfortunately he died before he had time to use it, but the equipment passed to the silent genius Henry Cavendish, who duly made the measurement with considerable accuracy. Ever since, this has rather unfairly been called Cavendish's experiment.

Thornhill is certainly not a centre of scientific excellence today, but in the late eighteenth century Michell attracted a great range of scientific friends, who came from far and wide both to exchange ideas and to take part in his splendid entertainments. These meetings at Thornhill were similar to those of the Lunar Society in Birmingham (see page 36). Michell's guests probably included Joseph Priestley, John Smeaton (1724–92) – a civil engineer from Leeds – and the organist ● **WILLIAM HERSCHEL** ● Herschel and Michell enjoyed making music together but, more importantly, Michell gave his friend a telescope which was to change his career out of all recognition.

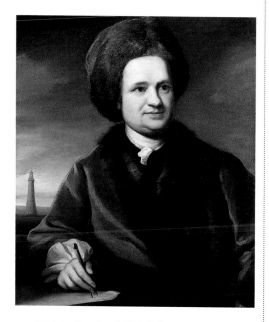

20. John Smeaton (1724–92)
George Romney after Rhodes, 1779
Oil on canvas, 765 x 643mm (30 x 25¹/₄")
National Portrait Gallery, London (NPG 80)

Friedrich Wilhelm Herschel was born at Hanover in Germany, the son of a band-leader and music teacher, and he became an oboist and violinist in the army. When he was nineteen he moved to England and began to earn his living as a musician, first by copying music scores and then as a teacher, concert director and composer in Durham, Doncaster and Leeds.

In 1765 he applied for the job of organist at Halifax Parish Church, and was successful in the face of stiff competition. However, this was only because in his audition he used lead weights to hold down two keys so that he could effectively play with four hands at once! The following year he moved to Bath to be organist at the Octagon Chapel and settled in New King Street, first at No.7 and later at No.19. For many years he directed concerts, composed anthems and gave music lessons.

Having been given a telescope by John Michell, Herschel became interested in astronomy. He made his first observations in 1766, looking at Venus and an eclipse of the moon. However, he soon found that his instrument was inadequate, and he decided to make his own reflecting telescope.

The technology did not then exist for making mirrors by coating glass with silver or aluminium, which is how it is done today. Herschel had to use speculum metal, an alloy of copper and tin with a polished surface shiny enough to reflect about 75 per cent of incident light. To grind his mirrors he covered a cast-iron tool with abrasive grit, took a thick speculum disc 7 or 8 inches wide and rubbed it to and fro across the cast iron.

There were various perils and disasters. A temperature of around 1000°C was required to cast the metal; on one occasion the bottom fell out of the furnace, molten metal flowed across the floor and Herschel had to run for his life as flagstones started exploding. He had something like 200 failures but eventually produced some of the best mirrors in the world, with a focal length of 6 or 7 feet. He mounted them in wooden tubes of his own design. Some he sold to supplement his income, but the best he kept for use himself.

On 4 March 1774 he observed the Orion

William Herschel 1738–1822 ●

Nebula – an indistinct cloud-like object – and wrote a note informing the Royal Society. He was so excited that he resolved to continue improving the telescope and to 'leave no spot of the heavens unexamined'. This marked the beginning of his comprehensive astronomical survey. He was often seen during intervals in a concert, running in his lace and powder from the theatre to his workshop.

His efforts were rewarded on 13 March 1781 when, viewing from his garden, he discovered something new in the sky. He dashed off a note to the Astronomer Royal, Nevil Maskelyne (1732–1811), who summoned him to Greenwich and on looking through his telescope declared that it was finer than any instrument obtainable in London. Herschel thought at first that he had discovered a comet, but he 'lost' it during the summer

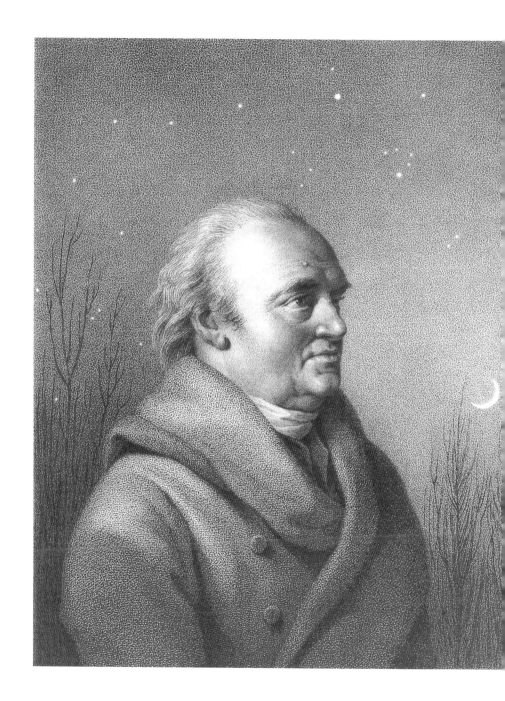

because it was too close to the sun for him to see. When it reappeared it turned out to be nothing less than a new planet – the first to have been discovered. There was great excitement; Herschel was awarded the Royal Society's Copley Medal. The planet was eventually called Uranus, but Herschel's proposal was to name it Georgium sidus, or George's Star, after George III.

Enormously pleased by this, the king asked Herschel to show his telescope to the royal family. The two men got on well; George III's family were German, and he and Herschel spoke German together. In 1782 George III asked Herschel to become his personal astronomer. He moved to Windsor, and then to nearby Slough, in 1788, marrying Mary Pitt. Their son **John Herschel** (1792–1871; see page 71) was to become as famous an astronomer as his father. Meanwhile Herschel the musician must have been somewhat sad to give up performing professionally. He took up observing all night whenever the weather was fine, often grinding mirrors during the day as well. Unfortunately for his neighbours, he found that the best material for the mould in which to cast them was horse dung, and he collected an immense quantity in his garden! He made more than 400 telescopes, and the king bought four 10-foot ones for 600 guineas each. He also built a 25-foot telescope for the Madrid Observatory, for which he was paid £3,150. (The mirrors for this still exist, but the telescope itself was smashed by Napoleon's troops.)

21. Sir William Herschel
James Godby after Friedrich Rehberg, published 1814
Stipple engraving, 320 x 230mm, (12⁵/₈ x 9")
National Portrait Gallery, London (NPG D9004)

22. Nevil Maskelyne (1732–1811)
Detail from engraving after *Men of Science Living in 1807–1808*
(NPG 1075a)

Herschel invented a new type of reflecting telescope. The type pioneered by Newton around 1671 had a primary concave mirror at the bottom of the tube, and a flat secondary mirror set at 45° near the top, to reflect the light out through the side of the tube. A few years earlier in St Andrews, James Gregory had designed a slightly different telescope; the Gregorian had a secondary convex mirror mounted on the same axis as the main tube, to reflect light back down the tube and through a hole in the middle of the primary. However, Gregory could not find anyone skilled enough to make his telescope; so Newton's was the first one to work; today, however, most reflecting telescopes are essentially Gregorian.

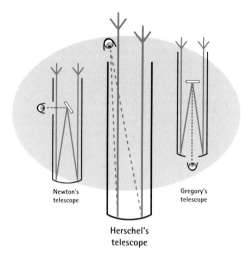

Newton's
telescope

Gregory's
telescope

Herschel's
telescope

23. Diagram of Herschel Telescope

Herschel thought he would lose less light if he avoided having a secondary at all; so he built telescopes with the main mirror sloping, so that the image was brought to a focus at the edge of the mouth of the tube. The first time he used a 20-foot telescope in

24. Sir William Herschel
John Charles Lochée, 1787
Plaster cast of bust, 826mm (32$\frac{1}{2}$") high
National Portrait Gallery, London (NPG 4055)

this 'Herschellian' configuration he discovered two moons of Uranus, Oberon and Titania, but in fact it turned out to have more problems than advantages.

Herschel was a brilliant astronomer, studying the rotation of the planets and the motion of double stars – pairs of stars that revolve around their common centre of mass. He was the first to define them, in 1803, and he catalogued over 800. He also studied nebulae, discovering more than 2,000 and proposing that they were composed of stars.

As well as being a musician and astronomer, Herschel was a fine physicist. Wondering whether the various colours that make up sunlight might be associated with different amounts of heat or different temperatures, on the 11 September 1800 he took a prism, separated the light into its various colours – as had Newton in 1666 (see page 30) – and placed a thermometer in the spectrum, one colour at a time. He went away for lunch; when he came back he found that the sun had moved round so far that the thermometer was out of the spectrum, way beyond the red. Yet it still registered hot: he had discovered infrared radiation – the electromagnetic waves now used in burglar alarms and auto-focus cameras.

Herschel was knighted in 1816, and in 1821 he became the first president of the Royal Astronomical Society. But he surely would not have achieved so much without the assistance of his sister ● **CAROLINE HERSCHEL** ●

25. George III (1738–1820)
Studio of Allan Ramsay, after 1761
Oil on canvas, 1473 x 1067mm (58 x 42")
National Portrait Gallery, London (NPG 223)

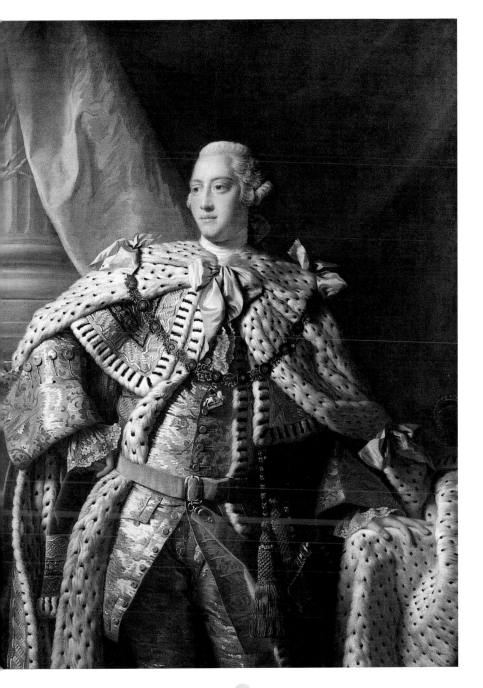

The woman who was to become the first important female astronomer, **Caroline Lucretia Herschel**, was treated as a drudge at home in Hanover. Her father managed to give her a few violin lessons, but her mother demanded that she spend all her waking hours at housework. Her brother William Herschel seemed to be the only member of the family who cared for her, so when he came home from Bath for a visit in 1772 and offered to take her back to England, she was delighted.

She had none of his advantages of education and musical training. Nor was she any beauty; she had caught smallpox, and her face was badly marked. At first she could not speak the language of her new country. However, she had lessons from her brother in English,

the tedious calculations he needed.

She kept house, and while he was grinding mirrors she would read novels aloud to him to relieve the tedium. Once he continued grinding without a break for sixteen hours, and apparently she not only cooked but actually put the pieces of food into his mouth. She was described as 'very little, very gentle, very modest, and very ingenuous'.

In 1782 Caroline Herschel began searching the heavens with her own telescope. She discovered eight comets and three nebulae. Remarkably, in 1787 the king agreed to give her £50 a year as an assistant astronomer. She worked extensively on the enormous

● Caroline Herschel 1750–1848

singing and arithmetic. She quickly became popular as a capable soprano and sang in choirs in Bath and in Bristol. Yet she preferred to help William in the workshop: 'I became in time as useful a member of the workshop as a boy in the first year of his apprenticeship.' She took notes for him, assisted with his observations and read his clocks so that he could keep his eye to the telescope and call out the exact instant when, say, a star reached the zenith. After teaching herself the necessary arithmetic, she also did all

catalogue of stars produced by John Flamsteed, completing, arranging and editing it. In 1828 the Royal Astronomical Society awarded her its gold medal, and so important was her contribution to astronomy that in 1889 a minor planet was named Lucretia after her.

Alas, on the death of her brother in 1822 she cut her career short and returned to Hanover. But the family name and reputation were to be continued by her nephew, ● JOHN HERSCHEL ●

John Frederick William Herschel was the only son of William Herschel and Mary Pitt. He was born at Slough in Berkshire, studied at Cambridge University and was made a Fellow of St John's College, where he was described as 'a prodigy in science, and fond of poetry, but very unassuming'. He became a great friend of the polymath William Whewell (1794–1866), and during 1815 they held famous philosophical breakfasts on Sunday mornings. Whewell was the person who coined the word 'scientist' to replace the previous term 'natural philosopher'; for in 1840 he wrote 'We need very much a name to describe a cultivator of science in general. I should incline to call him a scientist'.

Herschel was an idealist and made a pact with Charles Babbage and George Peacock to 'do their best to leave the world wiser than they found it'. In 1813 they formed the Analytical Society of Cambridge, and the following year they published an excellent translation of a book on calculus, which became a standard text. Herschel also published some sparkling mathematical papers of his own.

Then after 1816 he turned to astronomy, re-examining the double stars discovered by his father and bringing the total up to some 3,000. He was involved in the foundation of the Royal Astronomical Society and won a number of gold medals. In 1831 he received a knighthood; two years later he took his family at his own expense to South Africa. There he carried out

an immense five-year programme of observation, continuing the work initiated by Edmond Halley in mapping the southern sky (see page 31). Next he was to turn his attention to the new science of photography.

The first photograms had been made in 1802 by Thomas Wedgwood (1771–1805), son of Josiah Wedgwood. By placing leaves and other objects on chemically treated leather he had discovered that he could create silhouettes;

John Herschel 1792–1871 ●

but he had found no way of 'fixing' the images, and they gradually darkened all over when exposed to light. Some of his prints were kept inside books in dark corners of the Royal Society for a hundred years, and people could

27. William Whewell (1794–1866)
Edward Hodges Bailey, 1851
Plaster cast of bust, 721mm (28³/₈") high
National Portrait Gallery, London (NPG 1390)

28. Sir John Herschel
Julia Margaret Cameron, 1867
Albumen print, 340 x 264mm (13³/₈ x 10³/₈")
National Portrait Gallery, London (NPG P213)

29. Charles Babbage (1791–1871)
Antoine Claudet, c.1847–51
Daguerreotype, 70 x 60mm (2³/₄ x 2³/₈")
National Portrait Gallery, London (NPG P28)

go in and take a brief look at them as long as they did not let in too much light.

Herschel was probably interested in photography mainly in the hope of being able to photograph the stars through his telescope. Building on the work of Wedgwood and **Humphry Davy**, he formulated various ways of making paper sensitive to light by coating it with compounds of silver. In 1839 and 1840 he read papers to the Royal Society – winning a third gold medal from them – about silver halides and 'hypo', and may have coined the terms 'positive' and 'negative' for photo-graphic prints.

Most conventional film today uses silver salts to capture light, but Herschel found a way to use iron compounds instead. The most important feature of his cyanotype (from 'cyanos', the Greek word for deep blue) process

was that it needed only water to develop the pictures, which did not fade. But because of the chemical coloration, the images all appeared in Prussian blue (so-called because the same chemical dye was used for Prussian military uniforms). This made cyanotypes unsuitable for portraiture – people were not keen on the unhealthy blue tinge – but for other subjects it was absolutely fine.

Herschel was Master of the Mint for five years before retiring, and during this period he not only completed several vast astronomical catalogues but also translated various major works into English, including Homer's *Iliad*. His interests were enormously wide-ranging, and he shared his thoughts generously; he was apparently loved by all who knew him. Thus when he invented new processes for photography he quickly published his results and told his friends, so that they could try his methods for themselves. One of these friends was ● **ANNA ATKINS** ●

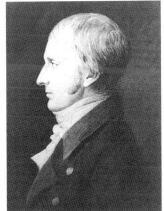

30. Thomas Wedgwood (1771–1805)
Reproduction of a drawing,
144 x 108mm (5⁵/₈ x 4¹/₄")
National Portrait Gallery, London (NPG RN46983)

● Anna Atkins 1799–1871

Ferox Hall, at Tonbridge in Kent, was the splendid childhood home of **Anna Atkins**, née Children. Her mother died when she was young, and she grew up close to her father, John George Children (1777–1852), who was an enthusiastic scientist, Secretary to the Royal Society and Keeper of Natural History and Modern Curiosities at the British Museum. Atkins became a gifted artist; young women were expected to be able to draw and paint, but she was to use her skills scientifically. When her father produced an enormous book about sea shells, Atkins made 250 beautiful engravings as illustrations.

Because of his position at the Royal Society, Professor Children knew all the important scientists of the time. **Humphry Davy** was a friend and often visited them to do experiments in the outhouse laboratory. Another friend of the family was photography pioneer John Herschel, and by 1840 Atkins was carrying out her own photographic experiments. Her father helped by making up the chemicals she needed, using a monster battery he had built – the biggest in England, a 5-foot cube containing 945 gallons of acid.

Meanwhile Atkins became involved in botany; she was elected to the Botanical Society of London – one of the few scientific societies that admitted women as members, although none held office nor even spoke at meetings. She was particularly interested in seaweed and collected specimens whenever she went to the coast for day trips. After she married sheriff John Pelly Atkins in 1825, her husband brought back seaweed specimens from Jamaica, where he owned a coffee plantation. She then traded with other botanists around England until she had enough dried specimens to produce a book: *British Algae* (1841).

Atkins illustrated her book with photographs, using the cyanotype process invented by Herschel (see page 4). Each picture had to be taken as a separate photograph and laboriously pasted into the book; making copies of *British Algae* took ten years. Then in 1854 Atkins turned her hand to an even larger project: *Cyanotypes of British and Foreign Flowering Plants*. Each copy of this book contained 160 photographs of seaweed, flowers and even feathers.

Atkins and her husband were buried alongside each other. His side of the gravestone lists his various achievements, but all that was said about her was that 'she was the daughter of John Children'. Her achievements went unnoticed by the world. Yet she had produced the first book in the world with photographic illustrations, predating even the publications of ● **WILLIAM HENRY FOX TALBOT** ●

Lacock Abbey, near Chippenham in Wiltshire, was originally built as a nunnery in 1232, but by 1800 it belonged to the family of **William Henry Fox Talbot** – the man who has become known as the father of modern photography. However, Talbot was born at Melbury in Dorset, because his father, an extravagant army officer, had spent all the family money and then died, and it was not until he

camera lucida (Latin, 'bright room'), invented by the chemist and physicist William Hyde Wollaston (1766–1828).

None of these aids worked. Whatever Talbot did, his sketches were hopeless, and he became so frustrated that he fantasised about having light-sensitive paper that would make the sketches for him automatically. When he got home he started working on the idea. He knew

William Henry Fox Talbot 1800–77 ●

was twenty-seven that Henry was able to move into the family home. He generally called himself Henry Talbot; the use of all four names was something of an affectation.

Talbot was exceedingly bright, and won various prizes and medals at Trinity College, Cambridge. By the time he returned to Lacock Abbey as squire he had written several high-powered papers on mathematics, and in 1832 he was elected a Fellow of the Royal Society. In the same year he got married and became Member of Parliament for Chippenham.

Talbot's interest in photography began when he went to Lake Como in Italy on his honeymoon. On 1 October 1833 he was trying, but failing, to record the scenery by sketching it freehand. He then tried a *camera obscura* (Latin, 'dark room') – a dark box with a pinhole in the front and a sheet of tracing paper across the back. That did not work for him either; so he tried using a different sketching aid, the

of Thomas Wedgwood's photograms (see page 71) and decided to explore ways of fixing images. He worked on this for five years.

Meanwhile in France in 1827 the physicist Joseph Nicéphore de Niépce (1765–1833) produced the first permanent photograph, using a

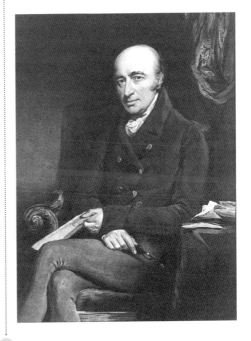

31. William Hyde Wollaston (1766–1828)
William Ward after John Jackson, 1824
Mezzotint, 455 x 302mm (18 x 11⁷/₈")
National Portrait Gallery, London (NPG RN36553)

bitumen-coated pewter plate exposed in a *camera obscura*. And in about 1831 the painter Louis Jacques Mandé Daguerre (1789–1851) began to produce beautiful crisp photographs on silver plates coated with silver iodide and developed using mercury. These pictures came to be called daguerreotypes, and were shown to the French Academy of Sciences on 7 January 1839.

Three weeks later, Talbot reported his 'Art of photogenic drawing' to the Royal Society. His calotype process was quite different from those of the French inventors, because his prints were made on paper. He had discovered that paper coated with silver iodide could be made more light-sensitive by painting it with a solution of silver nitrate and gallic acid. By exposing such photographic paper to the light one can produce an image, but it requires an incredibly long exposure time. By accident, Talbot found that an image did exist after only a very short exposure. He could not see it, but he managed to develop it chemically, using the silver nitrate and gallic acid solution once again, into a useful negative.

Having produced a good negative, he then fixed it by washing it, first with salt solution and then with 'hypo', as pioneered by John Herschel. This removed the light-sensitive chemicals so that the negative could be viewed in bright light without destroying it. The picture was at this stage in reverse values – the brightest areas looked black, the darkest white. Talbot realised that he could print from the negative and make any number of positive prints – something that was not possible with the daguerreotype, which provided just one photograph per silver plate. Daguerreotypes, however, contained more fine detail than calotypes. In 1844 Talbot produced a splendid book, *The Pencil of Nature*, which explained his method and was illustrated with his own photographs.

Talbot's interests took in astronomy, the study of language and archaeology, and he was one of the first people to read and translate the cuneiform inscriptions of ancient Nineveh. He also patented various wonderful machines, including internal combustion engines, and probably took the world's first photograph with high-speed flash, in 1851.

Unfortunately Talbot was less generous and open than John Herschel. Talbot did not invent any of the three basic processes of photography – developing, fixing and printing – yet he patented all three! This caused a great deal of argument and bitterness, and held up the progress of photography in England for many years. Eventually in 1853 he was persuaded by the presidents of the Royal Society and the Royal Academy to let his patents lapse. Even then he held on to his patent on the process of taking a photographic portrait – so anyone who wanted to take a photograph of a person had to apply to him for a licence.

However, he was truly a pioneer, bringing together developing, fixing and printing and improving them all. And it was he who invented the process of making first a negative and then a positive, which has formed the basis of most photography for the past 160 years.

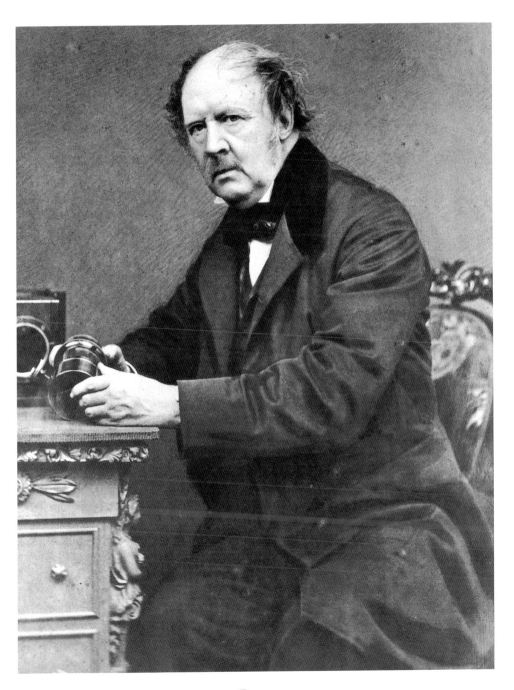

4

The Body and its Diseases

William Harvey 1578–1657

Edward Jenner 1749–1823

Florence Nightingale 1820–1910

Thomas Crapper 1837–1910

Ronald Ross 1857–1932

Alexander Fleming 1881–1955

H empstead, near Saffron Walden in Essex, is the birthplace of the notorious highwayman Dick Turpin, and also the final resting place of one of the great pioneers of medical science, **William Harvey**. He worked out how blood circulates around the body and discovered the role of the heart in

● William Harvey 1578–1657

propelling it, thus laying the foundations of modern physiology. His mortal remains lie in a stone sarcophagus in St Andrew's Church, and there are forty-nine other dead Harveys in the crypt below.

Harvey was born in Folkestone, Kent on April Fool's Day, 1578. His father was a merchant and had some inherited property, which meant that he was wealthy enough to pay for the best local education at the King's School, Canterbury. Harvey went on to Gonville and Caius College, Cambridge, founded by Dr John Caius, a distinguished but rather old-fashioned anatomist. In 1599 Harvey suffered a nasty attack of 'quartan ague' (malaria), which was then a common disease in the marshy fens. However, he must have made a pretty good recovery, because the following year he travelled to Italy to take in the latest medical ideas at what was probably the best medical school in the world – at the University of Padua.

At Padua, Harvey was taught by the famous Hieronymus Fabricius ab Aquapendente (1537–1619), who had designed the anatomy theatre, a surgery classroom with tiered seats where even students in the seventh row were only 25 feet from the cadaver being dissected. He has also been credited with discovering the valves of the veins, but in fact they had been known of for some time, if not understood. He said that their purpose was to restrict the flow of blood and stop it from reaching the extremities too quickly. Padua University was a centre of revolutionary scientific thinking – the Polish astronomer Nicolaus Copernicus (1473–1543) had been there, and so had Andreas Vesalius (1514–64), the pioneering Belgian anatomist. What is more, Galileo was there at the same time as Harvey.

Harvey was a medical student in the early 1600s; at that time the latest authority on the movement of the blood was a Graeco-Roman physician Galen (*c*.129–199)! Part of the problem was that printing was a fairly recent invention, so new ideas did not travel quickly. More importantly, however, Classical authority was celebrated, even though to a modern eye there was plenty of evidence to suggest that the ancients were wrong.

Galen had said that there were two quite separate tides of blood in the body: the venous and the arterial. Venous blood was made in the liver to nourish the body; it constantly ebbed and flowed, being replenished by seeping through pores from the right to the left side of the heart. Generally, blood moved out to the body during the day and then was attracted back to the heart at night. Arterial blood, impregnated with air from the lungs, rose to the brain where it was changed to 'animal spirits', which powered the nerves.

Harvey realised that this was all nonsense.

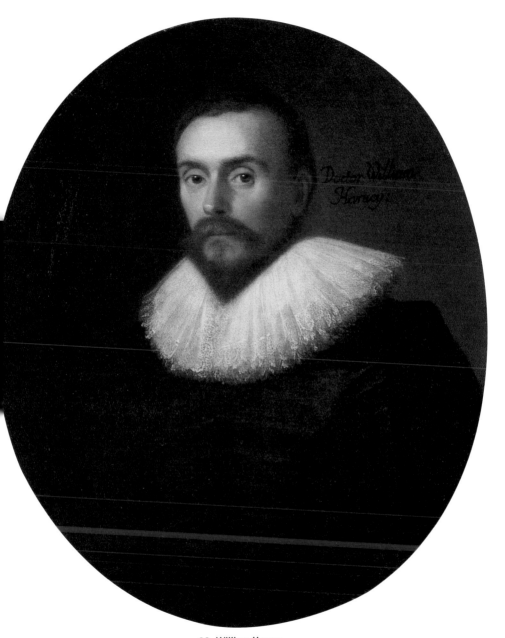

33. William Harvey
Attributed to Daniel Mytens, c.1627
Oil on canvas, 724 x 610mm (28$^1/_2$ x 24")
National Portrait Gallery, London (NPG 5115)

He had dissected many living creatures and knew that the heart was a pump. A human heart pumps about 2 fl oz per beat and beats on average 72 times a minute. So how much blood would Galen's venous circulation have had in it? Simple arithmetic showed that in a minute the heart pumped 7 pints of blood, in half-an-hour 27 gallons – which is considerably more blood than there is in the human body. There was no way that all this blood could even be fitted into the body, let alone be manufactured by the liver.

Harvey's conclusion was clear: the same small amount of blood was going round again and again, and the arterial system was filled not with air, but with blood. The heart was a two-chamber pump which sent blood to the body down the arteries from the left side. It came back through the veins to the right side; then the heart pumped it round the lungs to get rid of carbon dioxide and to take on more oxygen. The refreshed blood, now lighter in colour, returned to the left side, where the cycle began again. This was utterly different from the explanation that had survived for 1,400 years.

As for Fabricius's theories concerning the valves in veins, Harvey performed some experiments and found that valves did not just slow down blood-flow from the heart – they completely prevented it. So there was no way that blood could flow *down* the veins; the only purpose of veins, he said, was to take blood *towards* the heart in stages that reduced the mechanical pressure on it.

Harvey gained his medical degree from Padua University in 1602 and returned to England to practise medicine in the London area. He went on to have a distinguished medical career, was elected a Fellow of the College of Physicians in 1607 and became chief physician at St Bartholomew's Hospital, London. Later he was Physician Extraordinary to James I and Physician in Ordinary to Charles I. He began to present his ideas on circulation in lectures from about 1616, and in 1628 he finally published his great book, *Exercitatio Anatomica de Motu Cordis et Sanguinis in Animalibus* ('Anatomical Essay on the Motion of the Heart and Blood in Animals'). Little is known of Harvey's private life, but in a letter he revealed that his wife owned a talking parrot, and he may have been one of the first people to become addicted to coffee.

Harvey did more than simply work out some facts about the circulation of blood. He was a crusader for the belief that argument and experiment were more important to science than ancient authority, alongside such figures as Francis Bacon, Robert Boyle and Isaac Newton. It was this sort of modern scientific approach that was to produce effective action against disease in the following century by medics such as ● EDWARD JENNER ●

Jenner was a Gloucestershire man, born at Berkeley, where he chose to spend most of his life. Indeed, when offered the chance to go with Captain Cook on his second voyage around the world he politely declined. In 1785 he bought Chantry Cottage, Berkeley – despite its name a substantial house, and now the Jenner Museum. He lived and practised medicine there for the rest of his life, and it was at Chantry Cottage that he performed the experimental vaccination that led to the eradication of smallpox.

As a young man, having finished his medical training in Edinburgh, Jenner became a journeyman doctor, riding around the county, tending to his patients and staying with anyone who would put him up.

A keen observer of the countryside, Jenner became interested in the habits of cuckoos. In fact he was elected to the Royal Society on the strength of a long paper he wrote in 1788 describing their behaviour – in particular, how baby cuckoos hatch in other birds' nests, push out any eggs that belong there and take over.

Jenner was something of a dandy, who rode to his patients on a smart horse while wearing a blue topcoat and shiny riding boots with silver spurs. Interested as he was in appearances, he observed that dairymaids were unusually pretty, mainly because they did not seem to have the pockmarks associated with earlier attacks of smallpox. Almost everyone used to catch the disease, and those who survived were left with ugly pockmarks. But not milkmaids, whose prettiness was legendary, and was recorded in the folksong:

Where are you going to, my pretty maid?
I'm going a-milking, Sir, she said.
What is your fortune, my pretty maid?
My face is my fortune, Sir, she said.

There was an old wives' tale that milkmaids sometimes contracted cowpox, a mild infection of cows' udders, and that those who had had it never caught smallpox. Jenner set out to find whether there was any truth in this. He asked all his friends, and he asked every doctor he met, and he became such a cowpox bore that he was banned from the local medical club. He even asked milkmaids; they confirmed the story.

Edward Jenner 1749–1823 ●

There was – and is – no cure for smallpox, but in 1718 attempts had first been made to inoculate people using pus from smallpox sores. This was a most unpleasant process and fraught with danger – a significant number of people died as a result of the inoculation. Jenner himself had suffered a dreadful terrifying inoculation as a youth. He saw that it would be much better to prevent smallpox by using pus from the much milder cowpox infection.

Reassured by the dairymaids, he decided to try an experiment – a dangerous experiment that would hardly be allowed today. He had to wait some time, because cowpox was rare, but eventually he heard of a sick cow called Blossom. Her milkmaid, Sarah Nelmes, had caught the cowpox, and had a sore on her hand. Delighted, Jenner invited Nelmes to help in his experiment. He chose as 'victim' an eight-year-old boy called James

Phipps, who had never had either smallpox or cowpox. On 14 May 1796, using a small penknife, he made a couple of scratches on the boy's arm. Then he squeezed some pus from the sore on Nelmes's hand and rubbed it into James's cut. A few days later, James showed symptoms of cowpox; on the fourth day he had a slight fever and a sore arm; by the fifth day he had recovered. Then came the dangerous part of the test: Jenner deliberately inoculated James with smallpox, to see whether he was still susceptible to it.

James failed to catch smallpox, even though Jenner exposed him to it several times; indeed he lived to a ripe old age. So Jenner had his evidence: people who caught cowpox *were* protected against smallpox.

In fact he was not the first to use cowpox this way. Some years earlier a farmer in Dorset, having heard the same tales and come to the same conclusions as Jenner, had vaccinated his whole family to protect them against smallpox. Jenner may even have heard about this, but the farmer did not publish his story, and Jenner was certainly the one who performed the critical experiment. In 1798 he published his results under the title *Inquiry into the Causes and Effects of the Variolae Vaccinae*.

The Latin for cow is *vacca*, and Jenner's method came to be called vaccination. He offered free vaccination to the poor of Berkeley in a curious rustic shed in his garden that still stands today. Some years went by before his lead was followed, but eventually he was believed, action was taken, and millions of people were vaccinated. Jenner was rewarded by Parliament with £10,000 in 1802 and £20,000 in 1806, and in 1813 Oxford University awarded him an honorary doctorate in medicine. According to the World Health Organisation more than 10 million cases a year with 2 million deaths were normal before 1967, but vaccination changed all that. The last case of smallpox was reported in 1978, and now the disease seems to have been wiped off the face of the earth, thanks largely to Jenner and his discovery.

34. Edward Jenner
James Northcote, 1803, completed 1823
Oil on canvas,
1270 x 1016mm (50 x 40")
National Portrait Gallery, London (NPG 62)

35. Florence
Nightingale and
her sister Frances
Parthenope,
Lady Verney
William White,
c.1836
Watercolour,
451 x 349mm
(17³/₄ x 13³/₄")
National Portrait
Gallery, London
(NPG 3246)

W illiam Edward and Frances Nightingale were enthusiastic travellers, and when their first daughter arrived they happened to be in Italy. They country gentleman who gave her a thorough Classical education. However, her mother Frances was an ardent socialite, caring more about marriage prospects for her daughters than about their

● Florence Nightingale 1820–1910

own hopes for their lives. Frances was quite happy

called her **Florence** after her birthplace – which, surprisingly, is where I am as I write this. The family home was in Derbyshire, but in 1826 the Nightingales bought Embley Park, near Romsey in Hampshire, and they took to spending the winters there.

Nightingale's father was a rich and cultured

arranging flowers, doing her tapestry, and practising on the piano, but Florence grew increasingly rebellious; she wanted to help

36. Florence Nightingale
Printed and published by H. Hering, 1850s
Albumen carte, 87 x 54mm (3¹/₂ x 2¹/₈")
National Portrait Gallery, London (NPG x29671)

people, work in hospitals, change the world. There were terrible family rows when in 1849 she went abroad to study the European hospital system. The following year she enrolled to train as a nurse at the Institute of St Vincent de Paul in Alexandria, Egypt.

Things came to a head in 1851 when Nightingale left for Germany to spend four months on a training course at the Institute for Protestant Deaconesses at Kaiserwerth, near Düsseldorf. It had been founded as a home for the destitute but had become a training school for teachers and nurses, run on the basis of poverty, simplicity and common sense. Nightingale later wrote, 'Never have I met with a higher love, a purer devotion, than there. There was no neglect. It was the more remarkable because many of the deaconesses had been only

38. *The Mission of Mercy: Florence Nightingale Receiving the Wounded at Scutari*
Jerry Barrett, 1857
Oil on canvas, 1410 x 2127mm (55¹/₂ x 83³/₄")
National Portrait Gallery, London (NPG 6202)

peasants: none were gentlewomen while I was there.' On 12 August 1853 she took up her first post, as Superintendent of the Hospital for Invalid Gentlewomen, in London.

In March 1854 the Crimean War broke out, and *The Times* sent W.H. Russell out to report on its progress – he was in effect the first war correspondent. He sent back graphic stories of the hopeless incompetence of the army commanders and harrowing accounts of the plight of the ill and wounded, who were dreadfully neglected, unlike the French soldiers. 'Are there no devoted women among us', he

wrote, 'able and willing to go forth to minister to the sick and suffering soldiers …?'

Nightingale read this and immediately, on 14 October, wrote to the Secretary of State for War offering her services. He had in fact written to her the same day – their letters crossed in the post – and just a week later she set off for Üsküdar in the Crimea (now part of Istanbul, Turkey) with thirty-eight nurses. What she found in the hospital was appalling. There were 4 miles of beds, all in use, many shared. The soldiers had wounds, frostbite, cholera and typhoid, and infectious patients were not segregated at all. There was no hot water, no soap, no fresh clothing and no proper sanitation. The food was dreadful.

More than half of those admitted to the hospital died, most of them from infectious

39. Queen Victoria (1819-1901)
Replica by Sir George Hayter, 1863, after a portrait of 1838
Oil on canvas, 2858 x 1790mm (112¹/₂ x 70¹/₂")
National Portrait Gallery, London (NPG 1250)

England, 'She has such nerve and skill; she is so gentle and wise and quiet; even now she is in no bustle or hurry, though so much is on her hands'.

Nightingale was not a great scientist – her theory of disease was quite wrong – but she was practical and tremendously forceful. She insisted on good hygiene and nourishing food; she demanded improvements and made things happen. Above all, she collected statistics on everything: admissions, deaths, delays in delivery of supplies, even the distance between the beds. After her arrival towards the end of October 1854, the death rate climbed each month throughout the terrible winter, with ravages from frostbite, typhus and cholera, until February. Then gradually, under her tough regime, it began to fall. By June the mortality rate was down from 50 to 2 per cent.

In September 1856, after her return to England, Nightingale was summoned to Balmoral to talk to Queen Victoria. Prince Albert wrote, 'We are much pleased with her; she is extremely modest'. Nightingale wrote reports for various commissions, in which she stated bluntly that the army took only the fittest young men, yet every year it managed to kill 1,500 of them through neglect, bad diet and disease. Those young men, she said, might as well be taken out on Salisbury Plain and shot.

With such plain speaking, backed up by her statistical information, Nightingale managed to get her message across, and largely as a result of her efforts the management of hospitals was

illnesses. A thousand soldiers died of disease before a shot was fired in battle, and even after the fighting started, for every soldier who died from wounds, seven perished from preventable infection. Nightingale tried not to let any soldier die alone, but sat and held his hand (she personally watched 2,000 soldiers die). She tried to visit every patient every day and was often seen still doing her rounds far into the night. Thus she became known as 'the lady with the lamp'.

She must have been an extraordinary person to have achieved what she did. She ruled and yet she slaved; it is said that she worked twenty hours a day, and yet none of her nurses was allowed in the wards after 8 p.m. Lady Canning wrote of her, just before she left

revolutionised. Nursing changed from a menial occupation for untrained and unmotivated women, often with a weakness for drink, into a caring profession. Her example also opened up the way for upper-class women to escape from the 'bondage of idleness' and become nurses. By 1860 the Nightingale Fund, set up in tribute to her work, had collected £50,000, and with that money she founded a school for nurses at St Thomas's Hospital, London. This marked the beginning of professional education in nursing. Her *Notes on Nursing* (1860) was the first textbook for nurses, and it was translated into many languages.

In 1907 Nightingale became the first woman to be awarded the Order of Merit, and when she died it was suggested that she should be buried in Westminster Abbey. However, she had told her family that she preferred the family plot by the tiny church at East Wellow, near Embley Park. The family memorial has four faces: three are richly engraved with the names and achievements of her parents and her sister, but her side simply says 'F.N. 1820–1910'.

Florence Nightingale undoubtedly saved thousands of lives by insisting on proper sanitation. Throughout the world the number one cause of death has always been contamination of drinking water with sewage. The main reason why infant mortality came tumbling down in the middle of the nineteenth century was because of effective sewers, septic tanks and efficient plumbing – installed by such people as the memorable ● **THOMAS CRAPPER** ●

Thomas Crapper was a successful London plumber and maker of sanitaryware, and he was therefore a significant part of the health revolution. However, in spite of what many people think, he did not invent the flush lavatory or even the siphon.

Crapper grew up in the little town of Thorne, near Doncaster in South Yorkshire, where his father was a sailor and his brothers were dockers, for the River Don was a useful shipping route. He was rather more ambitious;

● Thomas Crapper 1837-1910

he walked all the way to London and apprenticed himself to a plumber. In 1861 he started his own business in Chelsea, and it flourished. The company installed the drains when the royal family bought and refurbished Sandringham House in Norfolk, and its cast-iron manhole covers can still be found in many parts of the country. There are several in Westminster Abbey, for example, and at least one survives in Bristol. The company remained in business until 1960, and indeed has recently been revived, so Thomas Crapper high-flush lavatories are once again on the market. Crapper himself retired to Kent just before the turn of the century.

In his advertising material, Crapper suggested that he had taken out Patent 4990 for a valveless water-waste preventer – that is, a siphonic flush. This was not true. He did take out nine patents, starting in 1881 with one for ventilating house drains to allow gases to escape and ending, in 1896, with one for an improved pipe-joint – but none was for a water-waste preventer, and none was No.4990.

In practice he did not invent anything important. Even if he had been a brilliant innovator, he was born too late, for by the time he set up his business all the important lavatory parts were in general use. The siphon had been patented in 1853 by Joseph Adamson of Leeds, and the following year George Jennings had patented a flush-down lavatory almost identical to those in use today.

Crapper seems simply to have become famous because of his splendid name. The word 'crap' has been used since 1650 to mean 'rubbish', according to the *Oxford English Dictionary*, and since 1846 to mean 'defecate'. At that point Crapper was only ten years old and still living with his family in Yorkshire, so he cannot be held responsible for the change in usage. The name 'Crapper' is common in Yorkshire and probably comes from 'cropper' or 'crofter', meaning farmer.

In the United States the word 'crapper' is sometimes used as slang for 'lavatory'. Popular legend has it that American soldiers in England during World War I were impressed by lavatories with the Thomas Crapper label and took the word home in 1918. Unfortunately that is inconsistent with the first recorded use in 1932, according to *Webster's Dictionary*.

Whatever the origins of the word crapper, there is no doubt that the arrival of proper sewers and clean drinking water were the most important steps towards preventing such killer diseases as typhoid and cholera. Teasing out the details of specific diseases, however, needs a scientific approach.

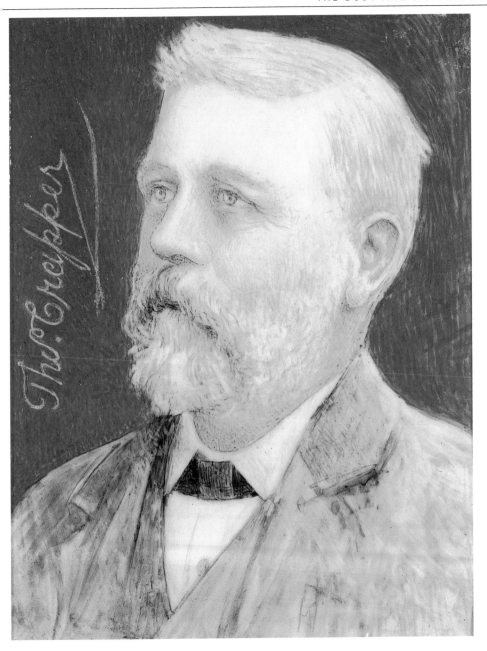

40. Thomas Crapper
Edith Bertha Crapper, n.d.
Watercolour on ivory, 64 x 51mm (2¹/₂ x 2")
Victoria & Albert Museum

One of the leading British centres of study for tropical medicine is in Liverpool, although the city is not noticeably tropical, for by the end of Victoria's reign the British Empire spanned the globe, and travellers from tropical paradises landed at Liverpool, bringing with them unpleasant tropical diseases. **Ronald Ross**, the first lecturer in tropical disease there, solved a problem that had been plaguing humanity for centuries: he discovered how malaria was spread.

Ross was born in a military outpost at Almora in the Indian Himalayas, where his father was serving as an army captain. At the age

● Ronald Ross 1857–1932

of eight, he was shipped back to England. He studied medicine at St Bartholomew's Hospital, London, and in 1881 joined the British-Indian Army Medical Services.

Malaria was a big killer in India, but little was known about it except that the blood of infected patients contained little black blobs. However, in 1880 a French army surgeon called Charles Louis Alphonse Laveran (1845–1922) was looking at some of these blobs in Algeria, when one of them sprouted tentacles and waved at him through his microscope. Laveran realised that it was a single-celled parasite and that it was probably the cause of malaria. It became known as *Plasmodium malariae*. But how was the disease transmitted?

The Scottish doctor Sir Patrick Manson (1844–1922), who spent most of his working life in China, had had a hunch. In 1877 he had discovered that mosquitoes suck up the *Filaria*

parasite that causes elephantiasis from the blood of sufferers and passed it on to new victims. Could it be that malaria parasites were also passed on by mosquitoes? During one of Ross's trips home he met Manson, who convinced him that mosquitoes were the culprits. Ross equipped himself with a new microscope and returned to India, eager to start work. So keen was he that on the voyage out he practised his dissection skills on the cockroaches he caught on board the P&O ship *Ballarat*.

The first thing he did on arriving in India was to rush to a hospital to look at the blood of a malaria patient, but he was unlucky. He started his investigation in the south at Bangalore, Karnataka, where there was not much malaria, for the wrong sort of mosquito flourished there. Then in 1897 the army moved Ross on to Secunderabad, where his luck changed. On 16 August, ten mosquitoes hatched from larvae he had collected the previous day. They were the right sort – *Anopheles* mosquitoes.

Ross now needed a malaria patient on whom to perform his experiment. He persuaded a man called Husein Khan to expose his hand to the mosquitoes, so that they could feed on his blood. Khan was paid 10 annas – one for each mosquito – which in today's money is less than $1/2$p.

Over the next few days, Ross dissected a couple of mosquitoes a day to see whether he could find the malaria parasite inside them and discover what it was doing. In the stomach wall of one of the infected *Anopheles* mosquitoes he saw large round cells that would not normally be there. They turned out to be full of tiny rod-

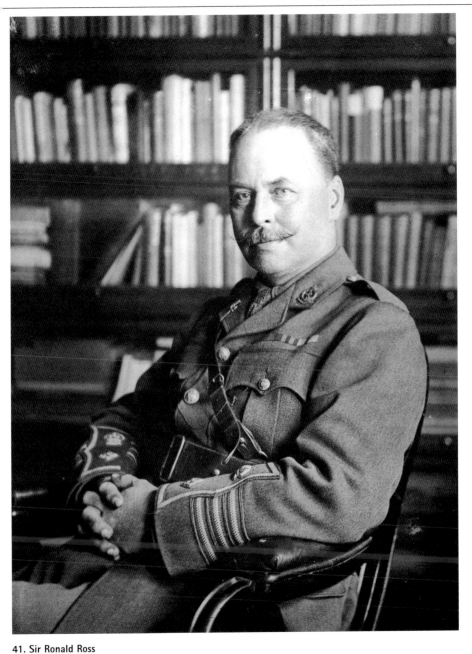

41. Sir Ronald Ross
Elliott & Fry, 1910s
Modern print from a half-plate glass negative,
203 x 152mm (8 x 6")
National Portrait Gallery, London (NPG x82161)

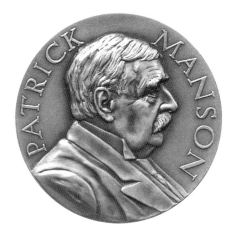

42. Sir Patrick Manson (1844–1922)
John Robert Pinches, 1922
Bronze medal,
51mm (2") high
National Portrait Gallery,
London (NPG 4058)

shaped organisms – the next stage in the parasite's life-cycle. This proved that *Plasmodium malariae* spent part of its life-cycle in the mosquito; Ross still had to show how it got back into the human bloodstream.

By June 1898 Ross had been moved to Calcutta, where he finally solved the puzzle, using birds. On 25 June he infected some healthy birds using mosquitoes carrying the malaria parasite. Three days later, he had proof that the little rod-shaped parasites wormed their way into the mosquito's salivary gland and from there were injected when the mosquito bit something, finally becoming the little black blobs visible in malarial blood. Now knowing the full life-cycle, Ross called 28 June Mosquito Day!

Ross was so excited that he immediately wrote to Manson, who announced his discovery to the British Medical Association. Ross wrote a poem:

This day relenting God
Hath place within my hand
A wondrous thing; and God
Be praised. At His command,

Seeking His secret deeds
With tears and toiling breath,
I find thy cunning seeds,
O million-murdering Death.

I know this little thing
A myriad men will save.
O Death, where is thy sting,
Thy victory, O Grave!

When Ross heard about the newly invented Nobel Prizes, he wrote to the committee asking whether he could have one. They sent him a stiff letter saying that *they* would decide who the laureates were to be. However, in 1902 they did award him the Nobel Prize for Physiology or Medicine for his fantastic discoveries through the microscope. Strangely, a few years earlier he had written, 'For the solution of the Indian fever question … they are much mistaken who imagine that so vast … a problem will ever be solved by a single *coup de microscope*' – yet that is exactly what he had done.

By another single *coup de microscope* came another astonishing breakthrough – although in this case it was a result more of luck than of dogged persistence by ● **ALEXANDER FLEMING** ●

**43. Sir Alexander
Fleming**
Yousuf Karsh, 1954
Bromide print,
502 x 401mm
(19³/₄ x 15³/₄")
National Portrait Gallery,
London
(NPG P490(31))

D uring the twentieth century, the most dramatic advance in the fight against disease was the discovery of penicillin, which came about because of the patience, skill and luck of a diffident Scot called Alexander Fleming. Born on a hill farm near Darvel in Ayrshire, he went to local schools. His father died when he was seven, and at the age of fourteen he was sent to London, where he attended the Polytechnic Institute in Regent Street.

Alexander Fleming 1881–1955 ●

Fleming spent four years working as a clerk in a shipping office but decided this was not for him, and in 1901 he enrolled as a medical student at St Mary's Hospital, Paddington. He spent much of his time shooting, swimming and playing golf, but was still a brilliant student. He won a string of prizes, scholarships and a gold medal and graduated with honours in five subjects.

44. Sir Almroth Wright (1861–1947)
Francis Dodd, 1932
Pencil, 375 x 273mm (14³/₄ x 10³/₄")
National Portrait Gallery, London (NPG 4127)

He stayed at St Mary's, starting as an assistant bacteriologist and becoming Professor of Bacteriology in 1928. He was unusually skilful both in handling equipment, like **Henry Maudslay** (see page 105), and in devising new techniques. If a problem emerged he would simply invent and build a new piece of apparatus to solve it. He also wrote intelligent and insightful essays, notably one in 1909 on the causes and treatment of acne.

During World War I Fleming went to France and worked in Boulogne with Almroth Wright on the treatment of war wounds. Among his important contributions was the scientific demonstration that most streptococcal infections happened after patients were admitted to hospital. Sixty years earlier, Florence Nightingale had similarly deplored the fact

that wounded men were catching fatal diseases in the very place that was meant to be healing them (see page 90).

In 1922 Fleming isolated the body's natural antibiotic, lysozyme, which he considered his most important discovery. For the rest of the world, however, penicillin was far more dramatic. He stumbled on it by chance in 1928, while writing a chapter on *Staphylococcus* bacteria. He had a series of Petri dishes (glass saucers) with the bacteria growing on them and had to check their progress regularly.

One day he noticed that a clump of mould was growing on one of the dishes, and all the nearby *Staphylococci* were turning transparent and falling apart. Most research scientists would have sworn and thrown away the contaminated dish, but Fleming was intrigued, and after his

45. Sir
Ernst Chain
(1906–79)
Wolfgang
Suschitzky, 1944
Bromide print,
292 x 387mm
(11¹/₂ x 15¹/₄")
National Portrait
Gallery, London
(NPG P555)

recent experience with lysozyme he decided to investigate this strange mould.

In his *British Journal of Experimental Pathology* paper of 1929 he wrote, 'the active agent is readily filterable, and the name "penicillin" has been given to filtrates of broth cultures of the mould … penicillin is non-toxic to animals in enormous doses and is non-irritant … It … may be an effective antiseptic …' This was something of an understatement. Penicillin proved to be astonishingly effective in killing bacteria; hence the general name antibiotic, derived from Greek and meaning roughly, 'killer of living germs'. When the power of antibiotics was recognised, doctors suddenly had a way of curing bacterial infections, and millions of lives were saved.

Between 1942 and 1944 **Dorothy Hodgkin** worked out the chemical structure of penicillin using X-ray crystallography (see page 181), and this allowed the chemists Sir Howard Walter Florey (1898–1968) and Ernst Boris Chain (1906–79) to make the material synthetically. Having once discovered the mould, Fleming the bacteriologist was content to let others make use of it. In 1945 he shared the Nobel Prize for Physiology or Medicine with Florey and Chain.

Although a brilliant scientist, Fleming was a poor administrator – he hated taking decisions. He was enormously loyal to his friends but hopeless at conversation. As one visitor put it, 'talking with him was like playing tennis with a man who, whenever you knocked the ball over to his side, put it in his pocket'. And the origin of the famous mould? No one knows. Fleming himself admitted that it was just a fluke. Some say that it grew on a Petri dish that he had not bothered to wash up; another theory is that the spores drifted in from the pub across the road.

5

Men of Precision

Joseph Bramah 1748–1814

Henry Maudslay 1771–1831

Marc Isambard Brunel 1769–1849

James Nasmyth 1808–90

While **John Harrison** (1693–1776; see page 137) was the first to build portable precision clocks, he remained essentially a loner, producing them on his own, with just a little help from his son. His fellow Yorkshireman **Joseph Bramah**, however, had a string of brilliant practical ideas which he passed on, and so founded a dynasty of excellence.

Bramah came from a farming family near Barnsley, and would probably have become a farmer in his turn had he not injured his leg jumping in the annual feast at Bolton-on-Dearne. Unfit for farm work, he apprenticed himself to a cabinetmaker. His scientific innovation started in 1778, when he took out a

● Joseph Bramah 1748–1814

patent for an improved water-closet. This was only the second English patent for a water-closet, the first having been registered in 1775 by a London watchmaker, Alexander Cumming.

Flushing lavatories were far from new – the Romans had built many in Britain – but self-contained water-closets were to become a new fashionable luxury.

Bramah's lavatory was fitted into a solid mahogany box but otherwise it looked fairly similar to today's lavatories. Underneath was a hinged valve to keep a few inches of water in the bowl. After use one pulled a handle to open the valve and allow the waste to fall into the trap below. Then the valve shut and the bowl filled with a little water, ready for the next person. The lavatory was a great success; Bramah moved to London to exploit it, and sold 6,000

in the following years (one of his customers was Matthew Boulton). Indeed, it remained one of the finest lavatories in the land for some seventy-five years. However, it could not be installed in most homes for lack of both running water and means of disposing of the sewage. London's modern sewerage system was not to begin operating until the 1860s. By then a new breed of sanitary engineers were active, including George Jennings and Thomas Crapper (see page 92).

Bramah's next great invention was an unpickable lock. Most locks at the time were 'ward locks', in which a ward or barrier was supposed to make the lock impossible to open without the key that matched the shape of that particular ward. In practice, however, they were easy to pick; anyone could easily take a wax or soap impression of the ward and so cut a key that would work.

Bramah's lock could be opened only by a cylindrical key with slots cut in its end, and the position and depth of the slots were the critical variables. From the outside, all of his keyholes looked identical – little more than a round hole – and there was no easy way of picking the locks. Nor could wax impressions be taken. Bramah had such confidence in the security of his design that he placed a challenge padlock in the window of his premises in Piccadilly and offered a prize of 200 guineas to anyone who could produce an instrument to open it. The lock was eventually picked by Alfred Hobbs, a professional lock-pick from America who came over for the Great Exhibition of 1851. It took him forty-four hours over sixteen days to get into the padlock – but that was not until thirty-

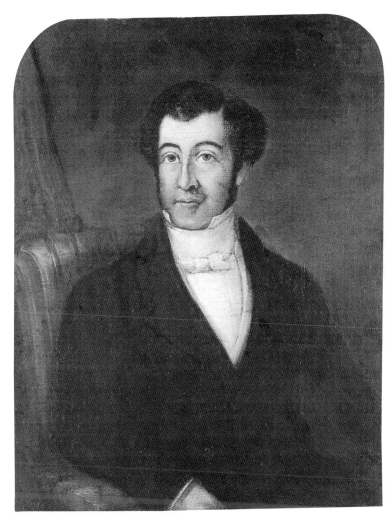

46. Joseph
Bramah
Unknown artist, n.d.
Oil on canvas,
420 x 370mm
(16$^1/_2$ x 14$^1/_2$")
Institution of
Mechanical Engineers

seven years after Bramah's death. Bramah Security still make unpickable locks today.

Bramah also invented the beer engine, to pump beer up from pub cellars to the bar, and the science of hydraulics – his hydraulic press, patented in 1795, was to revolutionize printing and other industrial processes – but his greatest legacy remains the idea of precision engineering. Even now, when something is beautifully made, Yorkshire people say, 'That's a real Bramah!'

Designing his locks was a stroke of genius, but the tricky process of making them also required great skill and exceptional manual dexterity. For that challenging job Bramah hired a young blacksmith called ● HENRY MAUDSLAY ●

H. MAUDSLAY.

47. Henry Maudslay
Charles Etienne Pierre Motte after
Pierre Louis ('Henri') Grevedon, 1827
Lithograph
National Portrait Gallery, London (NPG D1378)

Some great engineers have brilliant new ideas that allow science or technology to progress; others invent fantastic new devices that make our lives easier or more fun. A rare few seem to think with their fingertips and craft their ideas with their hands, enabling succeeding generations to do things better. Such a man was **Henry Maudslay**, who rose from humble origins to become the father of precision engineering.

Born at Woolwich in south-east London, Maudslay got his first job at the age of twelve as a powder-monkey – filling cartridges at Woolwich Arsenal. He moved to the smithy when he was fifteen and quickly became a highly skilled metalworker, learning to work with the hot iron rather than fight against it. And he acquired a glowing reputation. When Joseph Bramah was looking for a really skilled blacksmith to make his unpickable locks he was lucky that a friend recommended Maudslay.

Bramah summoned Maudslay and was taken aback to meet a stripling of eighteen; he almost sent him packing. However, Maudslay impressed Bramah with his handling of a pair of pliers and persuaded his future employer to give him a chance. The prototype lock that Maudslay made was later exhibited in the Bramah shop window in Piccadilly, and in 1789 Maudslay became Bramah's foreman at the workshop in Denmark Street.

Maudslay designed and built machines to manufacture the locks – essentially the first ever machine tools – and he ran Bramah's workshop for eight years. During that period he married Bramah's housekeeper, Sarah Tindale, and they

had four children. But in 1797 he was still being paid only 30 shillings a week, and he asked for a raise. Bramah refused; so Maudslay left to set up his own business at 64 Wells Street.

In his shop window Maudslay kept on display a beautiful screw thread that he had made. It was spotted in 1800 by a French engineer, who knew that its stunning workmanship might interest a friend of his; Marc Isambard Brunel (1769–1849). Brunel had

Henry Maudslay 1771–1831 ●

designed a process for making ships' pulley blocks by machine. These blocks were of vital importance to the navy: a 72-gun warship needed 922 of them; in total the navy used 100,000 blocks a year – and each one was produced by hand, mostly by the company Taylors of Southampton.

Traditionally, the pulley wheel or sheave was made of *lignum vitae*. The pin was also made of *lignum vitae*, or later of iron, and the shell – the outside bit – was made of elm. Not only was it expensive to manufacture pulley blocks by hand; it was also frequently inaccurate. And when the components did not fit together perfectly, the friction under which they operated made them inefficient and dangerous – there were even tales of blocks catching fire in the rigging.

Brunel's system for making pulley blocks mechanically used twenty-two different machines. What he needed was someone to make models of them so that he could sell the idea to Taylors. Somewhat nervous about revealing his invention to anyone, he called on Maudslay and

asked whether he would be willing to make a model machine. Maudslay did, and Brunel then produced drawings for another – whereupon Maudslay said, 'Oh I see! You want to make pulley blocks!' At this point Brunel dropped his cloak of secrecy and engaged him, first to make the models and then to manufacture the actual machinery. Maudslay's models of the twenty-two machines are still in the National Maritime Museum at Greenwich.

Taylors were not interested in Brunel's invention; Samuel Taylor responded to him, 'My father has spent many hundreds a year to get the best model, and most accurate, of making the blocks, and he certainly succeeded; and so much so, that I have no hope of anything ever better being discovered, and I am convinced there cannot'. Brunel therefore went straight to the Admiralty, who acted with uncharacteristic enthusiasm. By 1807 Maudslay's machines were making all the navy's blocks. Ten unskilled men could allegedly do the work of 110 skilled blockmakers, and Brunel's fee was the saving they made in one year: £17,663 19s.

Maudslay's iron blockmaking machines comprised the world's first fully mechanised production line. He employed eighty workers to produce the blocks, and later the firm grew again. Maudslay took on a partner, Joshua Field, and his own sons also joined. The company then moved to Westminster Road, Lambeth, where it was to remain until 1900. It went on to produce steam engines for ships, calico printers and differential gear hoists. It also manufactured coin-minting machines, sawmill machinery, hydraulic presses and sugar mills. By the time Victoria came to the throne six years after Maudslay's death, Maudslay, Sons, & Field was probably the best engineering company in the world.

Maudslay's brilliance lay not only in the quality of his products, but in the way he tackled both straightforward and complex engineering tasks. He himself said, 'Avoid complexities, and make everything as simple as possible'. He worked out how to produce absolutely flat surfaces and perfectly regular screw threads. He built a micrometer that could measure to a ten-thousandth of an inch; he called it the Lord Chancellor, because it was the final arbiter when there was any argument in his workshop. He also taught some of the finest engineers of the next generation, including Joseph Whitworth (1803–87), the man who standardised nuts and bolts, and **James Nasmyth** (1808–90; see page 111).

Above all, Maudslay was a genius with metal. As one of his old workmen said, 'it was a pleasure to see him handle a tool of any kind, but he was quite splendid with an 18-inch file.' His memorial in Woolwich said that Maudslay was 'eminently distinguished as an engineer for mathematical accuracy and beauty of construction, and as a friend for a kind and benevolent heart'.

Maudslay's first stroke of luck had been to meet Joseph Bramah, but his second – equally important – had been to attract the attention and approval of ● **MARC ISAMBARD BRUNEL** ●

**48. Sir Marc
Isambard Brunel**
Unknown photographer, c.1845
Daguerreotype, 95 x 70mm
(3³/₄ x 2³/₄")
National Portrait Gallery, London
(NPG P578)

O n hearing the name Brunel, most people think instantly of the flamboyant **Isambard Kingdom Brunel** (1806–59; see page 156) who built the Great Western Railway and designed the Clifton Suspension Bridge. However, his father was an equally brilliant and more genteel engineer, who constructed the world's first tunnel through soft ground under a river.

Marc Isambard Brunel was born at Hacqueville in northern France. Although his had to run away to America. Kingdom did not get away and was clapped in jail for six months.

In America, Brunel was a great success professionally. He drew up plans for digging canals, designed buildings and became Chief Engineer of New York. But even after six years he pined for Kingdom, so in 1799 he sailed for England, tracked her down in London and married her.

Brunel came to England with a grand scheme for making ships' pulley blocks mech-

Marc Isambard Brunel 1769-1849 ●

father was a landowner and farmer, he managed to get an education in engineering. In 1793, after a few years in the French navy, he went to Rouen to stay with a cousin and there fell in love with the cousin's beautiful seventeen-year-old English lodger, Sophia Kingdom. Before Brunel had time to plight his troth, however, he got into trouble with the revolutionaries and anically. With practical help from Henry Maudslay it became an enormous success (see page 105) and put both engineers onto a firm financial footing. But Brunel's biggest and most spectacular venture was to dig a tunnel under the River Thames in east London, between Rotherhithe and Wapping. The fiery Cornishman Richard Trevithick (1771–1833), pioneer of

49. Richard Trevithick (1771–1833)
John Linnell, 1816
Oil on canvas, 760 x 690mm (30 x 27¹/₈")
Science Museum

a labourer can just work. Pile two more on top, and this is the basic unit. Stand twelve of these side-by-side, and thirty-six miners can all work together at the tunnel face.

In front of each man were a dozen removable boards, each 6 inches wide. His job was to remove each plank in turn, dig out the earth behind it to a depth of 4 inches, replace it and push it forwards as far as it would go. When everyone had removed the earth from behind all of the boards, the entire frame could be pushed forwards 4 inches by huge screw jacks, and then the whole process would start again. Meanwhile, bricklayers went to work on the exposed earth where the shield had moved forwards, to make good the walls and the roof.

This labour was unbelievably hard. Space was cramped. It was fairly dark – lit only by candles. And all the time the roof dripped, not just with water but with raw sewage, for the project predated London's modern sewerage system. Quickly men became ill and had to stop work. Brunel himself succumbed early on, and his son Isambard, all of twenty-one years old, had to take over as Chief Engineer. The work was particularly perilous because dredgers had been removing gravel from the river-bed, and the roof of the tunnel was in fact much closer to the water than the Brunels suspected.

On 18 May 1827 the roof sprang a leak

high-pressure steam engines, had almost succeeded in constructing a tunnel, but he had been narrowly defeated by the soft ground. Brunel conceived a way of digging his tunnel even through treacherous gravel, sand and quicksand.

He decided to tunnel from a shaft in Rotherhithe. First, he built a vast brick cylinder – a tower 50 feet across and 40 feet high. Then he gradually dug out the earth inside. As earth was removed, the cylinder sank – a few inches every day – until it finally became a shaft. This took most of the summer of 1825, and in November Brunel started the actual tunnelling, using a method inspired by a woodworm called *Teredo navalis*, which bores its way through the oak timbers of ships.

Brunel designed an extraordinary piece of equipment, the tunnelling shield, which he commissioned Maudslay to build. Imagine a box the size of a small wardrobe, 2 metres (6 foot) high and 1 metre (3 foot) wide, in which

50. Sir Marc Isambard Brunel
Samuel Drummond, c.1835
Oil on canvas, 1270 x 1016mm (50 x 40")
National Portrait Gallery, London (NPG 89)

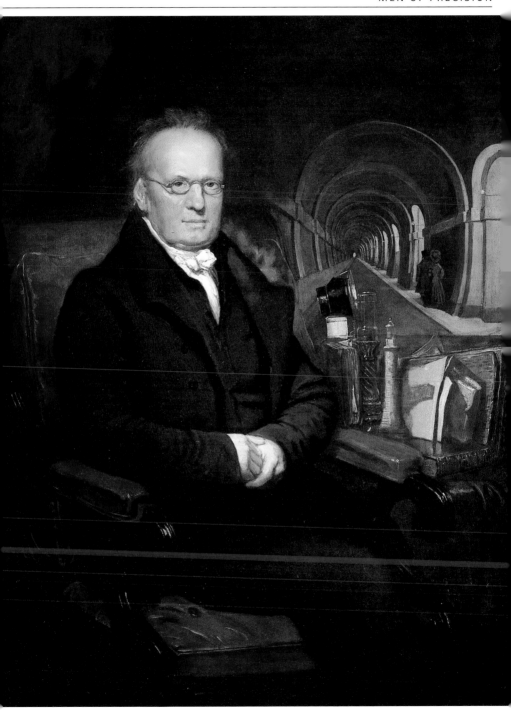

51. Arthur Wellesley, !st Duke of Wellington (1769–1852)
Robert Home, 1804
Oil on canvas, 749 x 622mm (29¹/₂ x 24¹/₂")
National Portrait Gallery, London (NPG 1471)

and the tunnel was flooded. Isambard Brunel had to go down into the river in a diving bell to pile clay over the hole, and it then took six months to complete repairs and pump out all the water and mud. At that point he insisted on holding a celebration banquet in the tunnel. At a long linen-draped table in one side of the double tunnel sat fifty guests while the band of the Coldstream Guards entertained them, and in the other side sat 120 miners and bricklayers. This may have helped temporarily to restore the confidence of the directors, but if it was also meant to please the river gods it failed, for on 12 January 1828 there was another massive flood. The whole tunnel was rapidly inundated with sewage; six men were killed, and Isambard Brunel was pulled unconscious from the water. He was seriously injured and took more than a year to recover.

By the middle of 1828 the company was anyway running short of money, and in spite of enthusiastic support from the Duke of Wellington, Marc Brunel had to admit temporary defeat. In August 1828 the tunnel – by then halfway across the river – was bricked up.

Seven years later, Brunel managed to raise the money to continue. He unbricked the tunnel, replaced the shield and started digging again. But conditions got worse and worse. There were not only floods but continual eruptions of gas – both poisonous hydrogen sulphide and inflammable methane, which frequently caused explosions and fires. During the whole of 1837 the tunnel advanced at an average of less than 1 inch per day. But finally it was completed in 1842, amid much celebration. Brunel was knighted by Queen Victoria, who paid a surprise visit to inspect the tunnel in the following year.

Although Brunel was the epitome of a French gentleman and a phenomenal engineer, he was not successful in business. The Admiralty took years to pay him for his pulley-block machines; a sawmill he built in Battersea was destroyed by fire in 1814; and a military boot factory he set up proved a liability in 1815 when the Battle of Waterloo ended the Napoleonic Wars and the soldiers were demobbed. To cap all, his bankers went broke, and he and his wife found themselves in a debtors' prison. They were released only after the Duke of Wellington bullied parliament into paying off their debts.

Brunel's most productive and lasting work was all done with the practical assistance of Maudslay. He, in his turn, was to take on, train and encourage a bright young Scottish engineer called ● **JAMES NASMYTH** ●

Perhaps the most basic of all engineering tools is the hammer. There are all sorts of different models – indeed, Karl Marx was amazed to discover in 1867 that in Birmingham alone 500 different types of hammer were being made. Nevertheless **James Nasmyth** managed to revolutionise the humble hammer, by inventing one of the most important tools of the age of steam.

Nasmyth was the son of a noted Edinburgh artist, but his interests lay elsewhere. The fathers of two of his friends owned a chemical works and an iron foundry, and he spent as many hours there as in school. By the time he was a teenager, he was accomplished in working metal, and he used to practise casting brass secretly at night – he had converted the fireplace in his bedroom into a furnace.

Nasmyth heard that the greatest engineer of the day was Henry Maudslay and was determined to work for him. He went to London with drawings and a model steam engine that he had made, and simply asked for a job. Maudslay refused him, since he had decided that apprentices were more trouble than they were worth, but he showed him round the workshop anyway. Nasmyth said he would be honoured to be allowed to muck out the boilers in such a famous place. On hearing this, Maudslay relented as far as to agree to look at Nasmyth's model engine. Twenty minutes later, he hired him as Personal Assistant. From Maudslay Nasmyth learnt the skills of the precision engineer. Eventually he set up on his own in Manchester.

Nasmyth became famous for his machine tools. In those days an engineer usually started business with some iron and from that hand-made a lathe, which he used to produce a plane, and so on. Nasmyth made all the tools for his works and then used them to turn out equally beautiful tools for others. He also produced steam engines and eventually constructed one so big that it had to be made on its side. One day the engine beam fell through the floor into the glassworks below. The landlord begged Nasmyth to find

James Nasmyth 1808–90 ●

bigger premises, so he moved out into the nearby countryside, to a site beside the newly opened Liverpool to Manchester railway at Patricroft. As it was also near the Bridgewater Canal, the new works became known as the Bridgewater Foundry.

Iron had been worked for thousands of years, traditionally by blacksmiths. The technique is fairly simple: the metal is heated in a forge until it glows bright red, which indicates that it is soft enough to work. Then it is hammered into shape. Both heating and hammering help to make the iron stronger – they temper it.

The challenge that was to face Nasmyth concerned not technique but size. In 1839 Mr Humphries of the Great Western Steamship Company wrote to him describing plans for a bigger forging than had ever been undertaken. The steamship *Great Britain*, then under construction in Bristol for **Isambard Kingdom Brunel**, required an enormous paddle-shaft. Humphries had not been able to find anyone with a large enough forge-

hammer to make it. Did Nasmyth have any ideas?

The mechanical hammers at the time were mostly 'helve' or tilt hammers, powered by steam or water. The intrinsic fault in their design was that the bigger the piece of work under the hammer, the smaller the distance the hammer head could fall. Thus the smallest job took the heaviest blows and the biggest job the lightest. Furthermore, the hammer never fell vertically, because it was tilted.

When the enquiry about the *Great Britain* paddle-shaft came in, Nasmyth realised immediately that something new was required. He was later to say, 'In little more than half an hour after receiving Mr Humphries' letter ... I had the whole contrivance in all its details before me in a page of my scheme book [sketchbook for new designs]'.

The idea was simple. The hammer was not hinged but was just a large piece of metal that could slide up and down. It was raised by steam under a piston and allowed to drop by releasing the steam pressure with a valve. Unlike the helve hammer, which ran at a steady rate and strength, this new steam hammer was completely controllable. The operator could time the blows precisely, and could also choose how high the hammer went, and therefore the force of each blow.

Nasmyth immediately sent the plans off to Brunel and his Managing Director, Mr Guppy, and they heartily approved. But Brunel changed his mind and decided to power the *Great Britain* by the brand new propeller system instead of paddle wheels. So there was no great paddle-shaft to be forged. Simultaneously, the iron trade took a downturn, and so the plans for the steam hammer lay dormant in Nasmyth's scheme book.

In 1842 Nasmyth visited the Creuzot Foundry in France and noticed how excellent its large forgings were. He asked how they had been made – and the answer astounded him. The chief engineer at Creuzot had visited Patricroft while Nasmyth was away, had seen the plans in his scheme book and had stolen the idea for himself! They even took Nasmyth to see his steam hammer in action!

A dispute about the patent ensued, because the French company had actually produced the first steam hammer, but it was resolved in Nasmyth's favour, and he soon built his own. The valve gear was improved by his employee Robert Wilson, making the hammer both more delicate and 'double acting', so that steam could be used above the piston to increase the force of the blow. Nasmyth used to demonstrate to visitors the delicacy of this huge steam hammer by using it to crack an egg in a wine glass, leaving the glass itself untouched.

Nasmyth was not only an engineer but also a fine astronomer. He built large telescopes in his foundry, and his book *The Moon* (1874) was a major work.

6

Nature's Revolutionaries

Adam Sedgwick 1785–1873

●

Charles Lyell 1797–1875

●

Charles Darwin 1809–82

●

Alfred Russel Wallace 1823–1913

●

Thomas Henry Huxley 1825–95

●

Richard Owen 1804–92

Adam Sedgwick 1785–1873 ●

Adam Sedgwick must have been a gifted and quick-thinking man, for without the relevant training he became one of the first professors of geology in England. He was to have a profound effect on the development of the subject as a science, although he was rather conservative and like many others he rejected the revolutionary ideas of **Charles Darwin** (see page 121) on evolution.

Born at Dent in the Yorkshire Dales, Sedgwick went to the local grammar school, then studied briefly with the surgeon and mathematician John Dawson, who had helped to deliver him into the world, before going to Trinity College, Cambridge, in 1804. Still at Cambridge eleven years later, Sedgwick became an assistant tutor. In 1816 he was ordained, and for the rest of his life he remained active in the Church.

This was a period of upheaval in the history of science, and especially geology. In 1815 William Smith (1769–1839), who has been called the father of English geology, had published the first geological map of the country, which had aroused great interest. For decades gentlemen had collected so-called 'curiosities', such as fossils, and displayed them in cabinets.

Gradually, however, the idea was dawning that fossils – and indeed the actual structures and forms of rocks – were more than mere curiosities. They were clues to the history of the earth and the creatures that had inhabited it.

In early summer 1818 the position of Woodwardian Professor of Geology at Cambridge University became vacant. Fascinated by the subject, Sedgwick decided to apply. There was just one slight drawback – he knew nothing whatever about geology! However, he did not let that stand in his way, and he so impressed the board with his enthusiasm that he got the job, beating a trained geologist by 186 votes to 59!

The post, before Sedgwick took it, had generally been regarded as a sinecure, but he resolved to take his duties seriously. After studying hard, he gave his first course of lectures in 1819. He became involved with the Geological Society, the Royal Society and the British Association for the Advancement of Science.

Sedgwick did many field studies and published papers on the rock strata of Cornwall and Devon, the Pennines, the Lake District and Wales. He was one of the first to be convinced that the earth was very old (see page 118). He was a moderate lecturer but a great raconteur, and he had the gift of passing on his enthusiasm for geology to others, among them ● CHARLES LYELL ●

53. Adam Sedgwick
Samuel Cousins after Thomas Phillips, 1833
Mezzotint, 288 x 206mm (11³/₈ x 8¹/₈")
National Portrait Gallery, London (NPG RN33648)

Some new scientific ideas come as flashes of inspiration, but others develop slowly with input and argument from various different people. The first half of the nineteenth century saw a gradual revolution in the way the earth was understood, and one of the most

● Charles Lyell 1797–1875

influential of the scientists involved was the Scottish geologist Sir **Charles Lyell**. Born at Kinnordy, north of Dundee, Lyell grew up in the New Forest in Hampshire, studied Law at Oxford University and was admitted to the bar. However, his interests lay in science, and he spent most of his adult life travelling the world, examining rocks, rivers and volcanoes. A contemporary said that Lyell would have been a man of commanding presence if his extremely short sight had not obliged him to

stoop and to peer into anything he wished to observe.

Since the 1650s, it had generally been thought that the world had been created in 4004 BC. The source for this date was the *Annals of the World* (2 vols, 1650–4) by the Anglican clergyman and biblical scholar Archbishop James Ussher of Armagh (1580–1656). He had used the genealogical lists in the early chapters of the Bible (Adam begat Cain and Abel, and so on) to calculate a biblical chronology. However, by the 1820s his assertion was becoming difficult to believe. In 1821, for example, the Rev. William Buckland (1784–1856) – Canon of Christ Church and Regius Professor of Geology – had found bones which he thought provided evidence for many generations of animals before the great biblical Flood. He spent his career seeking to reconcile Creation, as presented in the Bible, with current scientific evidence and theories. He, Sedgwick and others believed that the earth was about 6,000 years old, and that the strata showed where God had chosen to send cataclysmic events, or catastrophes, to wipe out vast numbers of animals. Then He could repopulate the world with the next, higher, order of creatures, in accordance with His grand design.

54. Archbishop James Ussher (1580–1656)
After Sir Peter Lely, c.1654
Oil on canvas, 781 x 654mm (30³/₄ x 25³/₄")
National Portrait Gallery, London (NPG 574)

55. Sir Charles Lyell
Replica by Lowes Cato Dickinson, 1883,
after a portrait of c.1870
Oil on canvas, 1222 x 889mm (48¹/₈ x 35")
National Portrait Gallery, London (NPG 1387)

56. William Buckland (1784–1856)
William Brockedon, 1838
Black and red chalk, 354 x 260mm (14 x 10¹/₄")
National Portrait Gallery, London (NPG 2515(87))

the entire 7-mile-long Niagara gorge in 35,000 years. In other words, to explain how the Niagara gorge was formed, you did not need a catastrophe; you only needed a process that was still going on – and a very long time.

In Sicily Lyell was struck by the immense age and size of Mount Etna. The catastrophists said that such a large mountain must have been thrown up by some colossal upheaval in the past, but he worked out by careful observation of the accumulated layers of lava that Etna was simply a volcano. If it had been erupting and spewing out rocks and lava for long enough, it would have built itself up to such a size.

When he came back from Sicily in 1829, Lyell wrote what was to become one of the great science books of all time: *Principles of Geology, being an Attempt to Explain the Former Changes of the Earth's Surface by Reference to Causes now in Operation.* The first volume was published in January 1830, and ● **CHARLES DARWIN** ● took it with him on *HMS Beagle* (see page 122); volumes 2 and 3 were shipped out to him later. The book shaped the way Darwin thought about the new world he was observing and was a major influence on his thinking about evolution.

The last catastrophe had been the great biblical Flood. They thought that many of the geological features of the earth had been shaped by these catastrophes, and they were called 'catastrophists'.

Lyell became convinced that their theory was wrong and looked instead to the uniformitarian view of the Scottish geologist James Hutton (1726–97). In 1785 he had suggested that the earth's features could be explained by processes such as sedimentation and erosion that were still going on. Lyell visited the Niagara Falls in North America, made careful measurements and calculated that the water passing over the falls was gradually wearing away the rock – by about 1 inch every month. Thus the falls were moving upstream at a rate of about 12 inches per year. At this rate, he reckoned that the falls could have carved out

57. Charles Darwin
Julia Margaret
Cameron, 1868
Albumen print,
330 x 256mm
(13 x 10^1/$_8$")
National Portrait
Gallery, London
(NPG P8)

Charles **Darwin**'s grandfathers were the physician Erasmus Darwin and the potter Josiah Wedgwood. He was born in Shrewsbury, and he became immensely famous for formulating the theory of evolution by the process of natural selection. His father, Robert, was a doctor, and the original plan was for Darwin to become a doctor too. After graduating from the best school in Shrewsbury in 1825, he went to Edinburgh University to study medicine. Unfortunately he could not stand the sight of blood, so in 1827 he left and

enrolled at Cambridge University with the aim of becoming a vicar.

However, he became more interested in collecting beetles than in his theological studies, and he spent most of his time pursuing them.

Charles Darwin 1809–82 ●

On one occasion he had caught two different specimens, and was holding one in each hand, when he spotted a third. So he put one in his mouth for safe keeping. Unfortunately it was a

58. Robert Fitzroy
Maull & Polyblank, early 1860s
Albumen carte-de-visite, 90 x 59mm (3¹/₂ x 2¹/₄")
National Portrait Gallery, London (NPG x13984)

voyage, and he was disappointed at how engrossed Darwin became in his work. The voyage must have been quite an ordeal for them both. Had he known that it was going to last for five years, Darwin might have been less enthusiastic about going. Nevertheless, he was amazed by what he saw in the waters of the Atlantic – even the plankton were most exquisite in their forms and rich colours. Why was there so much beauty in the vastness of the ocean, with nobody to admire it? It seemed created for so little purpose.

There was yet more variety on the South American mainland – the sheer diversity and abundance of life were staggering – and Darwin found himself wondering how such a range of living things had come about. He went on hunting trips into the interior, studying both the landscape and the wildlife.

After some four years the *Beagle* sailed up the west coast of South America and across to the remote Galapagos Islands – ten volcanic outcrops 500 miles west of Ecuador. There Darwin wrote that the hundreds of black cones reminded him of the iron foundries of Staffordshire. Darwin shot a number of finches that were to become famous, although at the time he was so homesick and fed up with the voyage that he could not be bothered to label his specimens properly. However, he wrote in 1839, in his journal *The Voyage of the Beagle*, 'Seeing this gradation and diversity of structure, in one small, intimately related group of birds, one might really fancy that from an original

bombardier beetle, and sprayed his tongue with acid – but even that did not put him off. In Cambridge Darwin was taught by John Stevens Henslow (1796–1861) and was also much influenced by Sedgwick (see page 117).

When Darwin was twenty-two he heard that Captain Robert Fitzroy was about to sail round the world on a scientific expedition in the survey ship *HMS Beagle* and was looking for an unpaid naturalist to join him. Darwin applied for the job, with Henslow's backing, and after some argument – both with his father and with Fitzroy – he was given it.

Darwin's cabin was just 10 foot by 11 and the ceiling was too low for him to be able to stand upright. He had to share it with the Assistant Surveyor. Fitzroy, a neurotic and irascible man, had simply been looking for a gentleman with whom to share his meals and pass the time of day, to ease the boredom of the

59. Charles Darwin
Copy by John Collier, 1883, after a portrait
of 1881
Oil on canvas, 1257 x 965mm (49^1/$_2$ x 38")
National Portrait Gallery, London (NPG 1024)

paucity of birds in this archipelago, one species had been taken and modified for different ends.'

With hindsight Darwin saw that each island had its own kind of finch; from the ten islands they took back thirteen species. He deduced that there could originally have been one kind of ancestor finch, which had gradually evolved into different species on each island. He discovered that the same applied to plants. On James Island, for example, he found a total of seventy-one plant species and, as far as he knew, of those thirty were unique to that place.

He returned to England in 1836 to find that the geological papers he had sent back to Henslow and Sedgwick in Cambridge had already earned him something of a reputation as a scientist. He carried on writing and in 1839 married his first cousin Emma Wedgwood – marrying Wedgwoods was a Darwin habit. They settled at Down House in Kent, where they produced ten children, seven of whom survived to adulthood.

At Down House, Darwin pursued his favourite occupation: watching nature. He studied bees, employing his children as research assistants. They would stand in a line down the garden, and when he shouted out, they all had to say which bees were on which flowers.

For thirty years he studied earthworms, and in 1881 produced a delightful book about them, *The formation of vegetable mould through the action of worms, with observations of their habits.* Among his conclusions were that worms are highly sensitive to touch and to bright lights, but totally deaf – he arranged for his children to whistle, shout and play the bassoon and the piano, but the worms were quite

unmoved. However, he said they showed intelligence, since when they dragged leaves down into their burrows they always chose the most pointed end to pull. By leaving out artificial leaves – triangles of stiff paper – he confirmed this; again, the worms invariably picked the most acute angle, which is impressive in view of the fact that they have no eyes.

Every morning, Darwin went for a constitutional on his sandwalk – a path he had made around a little patch of woodland. One of the things on his mind was an essay published in 1798 by the economist Thomas Robert Malthus on human population. Malthus asserted that people tended to have more and more babies until there wasn't enough food left for them. Population growth was then checked by famine, disease or war. Darwin realized that this was the key to what he had seen in the animal and plant world; only some of the offspring were selected to survive.

In 1859, after some twenty-five years' thought on the subject, he finally published his most famous and important book, *On the Origin of Species by Means of Natural Selection.* In it he explained his notion of how species evolved – described by some as the best idea that anyone ever had. The implication of Darwin's theory is staggering. As long as there is heredity, variation among offspring, and selection – for example, by limited food – there must be evolution; and evolution has produced every lion, every lamb and every leaf on planet earth.

The book was an instant success: John Murray cautiously printed 1,250 copies and sold out on the day of publication, 24 November. It provoked furious controversy, since it

implied not only that God had not individually created all creatures great and small but, even more contentiously, that human beings and apes had evolved from common ancestors. Darwin did his best to keep out of public arguments and was fortunate that his viewpoint was ably defended by such powerful allies as **John Tyndall** and **Thomas Henry Huxley**. The significance of his work was acknowledged by his contemp-oraries: he was elected to the Royal Society (1839) and the French Academy of Sciences (1878), and after death he received the great honour of burial in Westminster Abbey. Darwin's *On the Origin of Species* has been one of the most influential books of all time, and yet he might never have finished it had he not been pushed into the task by a letter from ● **ALFRED RUSSEL WALLACE** ●

Alfred Russel Wallace and Charles Darwin came from utterly different backgrounds, and yet in mid-life their paths ran amazingly parallel. Wallace was born in the small town of Usk in south-east Wales, and the family later moved to Neath, near Swansea. He learned the craft of surveying, was apprenticed for a while to a watchmaker and

caught fire, and he lost everything. Fortunately he was picked up after ten days in an open boat.

Undaunted, in 1854 Wallace set off again, this time to Singapore, Borneo and other parts of South East Asia. Again he collected hundreds of specimens, and as he examined them, he wondered why and how some species seem to change into other species and how

● Alfred Russel Wallace 1823–1913

tried teaching. Then he and his brother set up a small building company which also did surveying for the railways; they built the Neath Mechanics Institute. However, what Wallace really enjoyed was collecting – first plants and flowers, which he dried and kept in a herbarium, and after that beetles and butterflies.

Having been bitten by the naturalist bug, Wallace sailed from Liverpool on 20 April 1848 with his like-minded friend Henry Walter Bates for an expedition to the Amazon. In the tropical rainforest, Wallace was stunned at the variety of wildlife. Whereas in England he might hope to see thirty different kinds of butterfly, in Brazil he collected more than 400 species in two months. He began to question why there were so many and why lots of species were rare. Some of the questions he asked then are still puzzling ecologists today.

He sent back a few specimens and gradually built up a vast collection with which he planned to amaze the world and make a fortune. After four years in Brazil he sailed for home on 12 July 1852 with all his specimens and also some parrots, parakeets, monkeys and a wild dog. A few days into the voyage the ship

the new species could be so well adapted to their environments.

In February 1858 Wallace was struck down with 'intermittent fever' (probably malaria), and as he lay there sweating the answers came to him. He was so excited that he wrote a long letter to his colleague and friend Charles Darwin, explaining how he thought that new species might evolve spontaneously over many thousands of generations by a process of natural selection.

His letter was a terrible shock for Darwin, since Wallace's idea was exactly the same as his own. Darwin had first formulated the hypothesis twenty years earlier but had not published it because he knew it would be controversial, as well as unproveable. Not least, it would horrify his Christian wife Emma. Now in 1858 he was forced into action. Not knowing what to do, Darwin consulted his mentor Charles Lyell, who suggested that Darwin and Wallace should publish jointly. So the first

60. Alfred Russel Wallace
After a photograph by Thomas Sims, c.1863–66
Oil over photograph, 289 x 225mm (11³/₈ x 8⁷/₈")
National Portrait Gallery, London (NPG 1765)

scientific paper on natural selection was read in their joint names to the Linnaean Society that year: *On the tendency of species to form varieties; and on the perpetuation of varieties and species by means of natural selection.* Wallace always maintained that the original idea was Darwin's.

The phrase 'survival of the fittest' was apparently first used by the social philosopher Herbert Spencer in 1864. Wallace wrote to Darwin in 1866 and suggested that it accurately described the process that they were both talking about; Darwin agreed and started to use it himself.

Wallace went on to try to apply Darwinian principles to all sorts of human creations, such as socialism and land reform, publishing *Man's Place in the Universe* in 1903. He believed firmly that genetic evolution of humans themselves had stopped once they had developed big brains and minds, for these he considered provided evidence of God, or at least a great designer. This was where his ideas differed sharply from Darwin's, but the two men nevertheless remained friends until Darwin's death. So Wallace was a useful ally for Darwin, but by far his most active supporter was ● THOMAS HENRY HUXLEY ●

Thomas Henry Huxley was born in Ealing, London, the son of a not very successful teacher. Like Charles Darwin, his initial training was as a doctor, and like Darwin he then joined an expedition around the world, later becoming a biologist. However, unlike Darwin, he was not wealthy; so he had to work for his living and fight for his position in society.

When *On the Origin of Species* was published in 1859, Huxley found that he agreed with Darwin's ideas, and

Thomas Henry Huxley 1825–95 ●

as controversy broke out he rushed to defend his hero – this is what he is principally remembered for today. He became known as Darwin's bulldog!

The most famous Darwinian debate of all took place at the Natural History Museum in Oxford in June 1860. The British Association for the Advancement of Science was holding its week-long annual meeting. Huxley went for the whole week, but by Friday he was bored and ready to leave. A friend persuaded him to stay for one more day to hear a debate on Darwin's theory.

On the Saturday, an audience of nearly 1,000 people crammed into the beautiful chapel-like room, with its high curving wooden beams. On the podium was the Bishop of Oxford, Samuel Wilberforce. Wilberforce was a well-known speaker, with strict Anglican views – and a reputation as a vivid orator;

a contemporary nickname for him was 'Soapy Sam'.

After two hours of debate the crowd was getting increasingly restless, for nothing controversial about the evolution of humans from apes had been said. At last Wilberforce was called to speak. He started discussing Egyptian mummies and fancy pigeons – and then suddenly turned to Huxley and asked whether he was descended from an ape on his grandfather's or his grandmother's side.

Huxley stood up, and replied that if the question was, would he rather have an ape for a grandfather or a man endowed by nature and possessed of great influence who employs these

61. Samuel Wilberforce (1805–73)
George Richmond, c.1864
Oil on paper, 445 x 333mm (17¹/₂ x 13¹/₈")
National Portrait Gallery, London (NPG 1054)

faculties for the purpose of introducing ridicule into scientific debate, then he would affirm his preference for the ape. Curiously, there seems to be no clear record of exactly what either man said, and afterwards each thought that he had won the argument (Huxley's own account of the dramatic events was not written until some thirty years afterwards). The debate was widely reported and did as much as anything else to bring the controversial idea of evolution into the public eye. What is more, it has become historically accepted as a turning point in the acceptance of Darwinism by scientists.

In 1867, Huxley made his own great contribution to evolutionary ideas at the same Oxford museum. He was wandering through the displays when he noticed a large bone that looked to him like a bird's pelvis – he had just spent a year working on bird skeletons and he recognised the shape at once. However, the label said that the bone, found by Buckland (see page 118), was part of the ribcage of a *Megalosaurus*, the first ever dinosaur (in the present sense of the word) to be discovered and named.

At this date, the leading light in the study of fossils and dinosaurs was **Richard Owen** (1804–92). His ideas had dominated the subject for years. For the Great Exhibition of 1851, for example, he had made life-sized models of dinosaurs which looked like great lumbering rhinoceroses. Huxley realised that the models were far from correct. He spent Christmas 1867 in the British Museum, London, taking apart and reassembling its huge *Iguanodon* skeleton using his radical new ideas. What he ended up with was a giant two-legged bird with no wings. When the fossil *Iguanodon*

had first been discovered, a single spike was found, which was thought to belong on the beast's nose. Later it became clear that it was in fact a thumb!

Huxley took his idea one step further, applying Darwin's theory. If dinosaurs had bird-like hips, then perhaps birds had evolved from some sort of dinosaur. This was truly radical – Huxley was linking a completely extinct group of animals to one in every Victorian garden. It proved unpopular with many people, including Owen. The notion that one group of animals could evolve into another did not fit into non-Darwinian thinking.

Huxley was a fighter. He fought to find the cash to pay for his education at Charing Cross Hospital, London, he fought to get a well-paid scientific job. He fought the establishment views on evolution, dinosaurs and even religion – it was he who coined the word 'agnostic' to describe his idea that one can neither prove nor disprove that God exists. Above all, Huxley and Owen battled in the papers, in scientific journals and even in public. In the end, Huxley's views triumphed and the link between birds and dinosaurs was established.

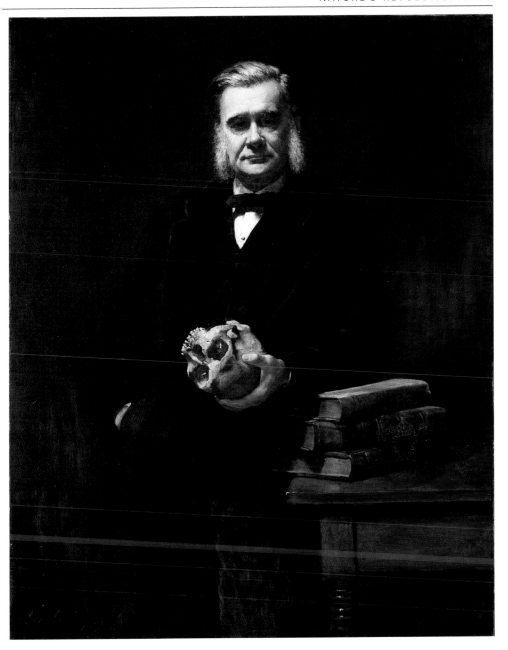

62. Thomas Henry Huxley
John Collier, 1883
Oil on canvas, 1270 x 1016mm (50 x 40")
National Portrait Gallery, London (NPG 3168)

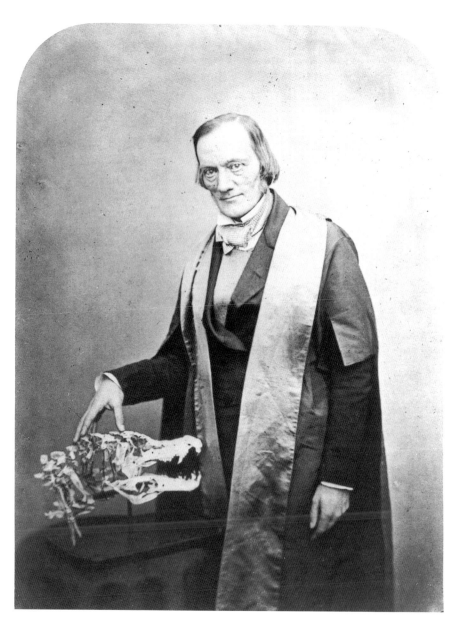

63. Sir Richard Owen
Maull & Co., c.1855
Albumen print, 200 x 146mm ($7^7/_8$ x $5^3/_4$")
National Portrait Gallery, London (NPG P106(15))

At grammar school in Lancaster **Richard Owen** met William Whewell (see page 71), who later became Master of Trinity College, Cambridge; they became lifelong friends. Owen then went to train with a surgeon, but in fact spent more time with anatomists dissecting corpses. After studying at Edinburgh and St Bartholomew's Hospital, London, he took the post of Lecturer in Comparative Anatomy at Bart's.

In April 1836 Owen was appointed Hunterian Professor of Comparative Anatomy and Physiology at the Royal College of Surgeons, where he was to spend nearly twenty years, becoming a highly distinguished anatomist and a Fellow of the Royal Society. He also won the Wollaston gold medal of the Geological Society and founded the Microscopical Society. A prolific writer, he produced books and papers and did an enormous amount of research. He published accounts of the anatomy and dissections of dozens of animals and birds, including armadillo, beaver, capybara (the largest living rodent), cheetah, crocodile, flamingo, gannet, giraffe, hornbill, kangaroo, orang-utan, pelican, seal, tapir, toucan, walrus, warthog and wombat. He also became immensely knowledgeable about the structures of bones and teeth.

However, his principal interest was the study of dinosaurs. Not only did he arrange for the erection of life-size models at the Great Exhibition of 1851, but when the Crystal Palace was re-erected at Sydenham in 1855 he arranged for their installation in the park there.

In 1856, after falling out with the Royal College of Surgeons, Owen took a new job as Superintendent of the natural history department of the British Museum. His duties turned out to be few, and he plunged into further research, especially on the bones of extinct animals. His papers for the Paleontological Society on extinct reptiles of the British Isles occupied more than 1,000 pages, and they were only a small part of his output.

From the late 1850s Owen began to campaign for the building of a museum for natural history, and eventually persuaded the Chancellor of the Exchequer, William Gladstone, to

Richard Owen 1804–92 ●

go ahead. Land was found at South Kensington in 1863, building was started ten years later, and finally in 1881 the Natural History Museum was opened to the public.

Owen was a rather difficult man. He often disagreed loudly with other people's ideas, and even when he had not made up his own mind he did not hesitate to assert that they were wrong. Thus on evolution he wrote that he had 'been led to recognise species as exemplifying the continuous operation of natural law, or secondary cause, and that not only successively but progressively', and yet when Charles Darwin's *On the Origin of Species* was published he attacked it viciously in an anonymous review. Similarly, he savagely laid into Thomas Huxley over the idea that birds might have evolved from dinosaurs. Indeed he attacked people so habitually that he became somewhat isolated scientifically. However, he did one great and lasting service: he named those long-extinct creatures, incorrectly but memorably, 'dinosaurs' from the Greek for 'terrible lizards'.

7

Navigators
and Explorers

John Harrison 1693–1776

James Cook 1728–79

Joseph Banks 1743–1820

John Franklin 1786–1847

Marie Stopes 1880–1958

I n 1707 a naval tragedy shook the newly formed British nation. Admiral of the Fleet Sir Clowdisley Shovell, sailing back from Gibraltar, was the victim of poor navigation. As a result, his fleet sailed straight into the shores of the Isles of Scilly. Four ships of the line were wrecked; 2,000 men died; and Shovell himself, after crawling ashore half alive, was murdered

● John Harrison 1693–1776

on the beach by a woman who stole the ring from his finger.

The root cause of this disaster was the inability of even the best sailors to work out while at sea how far east or west they were – in other words their longitude. In 1714 Queen Anne announced a reward of the colossal sum of £20,000 for anyone who could solve the problem to an accuracy of 30 minutes of longitude; the man who eventually did so was a village carpenter.

John Harrison was born in a tiny village on the estate of Nostell Priory, near Wakefield in Yorkshire, but when he was still a toddler the family moved to Barrow-on-Humber – today close to the south end of the Humber Bridge. Like his father before him, Harrison became the village carpenter, but his real fascination was with clocks.

In 1722 he built a beautiful wooden clock for the Earl of Yarborough. It still dominates the stable block at Brocklesby Park in Lincoln-

shire, and wound once a week it keeps remarkably good time, gaining perhaps a minute per week. Every part of this clock used original features, from the grasshopper escapement mechanism to the vanes on the pendulum designed to compensate for variation in air pressure. It was made entirely of wood – mainly oak and *lignum vitae* – even the cog-wheels were wooden, with the grain running along the teeth for maximum strength. This clock needs no lubrication, for *lignum vitae* exudes its own oil, and it has run for almost 280 years.

When he heard about the prize offered for an accurate method of determining longitude,

64. Sir Clowdisley Shovell (1650–1707)
Michael Dahl, c.1702
Oil on canvas, 2223 x 1422mm (87¹/2 x 56")
National Portrait Gallery, London (NPG 797)

65. John Harrison
(with H4)
Thomas King, 1767
Oil on canvas
Science Museum

Harrison naturally thought that the answer would lie in a clock. Any competent sailor on board ship could measure the time of 'local noon' – when the sun was highest in the sky. Suppose a ship sails west from England: local noon gradually becomes later as it approaches America, changing about one hour for every 600 miles. By the time the ship reaches New York, local noon is five hours after that of London.

Therefore, if a sailor measures local noon and knows when it is noon at Greenwich, the longitude is immediately obvious. But knowing what time it is at Greenwich requires an accurate clock, and so Harrison set out to build one. He soon realised that a clock with a pendulum, as already invented in 1657 by the Dutch scientist Christiaan Huygens (1629–95), would not be suitable, since the motion of the

pendulum would be affected by the rolling of the ship; and so he began to investigate various other timing systems.

Claims on the prize were assessed by a committee appointed by the government, the Board of Longitude, and they had to deal with several absurd schemes. One pair of scientists suggested that a ship should be anchored every hundred miles across the Atlantic, and that each of these ships should fire a cannon into the air at exactly Greenwich noon every day. Then any ship close enough to see or hear the cannon would know when it was Greenwich noon. Unfortunately these scientists had no immediate solutions to the questions of how to anchor the ships in water many thousands of feet deep, how to keep the people on board supplied with food and water and, most importantly, how they would know when it was Greenwich noon.

Another peculiar idea was the wounded-dog method. A dog would be deliberately wounded; the wound would be bandaged and then the bandage kept on shore while the dog was taken on board for the voyage. Every day at Greenwich noon, the bandage would be treated with the magical 'Powder of Sympathy' brought back from France by Sir Kenelm Digby. This would cause the dog to howl, and those on board would know that it was Greenwich noon. No one was quite sure over what range this psychic connection would work, and they agreed that for long voyages the dog might have to be wounded more than once...

Harrison suffered some frustration at the hands of the Board of Longitude. They were irritated by cranky suggestions, and partly because they believed the solution would be astronomical – Flamsteed had thought so (see page 24), and the Astronomer Royal Nevil Maskelyne became one of the Board – they thought that Harrison was just another crank. They kept moving the goalposts, and even when he had fulfilled their conditions they claimed that he had not done enough to show others how to produce his clocks or measure longitude.

To an extent, Harrison was his own worst enemy; when he had all but satisfied the Board he suddenly announced he could build a better clock and disappeared back to Yorkshire. As early as 1730 he reckoned he could make a clock that would be accurate to within a second a month. But he was utterly besotted with the quest for precision. In 1759, when he had produced H4, his fourth marine chronometer – essentially a pocket watch – he said,

Verily I may make so bold to say there is neither any mechanical or mathematical thing in the world that is more beautiful, or curious in texture, than this my watch, or timekeeper for longitude, and I heartily thank Almighty God that I have lived so long as to in some measure complete it.

Eventually, after intervention on his behalf by George III, the Board gave Harrison the prize in 1773. He was then eighty years old and had been working on the clock for more than fifty years. Fortunately, when he died three years later, his skills survived him, and a replica of H4 went around the world with Captain ● JAMES COOK ●

66. James Cook
John Webber, 1776
Oil on canvas, feigned oval,
368 x 292mm (14¹/₂ x 11¹/₂")
National Portrait Gallery, London
(NPG 26)

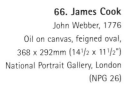

In 1740 the twelve-year-old **James Cook**, born in the village of Marton, near Middlesbrough, in North Yorkshire, was apprenticed to a greengrocer in the tiny town of Staithes, where the streets slope steeply down to the sea. He soon decided that the retail trade was not for him, and went a few miles down the coast to Whitby to work as a sailor for John Walker, who shipped coal from Newcastle to London, and regularly had a dozen young apprentices boarding in the attic of his house by the harbour in Grape Street.

Cook learned his seafaring skills in the tough school of the North Sea and studied navigation in the evenings; he had a flair for mathematics. When he was twenty-six Walker offered him the command of his own ship, but he chose instead to leave Whitby and join the Navy as an able seaman. Again he rose rapidly through the ranks, within four years becoming Master of a ship. He went on to be one of the

James Cook 1728–79 ●

finest naval surveyors of all time. His instruments were the sextant and the compass, and he managed to use them with unequalled precision.

Between 1756 and 1767 Cook made surveys of the coastal waters off Quebec, Labrador and Newfoundland. In 1766 he observed an eclipse of the sun and sent a report about it to the Royal Society, which may have helped to bring about his first great voyage to the South

Pacific. For on 3 June 1769 there was to be a transit of Venus – the planet was going to pass across the face of the sun – which happens only twice in every century or so. Astronomers hoped that by careful observation from several places around the world they might be able to calculate accurately the distance between the earth and the sun. All the relative distances in the solar system had been estimated, and if they could get one absolute measurement they would be able to calculate all the others.

Therefore the Royal Society despatched observers to India, Canada and South Africa, and to take a ship half way round the world they picked the finest navigator available, Cook. Asked whether for this crucial voyage he would like a ship of the line he replied that he would rather sail in a second-hand coal barge – a Whitby 'cat' of the type he knew so well. These boats were reliable in terrible weather, and were flat-bottomed, which meant that they could be winched up on any beach in the world, for repairs or refitting.

Cook set off from Plymouth in the *Endeavour* on 25 August 1768, with three sets of sealed orders, not knowing in advance where the voyage might take him. He reached Tahiti on 13 April 1769, in plenty of time to observe the transit. After that he sailed right round and charted the coastlines of both islands of New Zealand – a distance of 2,400 miles. The gap between the islands is still known as Cook's Strait. Before returning home in 1771 he sailed up the east coast of Australia, claiming it for Great Britain and naming it New South Wales because he thought it looked like the view from the Bristol Channel.

In 1772 he set off on his second great expedition, in command of the *Resolution*, this time sailing further south than any previous explorer. On this voyage he disproved the existence of a mysterious southern continent, the Terra Australis, which had been thought necessary to balance all the land masses of the northern hemisphere. Again he was away for three years, and perhaps the most remarkable aspect of the trip was that only one man died out of a crew of 118, whereas 30 or 40 per cent mortality from scurvy was common at the time. Cook had made the crew eat fresh fruit, although he also made them take vinegar and seemed not entirely sure which was the more effective.

For his third great voyage he set sail in 1776. This time he had with him a replica of the chronometer H4 made by John Harrison. He surveyed the west coast of America all the way up to the Bering Sea, looking for the North West Passage (see page 145) and then turned south into the Pacific and discovered Hawaii. The clock survived with triumph; when it returned to England it was in error by less than a minute after three years at sea. Cook, however, was less fortunate; on 13 February 1778 he was killed in a skirmish on Karakakoa Beach.

Cook was a superb sailor and navigator, and is possibly even more famous in Australia and New Zealand than in Britain. He was tremendously ambitious, as he himself described: 'I whose ambition leads me to go not only further than any man has gone before me, but as far as I think it is possible for a man to go'. His scientific reputation depends partly on his navigation, but also on the crucial role he played in the observation of the transit of Venus. In this he was helped by the official naturalist on board ● JOSEPH BANKS ●

67. Sir Joseph Banks
Sir Thomas Lawrence, c.1795
Pencil, 248 x 203mm
(9³/₄ x 8")
National Portrait Gallery,
London (NPG 853)

Joseph Banks could scarcely have had a more different upbringing from James Cook. The Banks family owned a town house in London, and in Lincolnshire another house in Horncastle, plus extensive estates at Revesby. He had a conventional upper-class education, studying at Oxford University, and then announced to his parents that he wanted to travel.

Joseph Banks 1743–1820 ●

They were at first delighted, thinking that he intended to take the Grand Tour of European capitals. However, they were horrified when he actually took a passage to Newfoundland on a fisheries protection vessel. He was dreadfully seasick to begin with and scarcely enjoyed Newfoundland any more than the Atlantic, finding the country cold, wet and miserable.

In 1768 Cook invited Banks to accompany him, at his own expense, as botanist on the *Endeavour*. In spite of their differences in age and background, the two men seem to have got on well together and made a good team. Banks was an out-and-out hedonist, and in Tahiti was overwhelmed by the charms of the ladies. In his journal he admitted to all sorts of indiscretions.

On one occasion, after spending a night with a charming woman in a canoe, he woke to find that not only had she disappeared, but so had all his clothes, including the tail-coat in whose pockets he kept a pair of pistols to protect himself against thieves!

When the *Endeavour* sailed on to Australia, Banks was so fascinated by the plant life there that he called one place Botany Bay, which is still its name today. He brought back from the trip large numbers of plant and animal specimens, which are called *Banksii* in his honour. Many went to Kew Gardens; some are now on display at the Sir Joseph Banks Conservatory in Lincoln.

I am surprised Banks embarked on the voyage at all; it must have been tough and uncomfortable, and he was used to the luxuries of life. Clearly the Newfoundland trip had failed to put him off adventure, rather whetting his appetite instead. It appears that he and Cook had considerable respect for one another, for in 1772 Cook invited Banks to join him for his second voyage around the world.

Unfortunately Banks's playboy streak emerged at this point. He said that if he was to sail round the world again he would need a retinue of fourteen, including not only assistants and secretaries but also two horn-players, not to mention a pair of greyhounds! In order to accommodate them, he arranged for an extra deck to be built on the *Resolution*, but this made the ship so top-heavy she was unsteerable. Cook gave orders for the deck to be removed, whereupon Banks retorted huffily that he had decided not to go after all.

That year he visited Iceland, but he never went on another major voyage – surely a loss to science, for he was a fine botanist. Instead, he settled in London, and in 1778 he was elected President of the Royal Society, a position he was to hold for forty-two years. He ruled the Royal Society with enthusiasm, encouraging other scientists and keeping up a wide correspondence. In turn, he was well respected throughout the scientific world, so that for example when Volta devised the first electric battery (see page 12) he wrote to Banks, despite the Napoleonic Wars that were then raging. Consequently, within weeks the knowledge had percolated through the British scientific community, and it was soon put to use by Children (see page 74) and **Humphry Davy**.

Banks made his collections and his library available to anyone who was interested, and his house in Soho Square became a scientific Mecca. He, meanwhile, became a grand patron of science, publishing little himself.

It was to Banks that **Count von Rumford** turned when he wanted backing to found the Royal Institution (see page 166), and it was Banks who encouraged the young whaler William Scoresby to record his many scientific observations of meteorological data, water temperatures at various depths, and the shapes of snowflakes in the Arctic Ocean. One rather touching memorial to this famous man turned up at Waterloo in Pennsylvania where a Mr and Mrs Rhine produced a son seventy-five years after his death and named him Joseph Banks. Joseph Banks Rhine (1895–1980) became a biologist but then changed direction and founded the world's first laboratory for the study of parapsychology, at Duke University in North Carolina, and coined the phrase 'extrasensory perception'.

From time to time Banks would journey north from London to tend to his Revesby estates, usually in a vast coach which, like Erasmus Darwin, he designed himself. Travelling with him was apparently a nightmare, partly because whenever he saw an unusual plant he would insist on stopping and getting out to botanise, and partly because of the coach itself. One of his friends wrote,

It carried six inside passengers, with much more than their average luggage ... Sir Joseph ... travelled with trunks containing voluminous specimens ... and large receptacles for further vegetable matter,

68. Sir Joseph Banks
Thomas Phillips,
1810
Oil on canvas,
1419 x 1118mm
(55⁷/₈ x 44")
National Portrait
Gallery, London
(NPG 885)

which he might accumulate in his locomotions. The vehicle had … a remarkably heavy safety-chain – a drag-chain upon a newly-constructed principle, to obviate the possibility of danger in going down hill – it snapped, however, on our very first descent; whereby the carriage ran over the post-boy … and the chain of safety very nearly crushed him to death. It boasted also … a hippopedometer … by which a traveller might ascertain the precise rate at which he was going … this also broke, in the first ten miles of our journey: whereat the philosopher to whom it belonged was the only person who lost his philosophy.

Such men as Cook, Banks and Scoresby must have inspired dozens more to become explorers, both scientific – as in the cases of Charles Darwin and Alfred Russel Wallace – and purely geographical; none more than ● **JOHN FRANKLIN** ●

John Franklin was the youngest of twelve children, born in Spilsby, Lincolnshire. He joined the Navy and served with Nelson at the Battle of Copenhagen in 1801, and in 1805 also took part in the Battle of Trafalgar.

In 1818 Franklin started a quest for the North West Passage. Trade was increasing with China and other countries in the Far East, and the conventional route there took ships all the way round the Cape of Good Hope at the southern tip of Africa, which was a long voyage. Just looking at a globe, it seemed that there was a reasonable chance of finding a shorter route by sailing up past Greenland and then north-west, over the shoulder of North America and down to China. Explorers, including James Cook, had been searching for a north-west passage for some 200 years, but without success. Anyone who could find such a route would become famous, and possibly rich.

Franklin's first expedition to the Arctic, in command of the *Trent*, was a disaster; one of the ships was crushed in the ice. The following year he was ordered to set off on foot across Canada to survey the northern coastline, in the hope that he could find the passage. Almost two years of icy hardship went by before the party reached the Arctic Ocean in July 1821; then they sailed some distance along the coast and went inland, first by river and then on foot, through what was labelled on the map 'Barren Grounds'. This was the worst part of the terrible journey. Some of the explorers died,

John Franklin 1786–1847 ●

others were murdered and the few survivors actually had to eat their boots to stay alive.

Undaunted, however, Franklin went on a third Arctic expedition in 1825, this time by a combination of land and sea. He brought back some splendid geological information but still failed to find the passage and, tragically, his young wife died while he was away. He married again, spent three years in the Mediterranean, and from 1836 to 1843 served as Lieutenant-Governor of Van Diemen's Land (Tasmania). Yet the lure of the North West Passage still beckoned, and when the Admiralty suggested

another major expedition he volunteered at once. The First Lord pointed out to him that he was sixty years old. 'No, no, My Lord', he replied; 'Only 59!' And so on 18 May 1845 he sailed with two ships, the *Erebus* and the *Terror*, and 133 officers and crew. They were never seen alive again.

During the next twelve years, at least forty expeditions were sent out to look for Franklin. They found some cans of food that had gone rotten; they heard from Inuit who had seen European men die; they came across skeletons and eventually a written message. Apparently Franklin had died on 11 June 1847. In 1851 some sailors saw an iceberg in the open sea off Newfoundland; frozen into it were two ships – one upright, one on its side. Perhaps they were the *Erebus* and the *Terror*, floating off into the icy wastes of the North Atlantic Ocean.

69. Sir John Franklin
Replica by Thomas Phillips, 1828
Oil on canvas, 768 x 514mm (30¹/₄ x 20¹/₄")
National Portrait Gallery, London (NPG 903)

Marie Carmichael Stopes was born in Edinburgh but became a Londoner at the age of six weeks. A woman of great convictions and great passion, she managed to turn from romantic fossil-hunting trips around the world to an odyssey of discovery of her own body.

Stopes studied Botany and Geology at University College, London, passed her finals

● Marie Stopes 1880–1958

with honours after just two years and took the post of Lecturer in Botany at Manchester University – she was the first woman to join the scientific staff there. Manchester was set in the heart of a coal-producing region, so she was well placed to research a particularly rich source of fossilized plants. Deep within seams of coal, miners sometimes find hard lumps known as coal balls, which contain pieces of perfectly preserved plants some 310 million years old. They date from the Carboniferous Period – roughly when reptiles first appeared, and well before dinosaurs.

Stopes examined thin slices of coal ball under the microscope and was able to see the internal structures of the plants. She described the habitat as groves of large trees with herbs and ferns around their stems in flat, swampy levels, their roots in brackish or salt water – much like mangrove swamps today.

She met the explorer Robert Falcon Scott (1868–1912) – she found him a divine dancer – and begged to go on his next expedition so that she could look for fossils in the Antarctic. He refused but promised to bring some back; when

he was found dead, he had 33 pounds of fossils with him, clearly collected for her.

As she studied her coal-ball plants, Stopes noticed that there were no flowers. So where had all our roses and daffodils come from? Reckoning that she could predict the existence of particular fossils from the conditions of the surrounding rocks, she calculated that Japan would be the perfect place to find the answer. However, her theory may have been influenced by a romantic attachment to a Japanese professor who had returned home. Nevertheless, she was right: in Japan in 1907 she did indeed find the world's first petrified flower – *Cretovarium japonicum*, 85 million years old – but alas she did not find true love!

On her return, Stopes catalogued all the plants so far discovered from about 140 to 65 million years ago, the Cretaceous Period. This was her finest scientific work and it led to another discovery, for a piece of wood that she found in the Natural History Museum collections turned out, at 100 million years old, to be the earliest example of a flowering plant. She found that once the world had burst into bloom for the first time, flowers had quickly taken over. By the time dinosaurs became extinct at the end of the Cretaceous era more than half of plant species had them.

In America, Stopes met Dr Reginald Ruggles Gates, who instantly fell for her and proposed just a few days after their first meeting. They married quickly and came back to England. Stopes was thirty-one and, in spite of her biological training, still very innocent. After six months, however, even she began to feel that there was something lacking in her marriage.

70. Marie Carmichael Stopes
Sir Gerald Kelly, 1953
Oil on canvas, 724 x 857mm (28½ x 33¾")
National Portrait Gallery, London (NPG 4111)

She went to the British Museum and read every book she could find about sex. Then she visited her lawyer, filed for divorce on grounds of non-consummation and launched herself into an entirely new career.

Wanting to make sure that what had happened to her did not happen to anybody else, Stopes set out to write a guide to marital relationships, with basic information about sex. In particular, she encouraged the idea of sex as something husband and wife should share equally. When the book was published in 1918 under the title *Married Love*, it was dynamite. In this first book Stopes mentioned birth control only in passing, but she received such a huge response asking for more information that she wrote a second called *Wise Parenthood* – and it is for her birth-control campaign that she is best remembered. In 1921 she opened the first birth-control clinic in the country with the help of her second husband, Humphrey Verdon Roe.

However, Stopes had a tough and unpleasant side to her character. She became President of the Society for Constructive Birth Control and Racial Progress, and advocated sterilization or abortion for people of lower quality. Although she was a great sexual liberator of women, she was far from a saint.

8

High 'Esteam'

George Stephenson 1781–1848

●

Robert Stephenson 1803–59

●

Isambard Kingdom Brunel 1806–59

●

Daniel Gooch 1816–89

Just as James Watt is often wrongly credited with the invention of the steam engine, so **George Stephenson** is often mistakenly thought to have invented railways, the steam locomotive, or even the steam engine. However, he was quick to latch onto other people's ideas and bring them to fruition, even if he was not too good at giving credit where it was due.

Stephenson was the second of six children, son of a fireman at Wylam Pit, near Newcastle. The Stephenson family lived in one room of a cottage beside the wooden tramway on which coal from the pit was taken on the first stage of its journey to Newcastle and thence to London. He had no formal education and did not learn to read or write until he went to evening classes

● George Stephenson 1781–1848

at the age of seventeen. His first job was as a cowherd, but he soon came back to work alongside his father as a fireman. He became fascinated by the machines in the pit – and indeed in other pits, as he moved around.

Stephenson was able to transfer on to the stationary steam engines in the pits; he became in succession engineman, brakesman and enginewright. By now a competent engineer, in 1813 he was asked to build a steam locomotive at Killingworth Pit – this was the formal beginning of his lifelong work with steam engines.

At about the same time he set about tackling a problem that was becoming ever more serious in the local pits – explosions of firedamp (methane). Methane could be deadly, because it ignited when it came into contact with flames, and the mines were lit solely by

candles which the miners carried on their hats. A miner would be hacking away with his pick at the coal seam when suddenly he would hit a pocket of gas and it would come blowing out – these releases of gas were known as 'blowers'. There were terrible explosions, and dozens of miners were killed. Several mines became unworkable because of their particularly dangerous blowers.

The solution would be a type of lamp with a shielded flame. The first useful one was invented in 1813 by an Irishman, William Reid Clanney, but it was a cumbersome affair with water in it, and it never gained wide acceptance. Two years later, Stephenson reasoned that if he put a candle in a jar with a small hole or chimney in the top, then the 'burnt air' rushing out of the hole would stop the methane from getting in. Moreover, if he let air in through a small hole in the base, the rapid inward flow of air would prevent any flame from getting out at the bottom. Thus the lamp should be safe even near a blower.

In autumn 1815, to the horror of his colleagues, Stephenson went down into pits with active blowers, carrying a variety of peculiar lamps to find out whether they would cause explosions. Fortunately he survived, and he did end up with a lamp that was safe.

What he did not know was that the great scientist **Humphry Davy** had been asked to design a safety lamp and had come up with a

71. George Stephenson
T. L. Atkinson, 1849, after John Lucas, 1847
Line engraving
National Portrait Gallery, London (NPG RN33349)

similar design at the same time (see page 169). Davy arrogantly said that a colliery worker could not possibly have thought up this construction; Stephenson must have stolen his ideas. But there were many witnesses to his various experimental lamps, and in 1818 Stephenson was presented with a reward of £1,000 for what became known as the Geordie Lamp.

The steam locomotive was invented in 1804 by Trevithick (see page 107), and when Stephenson began constructing his first engines to haul loads in coal mines, he took the design from those built by John Blenkinsop and Matthew Murray in Leeds in 1811. In 1823 he set up a factory in Newcastle for their manufacture. So Stephenson did not invent the locomotive, but he was the man who got locomotive engines on the right lines – literally – because when he came to build the Stockton & Darlington Railway in the early 1820s he insisted on using wrought iron for the rails instead of cast iron, and this was crucial. Cast iron is obtained by pouring molten iron into a mould; it has high carbon content and is strong but brittle. Wrought iron is hammered into shape, which makes it much tougher (see page 111). Stephenson chose to put the rails 4 foot 8½ inches apart – either because that was how they were at the pit, or because that was the average length of axles that he measured on carts and carriages, or even (some claim) because it was the guage of Roman chariots – and to this day the standard gauge in Britain and many other countries is 4 foot 8½ inches.

There was tremendous opposition to the building of the Stockton & Darlington Railway from landowners, but after many political struggles the line was approved. Stephenson did the surveying for it with his son **Robert Stephenson** (1803–59). Opening to the public on 27 September 1825, it was the first railway in the world to carry passengers.

However, the most important new line was to run from Liverpool to Manchester, snaking across the bogs of south Lancashire. By 1829 Stephenson had won the contract to build it; the burning question was how the trains were going to be hauled. There were three options: first, by horse. This was rejected because of the weight and number of the trains. Second, by stationary steam engines every few miles along the track, pulling the wagons on cables. Many liked this plan. Third, by steam locomotive. If this choice were made, which type would be best?

Stephenson argued fiercely for the locomotive, and his opinion won the day. On 6 October 1829 a trial was set up in which four locomotives would compete for the job on a level stretch of track at Rainhill in Merseyside. Stephenson rightly took this competition immensely seriously and invited his son to build a brand new locomotive, the *Rocket*, especially for those Rainhill Trials.

The *Rocket* had a vital new feature in its boiler design, for passing through it from end to end were twenty-five 3-inch pipes carrying the hot gases and smoke from the firebox at the back to the smoke-box at the front. Fixing these pipes in without leaks took the Stephensons right to the limits of current technology, but once they were installed they provided so much surface area to heat the water that the engine proved far more efficient than its rivals. The *Rocket* pulled a load of three times its own weight at 12½ miles per hour and hauled a

72. William Huskisson (1770-1830)
Replica by Richard Rothwell, c.1831
Oil on canvas, 914 x 711mm (36 x 28")
National Portrait Gallery, London (NPG 21)

coach full of passengers at 24 miles per hour. It was the outright winner, and it was used to pull the first passenger train when the line opened on 15 September 1830.

Unfortunately that grand opening was marred by disaster. William Huskisson, Member of Parliament for Liverpool and a great supporter of the railways, managed to fall under one of the locomotives and died the next day. However, for the Stephensons it remained a day of triumph; they had set the standards, and they went on to build several more railways and locomotives. James Nasmyth came up for the opening of the Liverpool to Manchester railway (Maudslay was in Germany on business and gave him the time off). Nasmyth met the Stephensons, inspected the *Rocket*, walked the 30 miles along the tracks to Manchester and

spotted an excellent site for a factory en route at Patricroft (see page 111). The Dale Brothers in Manchester gave him a £500 loan to attract him to Manchester – which he took up when Maudslay died soon after.

When Stephenson retired from the railways in 1845 he settled in Chesterfield, Derbyshire, where at Tapton House he took to horticulture. Not only did he experiment extensively with various kinds of manure, but he also worked out how to grow straight cucumbers. He inserted baby cucumbers into tubes he called 'cucumber glasses', thereby brilliantly anticipating EC Regulation 1677/88 of 1988 on the Common Standards of Quality for Cucumbers: Section II Quality; Subsection B Classification; Extra Class and Class I; maximum height of arc 10mm per 10cm length.

Robert Stephenson 1803–59

obert Stephenson was born at Willington Quay, near Newcastle; his mother died when he was only two-and-a-half years old. As an only child, he grew up close to his father George Stephenson and became his indispensable assistant. He was the better engineer of the two, because he had a reasonable education. He stayed at school until he was sixteen and, after helping his father to survey the route for the Stockton & Darlington Railway in 1821 (see page 152), went for six months to Edinburgh University. There he met George Parker Bidder who despite being exhibited at fairgrounds in his youth as the Calculating Boy, had also received a good education and became a fine engineer. The two remained lifelong friends and frequently worked in partnership.

For a year or so Stephenson ran his father's locomotive factory in Newcastle; then in June 1824 he set off for South America to seek his fortune in the gold and silver mines there. On his way back he met the penniless Trevithick (see pages 107 and 152), who had made and lost fortunes in Columbia, and lent him money for his passage home.

Back in Newcastle, Stephenson supervised the building of the *Rocket* (see page 152) and assisted his father in various projects; then in 1833 he became engineer for the London & Birmingham Line. Thus he was the man who built the first railway into London, which he finished in 1838. He went on to construct railways in various countries, and a series of fine bridges: the high-level bridge over the Tyne at Newcastle, the Victoria Bridge at Berwick, Northumberland, the tubular-plate Britannia Bridge over the Menai Straits from Gwynedd to Anglesey – as well as two bridges across the Nile at Damietta in Egypt and the Victoria Bridge at Montreal in Canada.

Apart from his splendid engineering works, and the fact that he was a Member of Parliament from 1847 until his death, Stephenson is remembered for having argued and won two great engineering battles. One concerned the atmospheric propulsion system for trains (see page 158) and the other the distance between rails – the battle of the gauges. In both cases his opponent was the formidable ● ISAMBARD KINGDOM BRUNEL ●

73. George Parker Bidder (1806–78)
William Brockedon, c.1825
Black chalk and wash, 387 x 286mm (15¹/₄ x 11¹/₄")
National Portrait Gallery, London (NPG 2515(15))

74. Robert Stephenson
John Lucas, n.d.
Oil on canvas, 763 x 601mm
(30 x 23⁵/₈")
National Portrait Gallery,
London (NPG 5792)

Any child of Marc Isambard Brunel and Sophia Kingdom was likely to have an impressive name if not an impressive career. **Isambard Kingdom Brunel** had both. Inspired by the example of his aristocratic French engineer father, he wanted to be the finest and best-known engineer in the world. As a result, his flamboyant schemes were frequently late and hopelessly over-budget. But they were spectacular – and many still are.

During the 1820s Brunel worked with his father on the construction of a tunnel under the River Thames (see page 108), but after serious injury in 1828, he went to recuperate in Bristol. While there in 1831 he heard of a competition to design a bridge that would span the Avon gorge from Clifton to Leigh Woods. Intrigued, he submitted several designs, only to have them

venturers of Bristol. They asked him to help sort out the docks in Bristol – which he did by dredging and improving the locks – and later they invited him to build a couple of great ships there. Most important of all, they asked whether he might be interested in competing for the right to construct the Great Western Railway, from Bristol to London.

Their plan was to ask three or four engineers to survey routes and quote for the work; then they would choose the cheapest. Brunel refused to take part in this Dutch auction. He said that if they wanted him, he would survey the best route – it certainly would not be the cheapest, but it would be the best. Rather surprisingly, they agreed by a narrow margin to offer him the job; it was his first major contract. The undertaking took longer

● Isambard Kingdom Brunel 1806–59

rejected by the chief judge, the Scottish civil engineer, Thomas Telford (1757–1834), who had himself just finished the Menai Strait Suspension Bridge. Telford then put in his own design – a rather ponderous affair with massive pillars on each side of the gorge. Brunel appealed to the other judges and managed to persuade them of the superiority of his concepts, and eventually he was awarded the contract.

This experience opened up all sorts of opportunities for Brunel – not because of the Clifton Suspension Bridge itself, since due to shortage of funds it was not finished until 1864, five years after he died – but because through the project he met and impressed the merchant

than he expected and cost more than twice his estimate, but it was in the end a great success.

Brunel was unlucky that the expansion of the railways started in the mid to late 1820s and in the north of England, when he was working under the river in the south. He would have been perfectly capable of dominating the entire system, but he arrived on the scene just too late. When he started on the Great Western Railway in 1833 he said contemptuously that he would not use the coal-wagon gauge, and he placed his lines 7 foot $\frac{1}{4}$ inch apart, claiming – probably rightly – that the broader gauge would give greater stability and therefore allow trains to travel faster.

He had his own way for ten years, until the

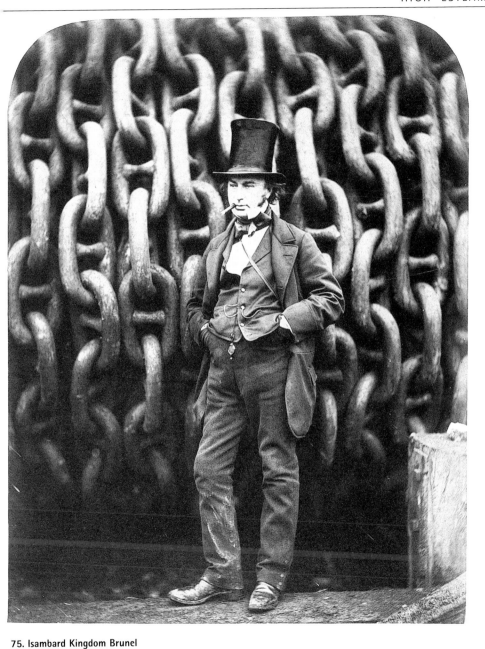

75. Isambard Kingdom Brunel
Robert Howlett, 1857
Albumen print, 286 x 225mm (11¹/₄ x 8⁷/₈")
National Portrait Gallery, London (NPG P112)

76. Thomas Telford (1757–1834)
W. Raddon after Samuel Lane, published 1831
Engraving, 286mm x 206mm (11¼ x 8⅛")
National Portrait Gallery, London (NPG D6933)

clay and had to be lined with 30 million bricks; the western section went through hard Bath stone. Each week a ton of explosives and a ton of candles were used, and in all at least 100 workers were killed.

Many distinguished people claimed that the tunnel would be lethal. If, for example, the brakes failed as a train entered from the east, going downhill, it would emerge from the other end at over 100 miles per hour, and everyone would be killed. The eminent geologist Buckland (see page 118) said that the rumblings of the train would cause an earthquake and bring the tunnel down. Neither of these disasters has happened in 160 years!

However, Brunel really did run into trouble as engineer of the South Devon Railway. He built it spectacularly right along the seafront from Exeter to Newton Abbot – and it is still a superb ride today. However, he chose to drive it with the new atmospheric propulsion system. A 15-inch cast-iron pipe lay between the rails, and a piston in the pipe was connected to the leading carriage by an iron rod. The air was pumped from the pipe in front of the piston, and the atmospheric pressure on the back of the piston pushed the train along.

Passengers loved it, for not only was there no smelly, noisy, dirty locomotive, but the train was smooth and amazingly fast. It routinely cruised at 50 miles per hour and on one occasion ran from Newton Abbot to Exeter in 20 minutes, which is faster than Intercity trains go today.

various lines began to meet, at places like Cheltenham Spa in Gloucestershire. Then, however, there was an obvious problem, since no rolling stock could run on both broad- and narrow-gauge tracks. The battle of the gauges was fought out in parliament, mainly between Brunel and Robert Stephenson, and the narrow gauge won the day. This was, financially and practically speaking, a sensible decision, because by then there were 1,900 miles of narrow-gauge railway and only 274 miles of broad gauge.

Brunel was quite prepared to tackle tremendous engineering challenges, notably the Box tunnel. In order to take the railway through the hills east of the small town of Box in Wiltshire he dug a tunnel a mile long, sloping at a gradient of 1 in 100. This was a colossal undertaking. The east end passed through soft

However, there were serious technical problems. There was no way of bringing two lines together and having points, for one set of rolling stock would have had to jump over the other pipe. Also, the connecting rod between the piston and the carriage came up through a slot in the top of the pipe. This slot was closed with a leather flap which was supposed to maintain a vacuum. Unfortunately, in winter it froze hard and in summer it dried out. So men had to be employed to walk along painting the leather with a mixture of lime soap and whale oil. The oil attracted rats, and the rats ate the leather, and the vacuum was never much good.

The atmospheric system had always been dismissed out of hand by George and Robert Stephenson, and in the South Devon Railway it was finally destroyed by a financial scandal – a piece of creative accounting suggested to the shareholders that the company was losing money. This was unheard-of and unforgivable, and they voted the system out; the last atmospheric trains ran on 10 September 1848.

Brunel nevertheless extended the railway to Penzance, Cornwall, constructing the amazing Tamar Bridge west of Plymouth en route, and designed wonderful stations at Paddington and Bristol Temple Meads. He also built three great ships: the *Great Western*, intended to sail from Bristol to New York and so serve as a continuation of the Great Western Railway; the *Great Britain*, one of the earliest great iron ships and the first major ocean-going vessel to use a screw propeller (now lying in the dock in Bristol where she was built); and the *Great Eastern*, a steamship several times bigger than any that had been built before, and the vessel from which the first cable was laid across

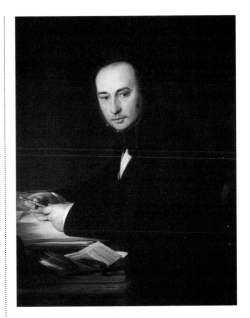

77. Isambard Kingdom Brunel
John Callcott Horsley, 1857
Oil on canvas, 914 x 705mm (36 x 27³/₄")
National Portrait Gallery, London (NPG 979)

the Atlantic. They all suffered mishaps in the building or the sailing or both, for Brunel was far too stretched to be able to concentrate fully on any of his projects. He was almost incapable of delegating, and would sit up all night designing everything – even down to the lamp-posts on Bath railway station.

Yet his ideas were magnificent. A close friend wrote in his diary when Brunel died that he was a 'man with the greatest originality of thought and power of execution, bold in his plans but right. The commercial world thought him extravagant, but although he was so, great things are not done by those who sit and count the cost of every thought and act'. This friend was the engineer ● DANIEL GOOCH ●

78. Sir Daniel Gooch
Barraud, c.1888
Sepia carbon print, 245 x 171mm (9⁵/₈ x 6³/₄")
National Portrait Gallery, London (NPG x5429)

Daniel Gooch 1816–89 ●

Daniel Gooch was a solid, sensible engineer, reliable and meticulous, the very opposite of Isambard Kingdom Brunel. Surprisingly, they got on well together.

Gooch was born in Bedlington, between Newcastle and Morpeth, and was apprenticed to Stephenson and Pease in Newcastle, where he learned how to build steam locomotives. When at the age of twenty-one he heard that Brunel wanted to use broad gauge for the Great Western Railway and would need new engine designs, he applied for the job of Locomotive Superintendent, was successful, and remained in the post for twenty-seven years.

At first Brunel 'helped' with the engine design. However, even he came to recognise that Gooch was better at this task, and once Gooch was given his head he produced some magnificent locomotives – especially the *Iron Duke*, the *North Star* and the *North Britain*. He was also a considerable innovator, inventing a speed indicator and a dynamometer carriage which carried equipment to test rolling friction and air resistance when in motion.

In 1864 Gooch left the Great Western Railway to help set up the first transatlantic telegraphic link, and he duly sent the first telegraphic message across the Atlantic in 1866 – the year he was made a baronet. He remained Chairman of the Telegraph Construction and Maintenance Company, but in 1865 he was called in to rescue the Great Western Railway from financial disaster, which he managed successfully. He must have had a remarkable range of skills to excel both at building locomotives as an engineer and at financial rescue as chairman.

He was involved in the digging of the Severn Tunnel in 1887 and was Member of Parliament for Cricklade, Wiltshire, for twenty years, but he will surely be remembered for his work on the Great Western Railway.

9

The Royal Institution and the Structure of Crystals

Benjamin Thompson, Count von Rumford 1753–1814

Humphry Davy 1778–1829

Michael Faraday 1791–1867

John Tyndall 1820–93

William Bragg 1862–1942

Lawrence Bragg 1890–1971

Dorothy Hodgkin 1910–94

Rosalind Franklin 1920–58

● Benjamin Thompson,
Count von Rumford 1753–1814

ike his fellow American Benjamin Franklin, **Benjamin Thompson** became a diplomat, but unlike Franklin he was neither very lovable nor much loved. Born at Woburn in rural Massachusetts, he almost blew himself up experimenting with gunpowder when he was sixteen. He served as an apprentice to a storekeeper in Salem and then took a job as a teacher in the little town of Concord, previously known as Rumford.

At the age of nineteen Thompson married a rich widow of thirty-eight and, on meeting the Governor of New Hampshire, talked his way into a commission as major in the 15th Regiment of Militia. From a poor, single teacher he had suddenly become a married officer and a landowner. However, within a couple of years the American War of Independence began, and being pro-British Thompson was declared a Rebel of the Streets. Fearing that a mob might attack his home he abandoned his wife and baby daughter, ran away to Boston and became a spy for the British Army.

In 1776 he emigrated to England, took a post in the Office of Foreign Affairs and rapidly wormed his way into high society. He was something of a ladies' man. He had already taken a couple of well-known lovers in Boston, and he found himself some more in London, including Lady Palmerston. Later he added to his list of conquests a pair of sisters in Munich and a princess.

In 1781 Thompson published his first scientific paper in the *Philosophical Transactions* of the Royal Society. It was entitled 'New experiments upon gunpowder', but most of his experiments were not new at all, and the paper was ninety-nine pages long. He would take ten pages to describe an experiment that did not work and another ten to speculate on why it had failed. Then the whole process would start again. His collected works, in four volumes (1870–3), do not make easy or exciting reading. Nevertheless, although his first paper was much criticised, he was on the strength of it elected a Fellow of the Royal Society.

Thompson became first deputy to the Inspector General of Provincial Forces, Under Secretary of State for the Colonies, and he made himself a great deal of money buying cloth in London and selling uniforms to the army in the colonies. He used some of this money to buy himself a commission as Lieutenant-Colonel in the King's American Dragoons. He managed to

79. Sir Benjamin Thompson, Count von Rumford
James Gillray,
12 June 1800
Engraving, 250 x 220mm
(9^7/8 x 8^5/8")
National Portrait Gallery,
London (NPG RN35362)

get himself promoted to Full Colonel, retired on half pay, decided to become a diplomat in Munich and persuaded George III he would be able to do a better job with a knighthood; so the king created him Sir Benjamin Thompson.

In Munich he continued to pursue his scientific investigations. He worked out that a man might carry in his pockets a thread long enough to reach round the world, and he wrote long rambling scientific papers on why he burned his mouth when he ate apple pie and on how to make a perfect cup of coffee.

On the work front, Thompson was app-

ointed colonel and aide-de-camp to Carl Theodore, Elector of Bavaria, and made himself extremely popular by initiating sweeping social and military reforms. Having discovered that the Bavarian army was a dreadful rabble of poor men who were expected to pay for their own clothes and food, he made sure they started to receive proper pay and treatment. He investigated various fabrics to find out which would give the best performance for military uniforms, and then on 1 January 1790 had all the beggars rounded up from the streets and put into factories, where he paid them (partly

out of his own pocket) to make the uniforms. In order to feed both the beggars and the soldiers, Thompson investigated various forms of food, arranged for the soldiers to grow their own vegetables and designed efficient new cooking stoves, saucepans, coffee pots and other equipment. In 1796 he wrote an essay *Of Food: and Particularly of Feeding the Poor* which included some information on the science of nutrition and much practical advice.

The results were so impressive that in 1791 the elector made him not only Chief of the General Staff but also a Count of the Holy Roman Empire. Thompson chose the title Count von Rumford, taking the old name of the place where he had first got a job.

In 1797 he did his most famous and significant piece of research, into the nature of heat. 'Whilst superintending the boring of cannons in the workshops of the military arsenal in Munich', he wrote, 'I was struck with the very considerable degree of heat which a brass gun acquired in a short time in being bored'. Lavoisier (see page 54) had said that heat was a fluid, *calorique*. If you bored a cannon, heat would leak out through the holes you were making in the metal.

But Count von Rumford (as he was now known), using a boring machine closely similar to the one invented by John Wilkinson in 1775, discovered that the blunter the borer, the more heat was produced. With a totally blunt borer he removed no metal at all – so no *calorique* could escape – yet he generated a great deal of heat. In fact, he was able to boil a couple of gallons of water during the experiment. Rumford deduced that heat must be some form of motion within the iron. This was a vital step in the theory of heat.

In the following year Rumford moved back to London, and in 1799 he decided to found an institution to teach 'the Application of science to the Common Purposes of life'. He gained approval from many prominent people, including the President of the Royal Society Sir Joseph Banks (see page 142), and managed not only to found the Royal Institution of Great Britain but also to arrange for the construction of a beautiful building for it, complete with a superb lecture theatre, in Albermarle Street in London's West End. It was chartered in 1800 by George III, but within a year Rumford had almost ruined it by his autocratic dictatorship. Fortunately he relinquished his grip and moved on once again, this time to Paris. There he married Lavoisier's widow (poor Antoine had been guillotined during the French Revolution and Rumford's wife had died in 1792).

Rumford and his new wife had terrible rows. They had a house in the middle of a big square garden with a high wall round it, and on one occasion, when he discovered that Madame had invited a lot of friends to dinner, Rumford went down, locked the gate, and took away the key; so when her guests arrived she had to chat to them by shouting over the high wall. She retaliated – by pouring boiling water on his favourite flowers. When he was buried, on 24 August 1814, few people went to the funeral. Before he left for Paris, however, he performed what was perhaps the most useful thing he did in his whole life: he recruited a young chemist called ● **HUMPHRY DAVY** ● as Assistant Lecturer in Chemistry, Director of the Chemical Laboratory, and Assistant Editor of the Journals of the Royal Institution.

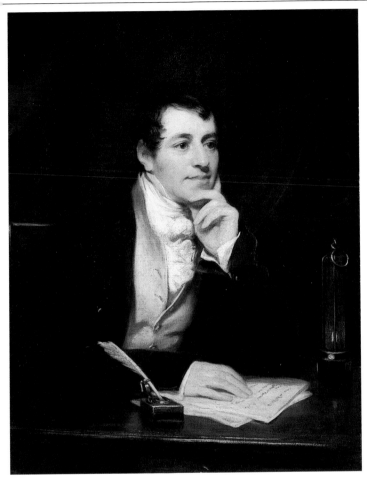

80. Sir Humphry Davy
Thomas Phillips, 1821
Oil on canvas, 914 x 711mm
(36 x 28")
National Portrait Gallery,
London (NPG 2546)

A t school in Penzance, Cornwall, the precocious **Humphry Davy** loved to stand on a market cart and regale his friends with tales from his history books. When the history ran out he made the stories up, and later he claimed that that was when he dis-covered how to use his imagin-ation. He was fortunate enough to learn some chemistry from Gregory Watt, sent to Cornwall for his health by his father James Watt. And so he was prepared when Dr Thomas Beddoes, founder of the new Pneumatic

Humphry Davy 1778–1829 ●

Institution in Bristol, came to Cornwall on a geology field trip. He was looking for an energetic young man with some interest in science to join his staff, and he had heard of Davy from his friends at the Lunar Society (see pages 34–61).

Hotwells Spa in Bristol had been a fash-ionable place to take the waters ever since Catherine of Braganza had gone there in 1677;

by the late 1700s it was one of the most crowded watering places in the kingdom. Many of the visitors lodged in Dowry Square, and this was where the nineteen-year-old Davy found himself working as Medical Superintendent at the Pneumatic Institution. It was funded by private subscription – £1,000 from Josiah Wedgwood, for example – and its aim was to find out whether the gases that had recently been discovered by Joseph Priestley and others (see page 54) had any medicinal value. It could handle eight inpatients and up to eighty outpatients, many of whom suffered from tuberculosis. The apparatus for handling the gases was made by James Watt.

Beddoes believed that tuberculosis might respond to the gases produced by cows. He understandably did not actually take the cows into the ward, but he kept a small herd in the garden next door and piped the gases into the bedchambers – both what the cows breathed out and what came from the other end. Patients must have felt quite an incentive to say they felt better and discharge themselves!

Davy produced various gases and tried them all out on himself. He almost died inhaling carbon monoxide, but he had a wonderful time when he discovered nitrous oxide, which came to be called laughing gas. Breathing laughing gas feels like being fairly drunk – say, having two large glasses of wine in a hurry. Colours seem to get brighter, or the contrast increases. As long as people have oxygen as well, they can take nitrous oxide for hours, staying awake and lucid. If the concentration is high enough, they may laugh uncontrollably at any joke. Yet the effect disappears two minutes after they stop inhaling,

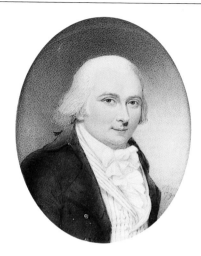

81. Thomas Beddoes (1760–1808)
Sampson Towgood Roche, 1794
Watercolour on ivory, 60 x 48mm (2³/₈ x 1⁷/₈")
National Portrait Gallery, London (NPG 5070)

even to the extent of being able to drive safely.

Davy used to wander around Bristol breathing nitrous oxide from a green silk bag. He tried it out on all his literary friends, who are said to have danced in the streets. Samuel Taylor Coleridge, one of the leaders of the Romantic movement, said it made him feel as warm as when he came home to a fire after a walk in the snow. The poet Robert Southey wrote to his brother, 'O Tom! Such gas has Davy discovered ... it made me laugh and tingle in every toe and fingertip. Davy has actually invented a new pleasure for which language has no name!'

Nitrous oxide has become one of the most useful of all gases in medicine; indeed, the Department of Anaesthesia at the Bristol Royal Infirmary is named after Davy. When mixed with oxygen it is called 'gas and air' and is used as a painkiller in childbirth, by paramedics in ambulances and by dentists. Davy suggested that it might be useful as an anaesthetic, but he

was utterly ignored, and the first anaesthetics, ether and chloroform, were not tried until forty years later.

In 1799, while Davy was working in Bristol, he heard about the new electric battery that had been invented by Volta in Italy (see page 12). He and Beddoes built a large battery in Dowry Square. Volta had said that he produced electricity simply by holding two different metals together. Davy disagreed: you never got something for nothing; there must have been a chemical reaction going on.

What is more, Davy argued that if chemistry could produce electricity then, conversely, electricity should be able to produce chemistry. Thus he conceived the idea of electrochemistry, and this was probably what caused Count von Rumford to invite him to go to London in 1801.

At the Royal Institution Davy was an immediate success. He was a brilliant speaker, and the magnificent lecture theatre was routinely packed. In those days, without television or cinema, the smart places to go to for entertainment were either the West End to see Shakespeare, or the Royal Institution to hear Davy lecture on electrochemistry! Albermarle Street was apparently made the first one-way street in London to cut down the traffic jams caused by carriages bringing people to his lectures. Ladies were delighted by his flashing eyes and curly hair, and he spoke with such passion that everyone became excited by his ideas.

His passion spilled over into his research, too. On 19 October 1807, while carrying out an experiment to try to isolate sodium, he literally jumped for joy when, for the first time,

he saw silvery drops of pure metal. According to his assistant, he danced around the room, and it was some time before he could regain his composure sufficiently to carry on with the experiment.

On 8 April 1812 he was knighted; three days later he married a rich widow, Mrs Apreece, and in that same year he and his wife went on a scientific tour of Europe. When he called on the inventor of the battery, Volta appeared in full evening dress, and was so shocked to see Davy in scruffy travelling clothes that for several minutes he was unable to speak!

In 1815 the miners of Newcastle wrote asking for his help in averting the danger of explosions in the mines from the dreaded gas firedamp (methane), which ignited when it came into contact with the candles they carried on their helmets (see page 150). He researched the problem and devised a safety lamp for miners – at almost the same time as railway engineer George Stephenson.

In 1820 Davy succeeded Joseph Banks as President of the Royal Society. He became quite rich, and famous throughout Europe. His finest work was arguably the isolation of the metals potassium and sodium:

Sir Humphry Davy
Abominated gravy.
He lived in the odium
Of having discovered sodium.
(E.C. Bentley, *Biography for Beginners*)

Yet when asked in later life what his most important scientific discovery had been, he replied ● MICHAEL FARADAY ●

Newington Butts is the improbable name of one of the streets that radiates from the Elephant and Castle in Lambeth, London. There it was that **Michael Faraday** was born, one of ten children of a Yorkshire blacksmith. Apparently he never went to school at all. When he was thirteen he started work as an errand-boy to a bookbinder in Blandford Street in London's West End, and worked there as an apprentice for eight years. Unlike the other apprentices he actually read some of the books, and was apparently fascinated by *Encyclopaedia Britannica* and by Jane Marcet's *Conversations on Chemistry*.

In 1812 a satisfied customer gave him tickets for four lectures by the great Humphry Davy at the Royal Institution. Faraday went along, sat in the seat above the clock and was utterly overwhelmed by the excitement of scientific ideas. He wrote detailed notes of the lectures, including diagrams, bound them and sent them to Davy, asking for a job. On Christmas Eve a carriage rolled up outside Faraday's home, unfortunately catching him in his pyjamas. He was given a note inviting him to the Royal Institution, and when he arrived, Davy offered him a job as his assistant in the chemistry laboratory at 25 shillings a week. Faraday was to work there for most of his life.

In 1812 he went with Davy and his wife on an extended scientific tour around Europe. Considering that the Napoleonic Wars were still

Michael Faraday 1791–1867 ●

rumbling, this sounds extremely dangerous. However, Napoleon was greatly interested in science and gave the party special passports. The trip was uncomfortable for Faraday for an entirely different reason: Lady Davy treated him as a servant and made his life as miserable as she could.

Faraday learnt all his science from books and from Davy and other colleagues. Although his knowledge of mathematics was poor, he was to become one of the great research scientists of all time. In 1820 the Danish scientist Hans Christian Oersted (1777–1851) discovered that passing an electric current along a wire generates a magnetic field around it in the shape of a cylinder, almost like a sleeve around an arm. Faraday heard Davy and Wollaston discussing this and wondered whether he could combine the cylindrical magnetic field with a field from a normal bar magnet to create motion. On 4 September 1821 Faraday tried it out and created the world's first electric motor. He passed a current through a circuit that included a loosely suspended wire whose bottom end dipped into a pool of mercury to complete the circuit. When he stood a bar magnet on end below the point of suspension, the wire revolved around the magnet like a maypole dancer. This was only a toy – William Sturgeon (1783–1850) made the first useful motor some years later – but Faraday led the way.

Sadly, Faraday's swift and intuitive action led to an unpleasant dispute with Davy and Wollaston, for Wollaston claimed that Faraday

82. Michael Faraday
Thomas Phillips, 1841–42
Oil on canvas, 908 x 711mm (35³/4 x 28")
National Portrait Gallery, London (NPG 269)

had stolen his idea. Priority was important. However, Wollaston progressed no further in the field of electromagnetism, while Faraday went on to make many more discoveries, including the induction coil, electromagnetic induction which led to the dynamo, and the fundamentals of electrolysis.

In 1824 Faraday was elected to the Royal Society, whose Royal and Rumford medals he was to receive but whose presidency he later chose to decline. The following year he was appointed Director of the Laboratory of the Royal Institution, and in 1833 he became the Professor of Chemistry. Faraday proceeded to produce a string of brilliant experiments. But he was not solely an experimenter; he also wanted to explain scientific concepts to the public at large. He delivered dozens of sparkling lectures, and started up the Friday evening discourses and the Christmas lectures at the Royal Institution.

On 31 March 1848, in a little wooden house in New York State, the modern spiritualist movement was born when two girls, Kate and Margaret Fox, claimed they were in touch with the spirits of dead people. A fashionable craze spread rapidly to Britain, and soon seances of many kinds were all the rage in London. One of the most popular events was 'table-tipping'. A group of people would sit in a darkened room around a table with their hands on it, pressing downwards. After a time the table would begin to move – of its own accord, they claimed; it would slide, tip, sway and sometimes seem to dance around the room. The sitters believed that it was being moved by spirits.

Faraday was sceptical and devised two simple scientific experiments to find out what was really happening. He wrote about them in *The Times* on 30 June 1853 and in a long scientific paper on 2 July. In the first he placed under the sitters' hands sandwiches of cardboard and special glue, so that if they were to push, the top layer of cardboard would slide and then stick, demonstrating that the table had been pushed, but not by the spirits. In the second he arranged for each sitter a sensitive pointer that would indicate to all present if force were applied to the table. Thereafter the table did not move. To the astonishment of the sitters, he managed to show that they were pushing the table themselves, although they were convinced they had not been doing so.

In 1855 Faraday delivered a set of Christmas lectures on the chemical history of a candle, with beautiful demonstrations, such as how a snuffed candle can be relighted an inch above the wick, and how two flames can be coaxed from one candle.

Rather less attractive was Faraday's description of a trip on the River Thames, stinking with sewage. On 7 July 1855 he wrote to *The Times*, 'The whole of the river was an opaque, pale brown fluid. I tore up some white card into pieces, moistened them so as to allow them to sink easily below the surface and then dropped some of these pieces into the water at every pier the boat came to; before they had sunk an inch below the surface they were indistinguishable, though the sun shone brightly at the time, and when the pieces fell edgeways the lower part was hidden from sight before the upper was under water...' Three years later the Great Stink was debated in parliament, three million pounds was given to the Metropolitan Board of Works, and in the 1860s sewers were built. There

83. Michael Faraday
Walker & Sons, 1860s
Sepia albumen carte-de-visite,
89 x 57mm (3¹/₂ x 2¹/₄")
National Portrait Gallery,
London (NPG x11953)

followed riches and fame for sanitary engineers, including Thomas Crapper (see page 92).

Faraday's genius was not just to be a great scientist but to be able to see science in the table-tipping of the seance room, in the household candle and even in the foul and fetid water of the river – and to explain that science in simple terms, by means of elegant demonstrations. His successor as Superintendent at the Royal Institution was a physicist who was similarly brilliant both as an experimenter and as a demonstrator ● **JOHN TYNDALL** ●

John Tyndall was a keen mountaineer who studied everything from magnetic crystals to fog horns and worked out why the sky is blue. He was born at Leighlinbridge, just south of Carlow in Ireland. His father owned some land and was keen to ensure that Tyndall had a good education. His first job was as a draughtsman with the Ordnance Survey, and he studied hard enough in his spare time to be able to move on to teach mathematics and surveying at Queenswood College in Hampshire, England.

At the age of twenty-eight Tyndall went to Germany to do a doctorate at Marburg University with Professor Robert Wilhelm Bunsen (1811–99), who is known as the

John Tyndall 1820–93

inventor of the Bunsen burner. In 1854 Tyndall was invited to give a lecture at the Royal Institution. His title may sound tedious – 'On the Influence of Material Aggregation upon the Manifestations of Force' – but his performance was so outstanding that Michael Faraday quickly appointed him Professor of Natural Philosophy at the Institution.

One of the phenomena Tyndall wanted to demonstrate in 1854 was total internal reflection of light; to do so he invented the light pipe. A simple form of this is a bottle with a hole in the side near the bottom. A beam of light from the other side of the bottle shines through the hole and out across the room in a straight line. However, fill the bottle with water so that it runs out of the hole, and the light no longer travels in a straight line but is trapped inside the

stream of water. It stays inside until the stream breaks into droplets. The same phenomenon keeps light trapped inside fibre optics, which is how most phone calls and e-mails are carried today.

Some years later, Tyndall pondered why the sky is blue during the day rather than black as it is at night. Clearly it is pale because it is lit by sunlight; he concluded that we see the light because it is scattered by particles of dust in the atmosphere. Because the particles are very small they scatter blue light more than red light, and so wherever we look in the sky we see blue light, scattered by the dust. What is more, the sun looks yellow, because sunlight starts white, but some of the blue light is scattered away, leaving yellowish light to reach us. Late in the afternoon, when the sun is low and the sunlight has to come through a lot of extra atmosphere to reach us, more blue light is scattered away, and the sun appears orange or even red as it sets.

Tyndall showed that if he carefully filtered all the dust out of a sample of air he could no longer see a beam of light passing through it. He then demonstrated that this 'optically' pure air contained no bacteria. He prepared various concoctions of fish and meat and kept them in jars; those in filtered air did not go bad. Indeed, there are still some of his samples of food in jars on display in the Royal Institution – but I should not be enthusiastic about eating any of them!

In Wales he studied the structure of slate and how it cleaves, and was encouraged by a friend to extend this interest to glaciers and why they crack. So he went to the Alps and became an enthusiastic mountaineer, sometimes studying the glaciers with his friend Thomas

84. John Tyndall
John McLure Hamilton, 1893
Oil on canvas, 457 x 610mm (18 x 24")
National Portrait Gallery, London (NPG 1287)

Henry Huxley (see page 129). He was one of the first people to climb the Matterhorn in Switzerland in 1860, and apparently the first to climb the Weisshorn in 1861. Being a scientist, he calculated that the amount of energy he would need to climb the Matterhorn was exactly the same number of calories as there are in a ham sandwich, which was therefore all he took to eat!

Tyndall became a chronic insomniac, and could sleep only after taking chloral hydrate. He died tragically after his wife accidentally gave him an undiluted dose.

Like Michael Faraday before him, Tyndall excelled in both research and demonstration at the Royal Institution, which also proved to be a superb environment for ● **WILLIAM** and **LAWRENCE BRAGG** ●

William Henry Bragg and Lawrence Bragg (1890–1971) formed a unique father-and-son team; they created the new science of X-ray crystallography, in 1915 they shared the Nobel Prize in Physics, and they both became Fullerian Professors at the Royal Institution.

William Bragg was born at Westward, near Wigton in Cumberland. His father was a naval officer turned farmer, and his mother died when he was just seven. He studied mathematics at Cambridge University, then in 1886

● William Bragg 1862–1942

moved to Australia to become Professor of Mathematics and Physics in Adelaide.

He stayed in Adelaide for more than twenty years, where he spent most of his time on teaching and administration. The first sign he showed of any interest in research was in 1896, when he heard about the discovery of X-rays by Wilhelm Conrad Roentgen (1845–1923). Bragg then set up what was probably the first X-ray tube in Australia. He returned to England in 1909 to take up the post of Cavendish Professor of Physics at Leeds University, and at this point launched into an intense programme of research.

First, intrigued by radioactivity, he studied the paths of alpha-particles – positively charged nuclear particles consisting of two protons bound to two neutrons. Then in 1912 the German physicist Max Theodor Felix Von Laue (1879–1960) showed that X-rays behaved like waves and were somewhat diffracted by atoms when they passed through crystals. Inspired,

Bragg and his son Lawrence immediately leapt into X-ray research. They improved on von Laue's system by reflecting X-rays off the face of a crystal at a low angle. From the patterns they observed they were able to work out the arrangement of atoms in crystals of diamond and rock salt (sodium chloride).

Both of these materials form huge crystals with the atoms in three-dimensional arrays, rather like tennis balls carefully stacked in a great box. This was the first time that anyone had discovered crystal structures; it was a true breakthrough and opened up an entire new field of science. Quite justly it earned the Braggs their Nobel Prize only three years after they had turned their minds to the subject, and indeed only about ten years after William had started research.

During World War I William Bragg worked successfully on underwater acoustics and the detection of submarines. Afterwards he returned to X-ray diffraction and began to tackle the structures of organic molecules, which presented great difficulties because they contained several different kinds of atom. From 1915 to 1923 he held the chair of physics at University College, London, and in 1923 he was appointed Fullerian Professor at the Royal Institution. Bragg was a fine lecturer, and his Christmas lectures were highly popular. He was knighted in 1920 and in 1935 he became President of the Royal Society.

85. Sir William Henry Bragg
Walter Stoneman, 1920
Modern print from an original whole-plate glass negative,
203 x 152mm (8 x 6")
National Portrait Gallery, London (NPG x25107)

William Lawrence Bragg spent the first nineteen years of his life in Adelaide, Australia. While at Adelaide University, studying mathematics and physics, he had a desk in his father's office, and so he was involved from the beginning with his father's research. By the time the family moved to England in 1909, Bragg had already graduated. He enrolled at Cambridge University, but he seems hardly to have allowed his studies to interfere with research, for by 1912 he was working with his father on diffraction. When they were awarded the Nobel Prize, Lawrence was only twenty-five – the youngest-ever Nobel Prize winner.

Lawrence Bragg 1890-1971 ●

During World War I, he served in the army, investigating sound ranging – trying to locate enemy guns from the noise they made when fired. He won the Military Cross, was promoted to Major and was three times mentioned in dispatches.

In 1919 Bragg became Professor of Physics in Manchester and set up an X-ray research school in competition with his father in London. However, Lawrence concentrated on the structures of metals and minerals and the theoretical aspects of X-ray diffraction. In 1938 he became Cavendish Professor of Physics at Cambridge, he received a knighthood in 1941 and in 1954 he followed in his father's footsteps as Fullerian Professor at the Royal Institution. There he built a research team

86. Sir Lawrence Bragg
Elliot & Fry, 1946
Modern print from an original quarter-plate glass negative,
203 x 152mm (8 x 6")
National Portrait Gallery, London (NPG x21164)

which went on to tackle the crystal structures of the protein myoglobin and the enzyme lysozyme; the latter had been discovered by Alexander Fleming in 1922.

Between them, the Braggs laid the foundations for the study of natural materials through the arrangement of the atoms in their crystals. This was enormously important, for several reasons. First, these crystal structures provided tangible proof that the theoretical models with which scientists had been working for a hundred years were true – that the formula of water was H_2O, for example, and that of salt NaCl. Second, they showed details of the ways the atoms were joined together – the angle between the two O–H bonds in the water molecule, and the arrangement of the sodium and chlorine atoms in the salt.

Knowing these details has irreversibly changed the face of chemistry, uncovering how catalysts help reactions to happen and how complicated biological systems work. And the technique of X-ray crystallography will continue to be a vital tool in unravelling those systems for many years to come. One of the more dramatic structures that would not have been understood without X-ray diffraction was that of deoxyribonucleic acid or DNA. The key figures in this field were **Rosalind Franklin** (1920–58), Maurice Wilkins (b.1916), James Watson (b.1928) and Francis Crick (b.1916; see page 184). The Braggs' idea was also to lead to analyses of huge molecular structures by another brilliant researcher ● **DOROTHY HODGKIN** ●

Dorothy Crowfoot Hodgkin was the first person to look inside a protein. She discovered the chemical structure and the exact positions of all the atoms in the molecules of penicillin and vitamin B12. She was born in Cairo, but when she was four her mother sent her to England. After this she rarely lived with her parents, and she attributed her tenacity and independence to this unusual childhood. She soon became interested in chemistry; when she was ten she set up her own laboratory in the attic of her home!

In 1928 Hodgkin went to Somerville College, Oxford – one of the few women's colleges – at a time when the presence of women in classes was seen as 'demoralising' for male students. She started studying archaeology and chemistry but dropped the archaeology when she heard about the Braggs' fascinating crystallography. At the time Sir William Bragg was just beginning to use the technique to study simple organic molecules; Hodgkin was drawn to the idea of looking at the internal structure of a complicated molecule.

During the final year of her degree, she entered the world of crystallography, and then in 1942 she started work on the structure of penicillin. The antibiotic value of penicillin had been discovered in 1928 by Alexander Fleming (see page 98), and the material was in great demand. Only minute amounts were available naturally, and the press-

88. Dorothy Crowfoot Hodgkin
Maggi Hambling, 1985
Oil on canvas, 932 x 760mm (36³/4 x 30")
National Portrait Gallery, London (NPG 5797)

Dorothy Hodgkin 1910–94 ●

ure was on for chemists to make the drug in large quantities. However, before they could begin they needed to know exactly how all the atoms in each molecule were linked. X-ray crystallography was the only technique for finding this out.

The X-ray diffraction pattern Hodgkin obtained from crystals of penicillin was the most complicated anyone had tried to analyse. She and her colleagues spent two years on the intricate mathematics before they had an answer. Unfortunately they had to delay publication until the war was over, but when

87. Dorothy Crowfoot Hodgkin
Walter Stoneman, 29 June 1947
Modern print from an original half-plate glass negative,
203 x 152mm (8 x 6")
National Portrait Gallery, London (NPG x26008)

181

she finally did go into print, the results enabled other scientists to work out how penicillin functioned. Not only could they start making it synthetically, but they were also equipped to design new antibiotics with similar structures.

Hodgkin did not stop there. From her laboratory in what is now the Oxford Natural History Museum, she turned her efforts towards the important compound vitamin B12, an enormous molecule – it contains nearly 1,000 atoms, compared with the twenty-three atoms in penicillin! Mastering the structure of vitamin B12 took her eight years. However, her crowning achievement was discovering the structure of insulin, which turned out to be more complex still. Hodgkin had begun work on it in 1933; it took her thirty-four years to solve the puzzle.

Hodgkin turned the technique of X-ray crystallography into one of the most useful tools in chemistry. In 1960 she became a research professor of the Royal Society and four years later she was the first British woman to win a Nobel Prize in any subject. She was an inspiration to people such as the Somerville student Margaret Roberts (later Thatcher), and later no doubt inspired ● ROSALIND FRANKLIN ●

89. Rosalind Franklin
Inside 'Cabane des Evettes', French Alps
Vittorio Luzzati, early 1950s
Glossy bromide print (R.C.), 229 x 302mm (9 x 11⁷/₈")
National Portrait Gallery, London (NPG x76912)

osalind Elsie Franklin was born in London into a thoroughly modern-thinking and wealthy family. Her father devoted his life to working with the poor, and her uncle spent six weeks in prison for taking a dog whip to Winston Churchill, who was at the time an opponent of women's rights. Franklin carried on the family habit of questioning the status quo: as a child she read the Bible, apparently to see whether she could find a reason to believe in God, and afterwards she commented, 'How do you know He isn't a She?'

Franklin studied at Newnham College, Cambridge, from 1938 to 1941, then earning a Ph.D. in Physical Chemistry from the university, while employed at the British Coal Utilization Research Association. In 1947 she went to work in Paris, where she became skilled in the technique of X-ray diffraction as well as having a great time socially; she loved to drink in Bohemian cafés, for example, with former

Rosalind Franklin 1920–58 ●

183

members of the French resistance. She was 'strikingly good looking' with 'brilliant eyes that could sparkle with amusement or flash with rage'.

In 1951 Franklin returned to London to work with a team of scientists at King's College. She was given space in a basement laboratory and invited to use her X-ray skills to investigate the structure of DNA.

DNA is the instruction book for every living thing on the planet; it exists in each cell not only of the human body, but of all creatures and plants. It tells the body how to grow, from a single cell at conception to a full-sized adult;

90. James Watson (b.1928) and Francis Crick (b.1916)
At the Cavendish Laboratory, Cambridge
Antony Barrington Brown, 21 May 1963
Modern bromide print from an original negative,
247 x 299mm (9³/₄ x 11³/₄")
National Portrait Gallery, London (NPG x45733)

it tells the stomach and gut cells how to digest food; and it tells muscle cells how to operate. It also transmits genetic characteristics from one generation to the next. In 1951 no one knew this, although they suspected that it was important; the first stage of investigation would be to work out its structure.

Chemically, DNA is made of phosphates, sugars, and bases. The phosphates and sugars together form the backbone – like the stem of a runner bean – while the bases are the 'hairy bits' – like the actual beans. There are only four of these bases – adenine, guanine, thymine, and cytosine, or A, G, T, and C for short – but the order in which they are fixed along the backbone comprises the genetic code. For example, I might have somewhere in my DNA a fragment with bases in the order GCCTGAGAC, and this might be the beginning of a section that would define a big nose, or dark hair.

Franklin knew that DNA formed long molecules and reckoned that, if she stretched it out into a thread, all the molecules would be lined up regularly like spaghetti in a packet. When she fired a beam of X-rays at her threads of DNA, she expected the beam to be scattered in a way that would be characteristic of the arrangement of atoms in the molecule. Her hunch was correct: an X-shaped pattern was produced, suggesting that the atoms were arranged in a helix, like a corkscrew.

By 1953 Franklin's analysis was progressing well. She had proved that DNA was not a single helix, but double. She also knew that the 'hairy bits' – the bases – of the two strands were pushed together on the inside, and that the phosphate 'backbones' of the structure spiralled up the outside. She worked out the width, pitch and repeat length of the helix. Just two parts of the puzzle remained to be solved – the direction of the helices and the inside connections between the bases.

On 18 March, the day after Franklin had written up her results to date, she heard that Watson and Crick had guessed a structure for DNA and built a model of it at their laboratory in Cambridge. She was surprised, as there had been a 'gentleman's agreement' between the two research teams: Cambridge would investigate protein structure; King's would work on DNA. But in January 1953 Watson and Crick had managed to get sneak previews of Franklin's work without asking her – it was passed to them by her colleague, Wilkins. After receiving her data they deduced the final elements in the structure of DNA. They then dashed off a paper to the science journal *Nature*, describing the complete structure. The only credit they gave to the London team was a phrase acknowledging that they were 'stimulated by a knowledge of the general nature' of the work of Franklin and Wilkins.

Would Franklin have disentangled the structure of DNA on her own? Probably all she needed was a little more time. But she did not have much more time. Sadly, she was desperately unhappy at King's, missing Paris. Rather than return to France, though, she moved to London's Birkbeck College. There she spent five years doing ground-breaking work on another helical molecule, the tobacco mosaic virus, and on the live polio virus. Tragically, when she was only thirty-seven, she died of cancer.

Watson, Crick and Wilkins were awarded a 1962 Nobel Prize for their work on DNA. However, Nobel Prizes are not given posthumously, so Franklin didn't get one. She was a brilliant and deeply committed scientist who came within a molecule's breadth of the scientific discovery of the century.

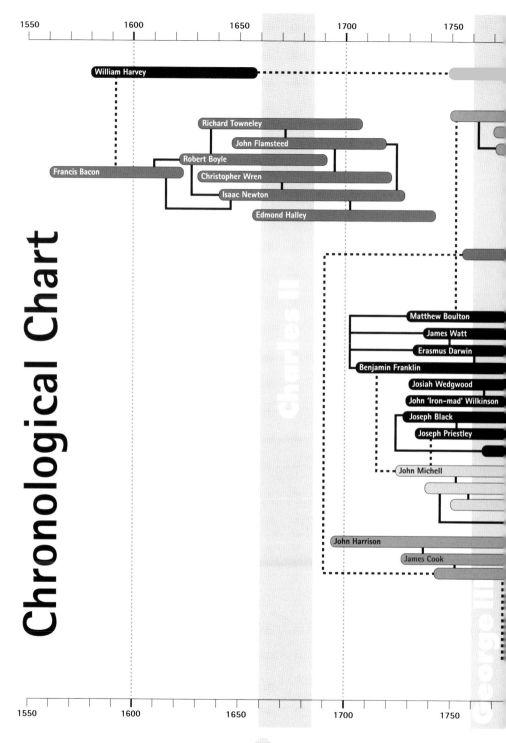

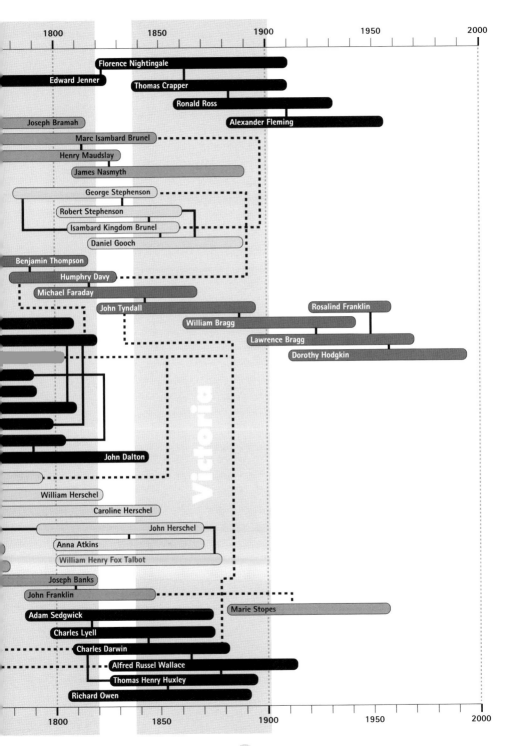

Houses, Museums and List of Sites to Visit

Many museums have interesting artefacts related to the characters in this book. This list is not meant to be exhaustive but the following places might be of interest:

Francis Bacon
Blue Plaque: 7 Cromwell Place, London SW7

Robert Boyle
Whipple Museum of the History of Science, Free School Lane, Cambridge CB2 3RH

Richard Towneley
Towneley Hall Art Gallery and Museums, Burnley, Lancashire BB11 3RQ – *where rainfall was first measured*

Christopher Wren
Blue Plaque: 49 Bankside, Cardinal's Wharf, London SE1

Isaac Newton
Grantham Museum, St Peters Hill, Grantham, Lincolnshire NG31 6PY

Woolsthorpe Manor, near Grantham, Lincolnshire – *the home of Isaac Newton*

Blue Plaque: 87 Jermyn Street, London SW1

James Watt
Avery Historical Museum, Foundry Lane, Smethwick, Warley, West Midlands B66 2LP

Mclean Museum and Art Gallery, 15 Kelly Street, Greenock, Inverclyde PA16 8JX

Matthew Boulton
Soho House, Soho Avenue, Birmingham B18 5LB – *the home of Matthew Boulton and the meeting place of the Lunar Society*

Avery Historical Museum (see James Watt)

Erasmus Darwin
Darwin House, Lichfield – *the home of Erasmus Darwin*

Josiah Wedgwood
Wedgwood Museum, Barlaston, Stoke-on-Trent, Staffordshire ST12 9ES

John 'Iron-mad' Wilkinson
Ironbridge Gorge Museum Trust, Ironbridge, Telford, Shropshire TF8 7AW

Joseph Priestley
Bowood House, Bowood Estate, Calne, Wiltshire SN11 0LZ – *where Priestley stayed*

Blue Plaques: 113 Lower Clapton Road, London E5; Fieldhead Farm, Birstall, West Yorkshire

Benjamin Franklin
Plaque: 36 Craven Street, London WC2

William Herschel
Herschel House and Museum, 19 New King Street, Bath, Somerset BA1 2BL

William Henry Fox Talbot
The Fox Talbot Museum, Lacock Abbey, Chippenham, Wiltshire SN15 2LG (The National Trust) – *the home of William Henry Fox Talbot*

National Museum of Photography, Film and Television, Bradford, West Yorkshire BD1 1NQ

Edward Jenner
Jenner Museum, The Chantry, Berkeley, Gloucestershire GL13 9BH

Wellcome Institute for the History of Medicine, 183 Euston Road, London NW1 2BE

Florence Nightingale
Florence Nightingale Museum, Gassiot House, 2 Lambeth Palace Road, London SE1 7EW

Thomas Crapper
Blue Plaque: 12 Thornsett Road, London SE20

Alexander Fleming
Alexander Fleming Laboratory Museum, St Mary's Hospital, Praed Street, London W2 1NY

Joseph Bramah
Gladstone Pottery Museum, Uttoxeter Road, Longton, Stoke-on-Trent ST3 1PQ – *exhibits a Bramah water-closet*

Henry Maudslay
Bethlem Royal Hospital Archives and Museum, The Bethlem Royal Hospital, Monks Orchard Road, Beckenham, Kent BR3 3BX

Blue Plaque: Lambeth North Underground Station, London

Marc Isambard Brunel
Brunel's Engine House, Tunnel Road, Rotherhithe, London SE16 4LF

Blue Plaque: 98 Cheyne Walk, London SW10

Charles Lyell
Cockburn Museum, Department of Geology & Geophysics, University of Edinburgh, King's Buildings, West Main Road, Edinburgh EH9 3JF

Blue Plaque: 73 Harley Street, London, W1

Charles Darwin
Down House, Luxted Road, Downe, Kent BR6 7JT – *the home of Charles Darwin*

Royal Botanic Gardens, Kew, Richmond, Surrey TW9 3AB

Alfred Russel Wallace
Blue Plaque: 44 St Peter's Road, Croydon

Thomas Henry Huxley
Blue Plaque: 38 Marlborough Place, London NW8

Richard Owen
Natural History Museum, Cromwell Road, London SW7 5BD

John Harrison
Nostell Priory, Doncaster Road, West Yorkshire WF4 1QE (The National Trust)

Blue Plaque: Summit House, Red Lion Square, London WC1

James Cook
National Maritime Museum, Romney Road, Greenwich, London SE10 9NF

Whitby Museum, Pannett Park, Whitby, North Yorkshire YO21 1RE

Pitt Rivers Museum, South Parks Road, Oxford OX1 3PP

Captain Cook Memorial Museum, John Walker's House, Grape Lane, Whitby, North Yorkshire YO22 4BE – *where Cook stayed as a young man*

Captain Cook School-room Museum, 101 High Street, Great Ayton, North Yorkshire TS9 6NH

Joseph Banks
Joseph Banks Conservatory, The Lawn, Union Road, Lincoln, Lincolnshire LN1 3BL

Blue Plaque: 32 Soho Square, London W1

Marie Stopes
Hampstead Museum, Burgh House, New End Square, London NW3 1LT

Blue Plaques: 14 Well Walk, Hampstead, NW3; 61 Marlborough Road, London N19; 108 Whitfield Street, London W1

George Stephenson
George Stephenson's Cottage, Wylam, Northumberland NE41 8BP

Stephenson Railway Museum, Middle Engine Lane, West Chirton, North Shields NE29 8DX

Robert Stephenson
Stephenson Railway Museum (see George Stephenson)

Blue Plaque: 35 Gloucester Square, London W2

Isambard Kingdom Brunel
Great Western Railway Museum, Faringdon Road, Swindon, Wiltshire SN1 5BJ

Ironbridge Gorge Museum (see John 'Iron-mad' Wilkinson)

Daniel Gooch
Great Western Railway Museum (see Isambard Kingdom Brunel)

Benjamin Thompson, Count von Rumford
Royal Institution of Great Britain, 21 Albermarle Street, London W1X 4BS – *Rumford was the founder of the Royal Institution*

Rosalind Franklin
Blue Plaque: Donovan Court, Drayton Gardens, London SW10

General Museums and Related Institutions

Black Country Living Museum, Tipton Road, Dudley, West Midlands DY1 4SQ

Bristol City Museum and Art Gallery, Queen's Road, Bristol, Avon BS8 1RL

Bristol Industrial Museum, Princes Wharf, City Docks, Bristol, Avon BS1 4RN

British Museum, Great Russell Street, London, WC1B 3DG

Derby Industrial Museum, Silk Mill Lane, Derby DE1 3AR

Kelham Island Museum, Kelham Island, Alma Street (off Corporation Street), Sheffield S3 8RY

Kew Bridge Steam Museum, Green Dragon Lane, Brentford, Middlesex TW8 0EN

Merseyside Maritime Museum, Albert Dock, Liverpool L3 4AQ

Museum of the History of Science, Broad Street, Oxford OX1 3AZ

Museum of London, London Wall, London EC2Y 5HN

Museum of the Royal College of Surgeons of Edinburgh, 18 Nicolson Street, Edinburgh EH8 9DW

Museum of the Royal College of Surgeons of England, 33–45 Lincoln's Inn Fields, London WC2A 3PN

Museum of Science and Industry in Manchester, Liverpool Road, Castlefield, Manchester M3 4FP

National Maritime Museum, Romney Road, Greenwich, London SE10 9NF – *for material on James Cook, John Harrison's clocks and Henry Maudslay's block-making models*

National Museums & Galleries of Wales: National Museum & Gallery Cardiff, Cathays Park, Cardiff CF10 3NP

National Museums of Scotland, Chambers Street, Edinburgh EH1 1JF

National Railway Museum, Leeman Road, York YO26 4XJ – *for material on the Stephensons, Isambard Kingdom Brunel and Daniel Gooch*

Natural History Museum, Cromwell Road, London SW7 5BD

The North of England Open Air Museum, Beamish, Co Durham DH9 0RG

Royal Photographic Society, Milsom Street, Bath, Somerset BA1 1DN

The Royal Society, 6 Carlton House Terrace, London SW1Y 5AG

Science Museum, Exhibition Road, London SW7 2DD – *for George III's scientific instruments, Boulton & Watt and Maudslay Sons & Field steam engines, the remains of the Rocket and much much more*

Whipple Museum of History and Science, Free School Lane, Cambridge CB2 3RH

Bibliography

Most of the people in this book have substantial entries in the *Dictionary of National Biography* (Oxford University Press, Oxford, 1995 – CD-ROM version).

For a fuller, different, and entertaining view, especially of the first chapter of this book, do have a look at Lisa Jardine's *Ingenious Pursuits* (Little Brown & Co. Ltd., London, 1999).

Robert E. Schofield's *The Lunar Society of Birmingham, Building the Scientific Revolution* (Clarendon Press, Oxford, 1963) is a mine of wonderful information, as is Desmond King-Hele's *Erasmus Darwin, A Life of Unequalled Achievement* (Giles de la Mare, London, 1999).

Samuel Smiles's *Lives of the Engineers* (John Murray, London, 1904) includes readable if not entirely reliable biographies of James Watt, Matthew Boulton, George and Robert Stephenson, and James Nasmyth.

L.T.C. Rolt's *Isambard Kingdom Brunel, A Biography* (Longmans, Green & Co., London, 1957) is also highly readable; he too wrote about the Stephensons. Adrian Vaughan's *Isambard Kingdom Brunel* (John Murray, London, 1991) is more recent and probably more accurate.

For each of the most famous people in this book there exist many biographies, and from them I would hesitate to single out one or two, but I do recommend Adrian Desmond

and James Moore's biography of Charles Darwin (Michael Joseph, London, 1991).

Of the many less well-known books I would like to mention Ian MacNeil's *Joseph Bramah, A Century of Invention* (David & Charles, Newton Abbot, 1968), N.D. McMillan and J. Meehan's *John Tyndall* (ETA Publications, Dublin), and the delightful biography by G.I. Brown: *Count Rumford* (Sutton, Stroud, 1999).

For a splendid if not wholly scientific account of the race to find the structure of DNA, try James Dewey Watson's *The Double Helix: A Personal Account of the Discovery of the Structure of DNA* (Atheneum, New York, 1968).

Index

Picture credits

The publisher would like to thank the copyright holders for kindly giving permission to reproduce the works illustrated in this book. Locations and lenders are given in the captions, and further acknowledgements are given below. Every effort has been made to contact copyright holders; any omissions are inadvertent, and will be corrected in future editions if notification is given to the publisher in writing.

Back cover: photograph © Paul Bader; page 37: © The Royal Medical Society, Edinburgh; page 61: © The Institution of Electrical Engineers Archives; page 68 (top): © Simon Loxley; page 77: © Christie's Images Ltd, 1986; page 93: © V & A Picture Library;

page 97: © By courtesy of Yousuf Karsh, Ottawa/National Portrait Gallery, London; page 99: © By courtesy of Wolfgang Suschitzky/National Portrait Gallery, London; page 103: © By permission of the Council of the Institution of Mechanical Engineers; pages 108 & 137: © Science Museum/Science & Society Picture Library; page 184: © Antony Barrington Brown.